Art Marketing 101

A HANDBOOK FOR THE FINE ARTIST

ArtNetwork

ART MARKETING 101, A HANDBOOK FOR THE FINE ARTIST

Updated April 2003 (Sixth printing)

Copyright ©1997 by Constance Smith

Cover and interior design by Laura Ottina Davis

Published by ArtNetwork, PO Box 1360, Nevada City, CA 95959-1360
(800) 383 0677 (530) 470 0862 (530) 470 0256 Fax
www.artmarketing.com <info@artmarketing.com>

ArtNetwork was created in 1986 with the idea of teaching fine artists how to earn a living from their creations. In addition to publishing art marketing books and newsletters, ArtNetwork also has a myriad of mailing lists—which we use to market our products—available for rent. See the back of this book for details.

Publisher's Cataloging in Publication (prepared by Quality Books Inc.)

Smith, Constance, 1949-
 Art marketing 101 for the fine artist / by Constance Smith.--
2nd ed.
 p. cm.
 Includes index.
 ISBN 0-940899-32-9 (pbk.)

 1. Art--Marketing.

N8353.A78 1997 700.68'8
 QB196-40361

DISCLAIMER: While the publisher and author have made every reasonable attempt to obtain accurate information and verify same, occasional address and telephone number changes are inevitable, as well as other discrepancies. We assume no liability for errors or omissions in editorial listings. Should you discover any changes, please write the publisher so that corrections may be made in future printings.

Printed and bound in the United States of America

Distributed to the trade in the United States by:
North Light Books, an imprint of F&W Publications Inc, 4700 E Galbraith Rd, Cincinnati, OH 45236
(800) 289 0963

ACKNOWLEDGMENTS

Several people suggested when I started this company that there weren't enough artists interested in marketing their artwork to support a publisher of fine art marketing tools. I disagreed and have since proven them wrong. With the new age at our doorsteps, more people are going into vocations that they enjoy, instead of jobs they must endure. Artists are no exception.

Turning around the myth of the struggling artist is no easy task! By changing this myth we will do our share to change the world.

I want to thank all the artists who have participated in ArtNetwork's growth—who purchased books, attended our seminars, had a consultation, gave us an interview. It is those artists who have inspired me in my daily tasks. They have also helped me discover new aspects of art marketing I didn't think about previously. Stories of these artists and their creative approaches appear in this book.

Constance Smith

FOREWORD

Art Marketing 101 is the most effective reference book ever published about the business of fine art. Ms. Smith, with her penchant for perfection and details balanced by her easy conversational style of writing, has produced a comprehensive yet easy to read book. This most pragmatic handbook is only possible because of her varied experiences as a curator, writer, lecturer and artist's representative.

The text is divided into units that permit the reader to obtain specific information or to read the whole story of marketing art in the order planned to maximize understanding. Legal, licensing and psychological aspects are given equal time to prints, greeting cards, sales and one-person shows. The chapter applying computer technology to the business of art is invaluable.

After reading *Art Marketing 101*, I returned again and again to certain chapters to sharpen my approach to the issues of most concern to me. In teaching painting and commercial art, I have integrated segments of the handbook into the syllabus. Very useful are the sections on phone and computer use. "Recommended Readings" at the end of each chapter are as useful to the instructor as they are to the student.

This handbook should be in the library of every art school and academic institution. The pages are laid out in a thoughtful manner that promotes ease of reading and comprehension. Fine and commercial artists will find a myriad of uses for this encyclopedic work. This handbook has been long in coming, but well worth the wait.

Professor Alvin C Hollingsworth, Visual and Performing Arts
City University of New York
1997

TABLE OF CONTENTS

SECTION 1 BUSINESS OF ART

Chapter 1 The Psychology of Success

Psychological roadblocks . 18

Changing your inner vision . 21

Chapter 2 Business Basics

Becoming a legal business . 26

Getting organized . 30

Creating an office environment . 35

Locating business assistance . 41

Chapter 3 Number Crunching

Keeping records . 44

Income and expense ledgers . 46

Tax preparation . 53

Budgets and projections . 56

Chapter 4 Legal Protection

Copyright . 60

Legal rights . 63

Contracts . 67

Finding the right lawyer . 71

SECTION II GETTING READY TO EXHIBIT

Chapter 5 Pricing

Pricing methods . 74

Maximizing your value . 78

Chapter 6 Shipping and Displaying

Packaging . 82

Shipping . 87

Framing . 90

Hanging artwork . 92

Care of artwork . 95

Chapter 7 Planning an Exhibit

The twelve-month plan . 100

SECTION III PRESENTATION KNOW-HOW

Chapter 8 Creating an Image

Presentation elements . 108

Business name . 109

Logo . 110

Tagline . 112

Letterhead . 113

Business cards . 115

Chapter 9 Resumés

Composing a resumé . *118*

Statements . *123*

Chapter 10 Photographing Artwork

Doing it yourself . *128*

Hiring a photographer . *129*

Reproduction methods . *130*

Chapter 11 Presentation Finesse

Portfolios . *136*

Cover letters . *140*

Video portfolios . *141*

CD ROMS . *143*

SECTION IV MARKETING SAVVY

Chapter 12 Marketing Plans

A personal plan . *146*

Setting goals . *148*

Short-term goals . *150*

Long-term goals . *151*

Chapter 13 Navigating the Art Market

Setting the stage . *154*

Research . *156*

The art of the telephone . *158*

Networking . *165*

Chapter 14 Promo Pieces

Postcards . *170*

Newsletters . *172*

Brochures . *174*

Chapter 15 Sales Techniques

Learning to sell . *184*

Closing a sale . *188*

After a sale . *189*

Special sales programs . *191*

Chapter 16 Advertising

Advertising placement . *196*

National directories . *198*

Internet advertising . *200*

SECTION V ENTERING THE MAINSTREAM

Chapter 17 Pitching the Press

Press releases . *204*

Meeting the press . *209*

National publicity . *211*

Chapter 18 Reps and Galleries

Reps . 214

The gallery scene . 219

Showtime . 226

Alternative galleries . 229

Chapter 19 Shows and Fairs

Outdoor shows . 232

Successful presentations . 236

Selling at shows . 238

Alternative shows . 242

Chapter 20 Locating New Markets

Competitions . 246

Publicly-funded programs . 250

Community involvement . 253

Museums . 255

Religious markets . 257

Businesses . 258

Architects . 261

Private collectors . 262

Chapter 21 Alternatives to Sales

Grants . 266

National Endowment for the Arts . 272

Residencies . 273

Sources of income . 274

SECTION VI PUBLISHING

Chapter 22 The Print Market

Self-publishing. 278

Iris/giclée prints . 281

Alternative printing methods. 283

Where to market prints . 287

Locating a publisher . 289

Other publishing possibilities. 293

Chapter 23 Greeting Cards

Self-publishing. 298

Handmade cards . 305

The printing process. 308

Locating a greeting card publisher . 309

Chapter 24 The Licensing Industry

What is licensing?. 312

INDEX

321

INTRODUCTION

This book was written to empower the artist. I wanted to create a user-friendly handbook, one that would take artists through the skills of business and marketing, step-by-step. We all know it's hard for artists to acquire business knowledge so I wanted to make it as fun and easy as I could.

WHAT IS THIS BOOK ABOUT?

This handbook is about self-promotion, strategies for emergence as an artist and for the furtherance of your career. The business of marketing art has become more and more complex and sophisticated. An artist must be educated in the art of business.

Artists in universities are taught the myth that great artistry is all they need to succeed—in fact having to work on developing consistency is proof of artistic failure. By and large, the only question universities deal with is how to look good enough for a gallery—rather than how to get into a gallery. Developing business savvy is often seen amongst artists as detracting from the main act of art. It's all supposed to 'happen.' Let's be practical! Waiting to be discovered is like waiting for Noah's Ark!

WHAT IS THE PHILOSOPHY OF THIS BOOK?

I believe that it is not harmful for an artist to think about business issues. Artists have the right to survive in this society while practicing their creative endeavors. To survive requires knowledge and creativity. By encouraging artists to become informed about the business of art and their possible place in it, I seek to broaden their survival rate.

It is impossible, even with great effort and talent, to guarantee a major career. Major artists emerge as the result of a confluence of factors. It is possible, however, to guarantee a career which allows the artist to use his artwork as his major source of income. To do this, most artists will have to change their way of thinking about the art field and their role in it. The more determined the effort, the longer the endeavor, the better are the chances of success.

WHO IS THIS BOOK FOR?

This book has been written to give fresh ideas to emerging and professional-level artists. It is not meant to turn artists into 'business people.' It is meant to help artists function in modern society, to guide them through the basic business techniques they need to know and to gain a positive attitude toward business. Insights gained from studying this book will not only help you market your work, but will free your mind and enrich your art as well.

Art Marketing 101, A Handbook for the Fine Artist is designed for both the beginner and the experienced marketer. It will guide you past the pitfalls, both in personal attitude and in the marketing process. I attempt to have you approach marketing creatively, initiating a marketing plan that is unique to your art and lifestyle.

Even though no one has forced you to read this book, not even a professor, you will find some things you'll refuse to do, areas that you haven't verified, old thinking patterns you don't want to break. Don't be alarmed if you don't implement everything I suggest. I expect this! Hopefully you will go back one day and understand why I stress a certain idea. As you market you will begin to understand some concept that you couldn't carry out, and then with this new understanding, you most likely will be able to make that difficult task part of your marketing plan.

WHAT WILL YOU LEARN?

You will learn the basic points to creating a successful business.

You will learn that marketing is a process, a continuous, ever-changing activity. Marketing is determining how and to whom to present a product. Having this knowledge will eliminate confusion and costly errors you might otherwise make.

You will learn practical information to further your art career. There are helpful tips, addresses, telephone numbers, forms you can copy, and research data that would take an individual artist years to accumulate.

Starting and progressing in any business is a life-building experience. You can't really fail; you can only learn. When you have a passion for something—in your case creating art—and want to develop it to be part of your everyday life, this often means taking a risk. And a risk you must take, or nothing will progress.

HOW TO USE THIS BOOK

How you use this book depends on how much you are committed to your career as an artist. This is not a "rah-rah" book. It's a book describing proven techniques that must be put into practice.

Treat it like a workbook. Fill in the blanks. Do one thing at a time. Start with the little things, and soon the bigger areas will become easier. I've tried to make the format simple to read, with plenty of space to jot down notes as you proceed through the chapters. Write all over the margins, as it will help you remember ideas. The detailed Table of Contents and Index should make it easy to find the exact topic you are looking for. At the end of six months, if your book is well-thumbed-through and full of scribbled notes, you're on your way to success as a marketing artist!

As any author would, I, too, suggest not skipping chapters. The chapters are in a particular order for a reason. If you skip to the end you will be missing some of the most important information on how to succeed in business—you're asking for the kiss of death! Even if you think you know all about a particular topic, take the time to read and reinforce what you know. You might be surprised at all the new ideas you learn.

Don't expect to find the one-minute magic answer in this book. Planning your marketing action takes time, open-mindedness, effort, aim, commitment and knowledge. You will need to discover as much about the art environment as you possibly can. All kinds of information about galleries, publishers, shows, competitions, portfolios, press releases and more will be useful in the progress of your career. Even successful artists must continue to learn in these areas in order to continue promoting their work successfully.

If it is in your heart and you want to earn your livelihood from that which you like to do most—your artwork—you will learn from this handbook that it is possible. With knowledge and strength, you will be able to make it through all the difficult times and make your dreams come true.

Everything we do reflects who we are. In most areas of our lives, the clarity of our aim has a direct relationship to the success that we achieve with it. This book is intended to help you achieve a clear aim in the area of marketing your fine art. As one famous artist who is a millionaire recently said to his stock broker, "You know, I'm not that great an artist, but I do know how to market!"

Good luck and stay with it!

Chapter 1
The Psychology of Success

Psychological roadblocks

Changing your inner vision

Whatever you can do or dream you can do, begin it. Boldness has genius,
power and magic in it. Begin it now!
 Goethe

PSYCHOLOGICAL ROADBLOCKS

The business of art is a long-distance marathon, not a sprint.

You probably didn't expect the beginning chapter of a book on art marketing to be on psychological preparation. Just as tennis is a psychological game, marketing is, too.

Every entrepreneur wears more than one hat and most entrepreneurs are not skilled in all facets of their business. When you enter the marketplace with your artwork, you'll need to have all your psychological artillery ready for action. This artillery will become important to take you through the pitfalls of your business and your life.

All of us have been raised with many attitudes that undermine our higher possibilities. Throughout our life we all must attempt to overcome those old barriers and attitudes and begin to think for ourselves—our better selves. As an entrepreneur—and that is what you are when you decide to start your art business—you will be, as defined by Webster's, "a person who organizes and manages a business undertaking, assuming the risk for the sake of profit."

Assuming risk? Yikes! You will need to become aware of your psychological blocks in order to take a risk and succeed in business. Study your negative attitudes toward success within your own psyche; find out what is holding you back. Follow only those attitudes that assist you in succeeding in your aims. That sounds simple, yet we all know it's not simple to change an ingrained attitude. It is, however, an axiom you must develop towards your art business.

Don't use any excuses! If you have them, keep them to yourself. Don't voice them. Excuses become more of a reality if they are voiced. Understand that they are only excuses. In case you're having difficulty seeing your excuses, here are some I hear all the time:

➤ I work full-time. I don't have the time to market.

➤ I've never marketed anything before.

➤ I'm shy.

➤ I live in an uncultured town.

➤ There's too much competition.

➤ I don't know how to price my work.

➤ I don't want to part with my work.

➤ Financial success will poison my artwork.

➤ The art market is saturated.

➤ I can't use the left side of my brain.

➤ I don't have any business abilities.

➤ A true artist should just be discovered.

➤ I would feel guilty about making money at what I love to do.

If you continue to believe any of these excuses, you will get nowhere. To make a living as an artist, you will have to have the courage—and take the risk—to break through any of your personal roadblocks. If you *truly desire* to accomplish the task of marketing and selling your art, you will create the courage to conquer these barriers. You can. You must. There's no alternative! You've broken through barriers in other areas of your life. Break through these, too.

By the way, you've already begun the process. You purchased this book because you *want* your career as a fine artist to flourish.

THE MYTH OF THE STRUGGLING ARTIST

Artists and non-artists alike are familiar with this ubiquitous myth. We've all been taught throughout our schooling that artists never make much money and don't care about money. This is just one of the many myths that have been heaved upon the creative people of the world. Don't believe it! Rubens, for example, didn't believe it. He was a politician and a very good businessman.

I know many artists across the U.S. who don't believe this myth, and for that reason they have prospered in the art business. They are not 'famous,' perhaps never will be 'famous' among the masses, but this isn't their aim. Their aim is to make a living as a fine artist.

You do not have to feel guilty about making money from your talents. You are fortunate enough to have a talent that can become an occupation. People want and need art. Get on with what you *like* to do! Have an attitude-change toward the business of art. Put an end to those lies society programmed into you.

Conquer the myth of the struggling artist. Get on with becoming a surviving artist in the new millennium.

FEAR OF REJECTION

Another myth artists are taught is that they are supposed to be rejected—by society, by galleries, by clients, by the business world. "Artists are eccentrics. They are rejects." Let's not advocate rejection

To succeed in any business venture a commitment is a must.

19

You must have the attitude that your work is worthy. Without that attitude, you cannot succeed.

any longer. Let's think anew. Believing this myth attracts rejection.

You will need to learn to distance yourself from—but take heed of—criticism. You are educating yourself for intelligent marketing. Listen to what people say when they comment on your work. They can give you important clues for future planning. Are they rejecting your portfolio? Did you catch them in the middle of a hectic day? Were you late to your appointment? Did you choose an inappropriate gallery?

As an artist you don't have to take a criticism personally. If you feel your work is truly inspiring, surely there will be other people who feel the same. If you consider your artwork of a top standard—and you should if you intend to market it—why is the opinion of someone you don't know so distressing to you? Perhaps you don't really feel that your work is *so good?*

Without the fortitude you gain from these inevitable critiques that hurt, you won't be ready for the psychological strength you need to be a success. Once you start marketing your artwork on a regular basis, this gut-level fear of criticism and rejection will begin to diminish.

BOOKS

Art & Fear by David Bayles and Ted Orland
Consortium Book Sales (800) 283 3572
An uplifting book written by two artists in their own right. Subtitled An Artist's Survival Guide, it covers questions that matter: What is your art really about? Where is it going? What stands in the way of getting it there? This book explores the nature of the difficulties that cause so many artists to give up along the way. It is about committing your future to your own hands. Available at bookstores.

Art without Rejection by Sheila Reid
Rush Editions, BP 13, 06141 Vence Cedex, France
(33) 49324 2613 Fax
Explains how to stop receiving rejection letters, to increase your creative powers and to eliminate creative block. $21ppd.

On the road to success you will need, use and discover many tools that are useful to your growth. Sports pros use the idea of visualization to help their athletes succeed. As an artist you can also use this technique. Visualize your artwork hanging in different venues: homes, galleries, corporations. Visualize yourself shaking hands with corporate buyers, with an art publisher at ArtExpo, whoever you need to help you along the way.

You will also find it helpful to go public! Start calling yourself an artist. You've probably considered yourself an artist for some time. Now you must announce it to the world. When someone asks you what you do for a living, your reply should be, "I'm an artist."

Once *you* start calling *yourself* an artist, you'll be surprised at how many other people will start referring to you as an artist, too. Hearing others call you "artist" creates an inner image that reinforces your aim.

DEFINING SUCCESS

Do you realize that you can set your own standards of success? Wow! This is a revelation! *You* decide what success is for you. Is it selling three originals? Is it finding a publisher? Is it setting up an art business? Is it finishing 10 pieces of work? Is it making $25,000? $5,000?

If you want to believe what someone else tells you success is, then you are going against the possibility of creating your own free will. Without the passion of your own heartfelt aims, you lose your inner power. You won't be able to create the passion to succeed if you use someone else's idea of a goal. Passion creates great powers within each of us and is needed to succeed in any business.

Take each year as one more step in building what *you* want—not what your mother, father, friend or business associate thinks you need, but what *you* determine you want!

PERSEVERANCE

In most parts of our lives, we've found that we must persevere through troubled and difficult times. It is no different for an entrepreneur, be he artist or baker. Just to survive in life we must persevere. To do what we want, we must really be committed!

You must plan to remain at this venture—not one or two years, but 10-40 years, i.e., all your life. You are an artist, after all: what else can you do? What else would you *want* to do for a living? With this atti-

CHANGING YOUR INNER VISION

You must define what you want. Only then can you make the efforts to get it.

Art is big business and I can be part of it! This is the new attitude you are developing.

tude, you will be able to conquer problems when they arise.

Along the way remember the adage "It takes money to make money." If you are not willing to spend money on promoting yourself, why would anyone spend money on buying your work? You need to value your work more than anyone else! If you are not willing to invest time, money and energy in your career, who is? You certainly won't convince an art rep to work for you for a commission. You will need to invest in portfolios, lawyers, books, and other promotional tools that you determine will help to build your business. How much will you sacrifice to achieve your goals? How important are they to you? How easily do you give them up or let life take them away? You are the one to decide your fate.

POINTERS

➤ If you are already established in another occupation, make your change slowly, intelligently.

➤ As an artist you will have two roles—creating art and marketing art.

➤ You will inevitably run up against some brick walls—both in yourself and in others.

➤ Take each step as it comes.

➤ Try to think of competition as good, as keeping you on your toes. There is space for everyone.

➤ Get your personal life in order. You will then have the proper energy that it takes to make your business survive. Starting a new venture while your life is in chaos will just defeat you.

➤ Know what you are willing to invest, money- and time-wise, in order to reach your goals.

➤ Let your family and friends know your intentions of starting a business. Also let them know it won't detract from your responsibilities to them, though it might change them a bit. Get their support, emotionally and psychologically. You will need it.

➤ Make a total commitment or no commitment at all!

Fortunately for humanity, you will use your creative genius to take the reins of your own destiny.

Present yourself as the artist you want to be, whether you've reached your goal or not.

INTERVIEW WITH A SUCCESSFUL ARTIST

I originally met Synthia Saint James through her exposure in the *Encyclopedia of Living Artists* in 1987. Soon after I began to notice press about her in many art publications. I have seen her success grow and grow. Many of her following comments confirm what I tell artists about the business world. Her final words of wisdom were: "Success creates more work, less leisure. I'm working harder now than I ever did before."

How long have you been marketing?

Since my first originals sold as commissioned pieces, some 25 years ago. The early commissions came by word-of-mouth. Someone would see a painting that I had done for an individual's home or office space and ask if I would accept a commission. I didn't think of it as marketing at the time, but now I do—exposure is marketing. Conscious marketing took place after I started sending out mailings and having exhibitions. I did research on various galleries and competitions and got into my first group show. My first exhibition was a one-woman show in 1977 at Inner City Cultural Center in Los Angeles.

Some important things you learned and are still learning?

➤ The importance of research
➤ Realizing that success is a personal responsibility
➤ The importance of working at my art as often as possible

What business practices have you learned?

➤ Make all agreements (commissions, exhibitions, etc.) legal by putting everything down in writing, signed by myself and client or gallery, with everything clearly defined. Know an attorney with whom to consult.
➤ Never start a commission without having received one-third or one-half of the payment in advance.

Do you have a rep or do you hire someone to assist you with office duties?

I have had agents, representatives and assistants. What works best for me is having a dependable assistant who can take some of the pressures off me, therefore giving me more time to paint.

Do you use the press to assist you? Do you advertise?

I make it a point to be listed in *Decor Source Directory* and *Art Business News Source Directory,* both of which come out annually for the art trade for my prints. Recently, with all the book covers, I have my first ad in *RSVP,* which comes out once a year featuring ads from illustrators and designers.

How important is it to be in a gallery?

I feel it is important to exhibit in at least one gallery regularly. That way people will always have a place to go to see your work or to bring friends. I also feel that there will always be special collectors of your work who should be allowed to buy directly from you. Galleries can be important outlets to sell reproductions. It is great to establish a list of galleries from which collectors can buy nationally.

Are you in any unusual markets?

Many types of companies have been licensed to use my images on various products: playing cards, mugs, magnets, boxes, t-shirts, greeting cards, neckties, gift bags, puzzles, etc.

ACTION PLAN

❑ Define your personal roadblocks.

❑ Rid yourself of the myth of the struggling artist.

❑ Use rejections to your advantage.

❑ Announce to the world that "I'm an artist."

❑ Practice visualizing success.

❑ Define your own terms of success.

❑ Define your goal, believe in it, and achieve it.

❑ Practice persistence and perseverance.

❑ Take risks when necessary to advance your career.

❑ Present yourself as the artist you want to be.

❑ Make a total commitment to your art career.

RECOMMENDED READING

The Artist Observed by John Gruen

Change Your Mind, Change Your Life by Gerald G Jampolsky and Diane V Cirincione

Creative Visualization by Shakti Gawain

Get the Best from Yourself by Nido Quebein

Happiness is a Choice by Barry Neil Kaufman

Life's Little Instruction Book by H Jackson Brown

Real Magic: Creating Miracles in Everyday Life by Wayne W Dyer

Wishcraft: How to Get What You Really Want by Barbara Sher and Annie Gottlieb

Chapter 2
Business Basics

Becoming a legal business

Getting organized

A marketing schedule

Creating an office environment

The Internet

Locating business assistance

To know how to live is all my calling and all my art.

Montaigne

BECOMING A LEGAL BUSINESS

Once you've made your commitment to start an art business, there is *no* way around the need to learn basic business practices in order to succeed. Learning these practices is not a guarantee for success, but it is certainly the most intelligent way to approach success.

If you plan to earn a living as an artist, you must start by establishing your business as an entity. You want to become legal to convince yourself that you are serious. Everyone else you deal with will then take your business seriously too.

Take the following list of things to do one step at a time. It will take several hours/days to complete, some patience and a little money. When you finish, you will be a professionally-registered business.

BUSINESS NAME

You don't have a business name? Well, it's a good time to start thinking of one! You don't have to come up with it right away; in fact, do spend some time brainstorming with friends and family. See Chapter 8 for more help on selecting a business name. Don't finalize any name until you are certain that it's a good one. Test it out. Make sure it creates a good image for you and your artwork.

Why have a business name—why not just use your own name? Your business name can summarize your style, subject matter or philosophy in art—and that's what it should do! Make it show clearly who you are and what you do!

When you've decided on the 'perfect' name, you will need to go to your local County Clerk's Office to register your fictitious name. They will verify that no one in your area is doing business with that name. You will have to place an announcement in the local paper for several issues running. The total cost will be around $25-50.

LICENSES

Contact your local Chamber of Commerce to verify that you don't need any special license for doing business in your particular area. Some residential areas require a business license, some don't. Some tax your business assets, some don't. Make sure there are no zoning problems regarding your business such as parking, delivery, etc.

BANK ACCOUNT

Open a business checking account. Have business checks printed with your company name. It will make you feel and look like a

professional. You are not required by law to have a separate account, but if you ever get audited it's easier to convince the IRS that you are in business. It also makes it easier to keep track of your business expenses.

CHECK COMPANIES

Artistic Checks
PO Box 1000, Mabelvale, AR 72103 (800) 224 7621
Unique checks with labels to match.

Check Gallery
PO Box 17400, Baltimore, MD 21203 (800) 354 3540

Checks in the Mail
2435 Goodwin Ln, New Braunfels, TX 78135 (800) 733 4443
Inexpensive and offbeat checks at good prices. They also produce checks for the Quicken computer program.

Rosencrantz & Guildenstern
PO Box 150, Milford, NH 03055 (800) 354 4708 (603) 654 6168 Fax
www.coolchecks.com
These checks, subtitled "Exceptional Banknotes," are ones that every artist should have. I wouldn't be caught without them! From Monet to Münch.

SALES TAX PERMIT

All states require a retail business—and that's what you are—to collect sales tax. As a retailer you must charge sales tax on your retail sales, just as a car dealer, a drug store or a department store would. When you write up the sales receipt, you add on your state sales tax. The taxes that you collect from customers are paid by you to the Board of Equalization, usually quarterly or annually.

When you sell to a wholesale client (i.e., someone who resells your work), you *do not* charge tax. This wholesale client must have a sales tax permit—just as you do. You must keep a record of their resale number on your invoice in case you get audited.

One applies for a permit at the local Board of Equalization. A sales tax permit does not cost anything; you simply need to apply by filling out a form. When you fill out the form, indicate honestly what you think you will be making in the first year from the sale of your art. Do not overestimate. Be modest. They are not holding you to any figures. They could require you to make a security deposit if they see that the amount of monthly sales will be substantial.

Do not think that sales tax is cutting into your profits. You add it onto your retail price, and eventually return that sales tax to the state.

27

The Board of Equalization will give you all the information you need on how to charge tax as well as how to fill out your sales tax return. The sales tax office *does* audit regularly, and they love to audit both commercial and fine artists, so keep accurate and honest records.

A resale number also allows you to buy certain products without paying taxes. Anything that becomes part of an artwork intended to be resold (paint, canvas, frame, marble, etc.) can be purchased without paying tax. You will be asked to present your sales tax permit when purchasing such items. Items such as easels, paint brushes, books, etc., do not become part of your end-product and are therefore taxable.

INSURANCE

Examine your situation to see which types of insurance you might need: private possessions, artworks, health/medical, life, liability, fire, earthquake, absence from work due to illness, auto, etc. You can also get coverage for your studio, business records, and artwork in progress. But do you need all this insurance? Probably not. Find a good insurance agent, see how much it all costs, and then make your educated choice.

Some artist organizations offer package deals on various types of insurance. See if the organization you belong to offers the insurance you need.

If you have an active studio with many people coming and going, you should consider casualty/liability insurance. The same is true if you exhibit at fairs and shows. People could sue you if they tripped over a rug in your booth. If you work with art councils on big commissions, they generally require you to have liability coverage.

If a work of art is lost or damaged while being delivered to a client, your home-owner's or renter's policy probably *won't* cover the loss. The insurance you need is called inland marine insurance and is usually added on to a regular policy. If you ship a lot of work, this could be a useful policy. It overrides any need for insurance coverage when shipping by mail or freight.

INSURANCE RESOURCES

Americans for the Arts/ACA

1 E 53rd St, New York, NY 10022 (800) 321 4510 (212) 223 2787
Health Insurance: A Guide for Artists, Consultants, Entrepreneurs, Self-Employed by Lenore Janecek. $15.95 + shipping. Ask for their free catalog.

FEDERAL IDENTIFICATION NUMBER

If you eventually hire employees you will need to apply for a federal tax identification number. Usually your local Small Business Development Center can help educate you in this area. If you are considering hiring help, remember: it ends up to be more expensive than just a per-hour rate. As an employer you have SDI taxes, FICA taxes, benefits, workers compensation insurance, etc.

Unless you have a very good reason for hiring someone, try to work with free-lancers. The general requirements for being considered a free-lancer are:

➤ Free-lancers are in business for themselves. They usually have a variety of clients they do work for.

➤ Free-lancers conduct their activity off your premises. They can have meetings with you there, but they cannot do the actual physical labor on your premises.

➤ Generally, you must pay them by the job, not by the hour.

LEGAL STRUCTURE

Different businesses, due to their nature, will want to take on different organizational structures. As an individual artist beginning a business, the wise structure for you to take is sole proprietorship. Being a sole proprietor means that you will be filing a tax return under your name, and you will be taxed on all profits. All liabilities will be in your hands.

Other future options could be a corporation, Sub-Chapter S corporation, partnership, limited partnership, nonprofit corporation or cooperative. Wait until you're more advanced to deal with these options.

GETTING ORGANIZED

So much of being successful is about being organized.

Some people have a tremendous problem getting organized—whether it be in their private life or business.

Are your files a mess? Is your desk a collection of piles? Organizing stores have sprouted up in most shopping malls to assist you. There are even college and adult education classes offered on organizing techniques. Must be a problem common to many. So don't fret!

A lot of people have difficulty throwing away old things. I once helped a friend clean her closet, which to me was more like a storage trap. I was able to convince her to toss three-quarters of the items. Without my help, however, she wouldn't have been able to take any of those items to the garbage. I love tossing things, so it was easy for me. Find a friend and get her to help you—or treat yourself to a birthday present and hire someone!

Invest a little time and money getting organized and you will feel more clear about your entire business situation. You'll finally get to experience how nice it is when you can quickly find the file that you are looking for.

You need to set up your files so they work for you. Taking an entire day to do this chore can save lots of time in the future. Refine your filing system as you go.

RESOURCES

Deluxe Office Products
(800) 328 0304
Offers all types of inexpensive office supplies through the mail.

Drawing Board
(800) 527 9530

Fidelity
(800) 328 3034

Hold Everything
(800) 421 2264
Both a store and a direct mail catalog, with lots of items to help you organize your office.

Reliable Home Office
(800) 869-6000
Modern office supplies

Art Office *is a book that has 80+ forms, sample letters, charts, legal documents and business plans to help you get organized. The forms can be photocopied for in-office use. Available also on diskette (MacIntosh Pagemaker only). Call (800) 383 0677.*

Quill
(800) 789 1331

Space Organizers
774 Mamaroneck Ave, White Plains, NY 10605 (914) 997 1434
(914) 428 6875 Fax <stefanie05@aol.com>
How to Organize Your Home, a 38-minute video by Stephanie Schur for
$19.95 + shipping.

TITLES FOR FILE FOLDERS

Accounts receivable	Bank account	Sales receipts
Legal documents	Sales tax returns	Fictitious name permit
Press releases	Slides	Resumés
Letters to clients	Hot file	Prospective clients
Idea file	Sample fliers, business cards, etc. for reference	

OFFICE ITEMS

stapler	business card punch	calculator
daily planner	file cabinet/crate	file folders
hanging files	highlight markers	letter opener
message pads	note pads	paper clips
paper cutter	pencils	pens
Rolodex	rubber bands	ruler
scissors	tape	wastebasket
staple remover	three-hole punch	endorsement stamp

USEFUL ITEMS

Calendar Creator
Available at any software store, this program helps you organize your
business activities and personal life. For Mac or PC.

Stationery House
1000 Florida Ave, Hagerstown, MD 21741 (800) 638 3033
Personalized post-it notes: 4x3", 10 pads for $15.75.

The to-do list helps you set priorities and focus on important tasks.

ACTIVITIES SCHEDULE

Not only must you be organized in your office setup, but you also must be organized in your activities schedule. With the highly complex information society that we have become, bombarded constantly with figures, ideas, facts, obligations, commitments, tasks and deadlines, we have a lot on our minds. If you don't already have an organizer or daily planner, get one. It is an inexpensive investment in your business. A commercially-produced planner is the ideal way to go. For $25, you will be amazed at how your life becomes simplified—providing you use it!

DAILY PLANNER PAGES

Current projects	Future projects	Clients
Potential clients	Books to read	Travel expenses
Cash expenses	Ideas	Books to research

Be sure to write down creative ideas—things you notice that you might want to use in the future. Don't vainly think you'll remember! You'll almost always forget. Did you attend an exhibit and note something about the display? The prices? Writing things down will free space for other things in your memory bank.

'To-do' lists should not be posted all over the walls. It should be just one list that you repeatedly view, i.e. it pesters you. Studies show that the moment you start a to-do list, you become 25% more efficient. When you arrive at your desk, you will see exactly what you need to do. No stalling. No excuses.

MAIL ORGANIZATION

Starting with a fresh, organized office space creates a mental attitude of success.

It is helpful to divide your incoming mail into groups so that you can prioritize and handle what is necessary first:

➤ Handwritten letters from prospects, family

➤ Promotional letters from businesses

➤ Bills

➤ Catalogs and brochures that you want to peruse when you have the time

➤ Catalogs and brochures that you dump directly into the trash

TIPS

➤ Buy a magazine file box for magazines that you want to keep to reference. If you have them handy you might do just that—reference them.

➤ Buy a business card punch so that you can put business cards directly into your Rolodex. As an alternative to a punch, buy plastic, color-coded Rolodex covers. Clean your Rolodex of un-used/unneeded cards annually.

A MARKETING SCHEDULE

How much time are you devoting to your artwork right now? Any time to marketing?

I know you don't want to hear this, but you have to. You must dedicate at least half of your art time to marketing! When I tell this to artists at my seminars, most of them gasp. The only ones who don't choke are those who have already prospered with their career and understand this theory.

Many artists learn that they have to spend *more* than 50% of their time marketing. The time never gets less—it's already at a minimum at 50%. The only exception would be if you hired someone to do it for you.

SPECIFIC MARKETING HOURS

The best schedule for a part-timer is to market the same day(s) and hours each week. Marketing will then become habitual, thus easier. For example, if you have 10 hours a week to work at marketing, work seven hours one day and three hours the next day. Take advantage of the momentum that can be created.

You have a 40-hour work week from 9-5? Don't say you don't have time or energy. These are excuses. If you really want to succeed, you will not have excuses. Remember, you are changing your attitudes! You cannot be half-interested, you cannot be a dreamer and think everything is magically going to happen just because your artwork is fantastic. You actually have to get out there and *do* something.

Whatever the total time presently devoted to creation of artwork, divide this time in half. That is the amount of time you should be devoting to marketing.

You only have two hours a week to spare? Wednesday or Friday is probably best, from 10-12. Remember: even with only two hours a week you're going to get further than the person not marketing at all!

When you decide on the hours best for you, remember during these hours you can only do marketing. No artwork. You can write down a great artistic idea, but that's it. If you start deviating with artwork, you are doomed. Don't do it! If you have a block during those hours, then sit and do nothing. Do not start creating artwork!

In the case of a 9-5, Monday-Friday job, here is some practical advice:

➤ Spend a half-hour of your lunch time researching, reading and planning what you need to do.

➤ Plan time on the weekend to go to the library for research, to attend an exhibition, to go to a gallery.

➤ Contact people by phone during your lunch time.

➤ Take a risk and ask your employer for a slightly different schedule, say 7-3; or ask for a two-hour lunch one day a week, making it up on another day.

➤ Let your family know exactly what your marketing hours are. They are not to interrupt you during this time. Make your own rules and enforce them. *Get respect!*

The determined are able to accomplish remarkable things. Going into business for yourself, whether it be as an artist or carpenter, takes great determination as well as discipline.

CREATING AN OFFICE ENVIRONMENT

To accommodate your art business, you will need to create an office environment. If it can't be an entire room, if it's only a small desk, make sure it's private, quiet and comfortable. You'll be spending lots of time there. You can't work with people interrupting you constantly. Is there ample lighting? Is there a phone connection? Electrical outlets? Heat?

Set up your desk, file cabinets, etc. so they are convenient. Put energy into your office environment. If you don't, you are not taking your business seriously, and you are neglecting an important factor in success.

TELEPHONES

The telephone is one of the best marketing tools you have. Learn how to use it to do research. Read more about telephone sales techniques in Chapter 15.

POINTERS

➤ If you do business outside your local area, get an 800 line, so when you leave a message for that special potential client, you can leave an 800 number for calling you back. Don't advertise this number (unless you've decided it's worth it), but do make it available to those special clients. It is impressive when you have an 800 number. Call your local telephone company to find out about the new, low rates.

➤ Don't be a penny-pincher. Follow up on all leads, even if they require long-distance calls.

➤ Don't give your business number to friends. Have them call your home phone.

Call waiting

A useful addition to your telephone service is the call waiting option. This allows you to put one caller on hold while you answer a second call. This option is quite inexpensive. If you think it could improve your business, try it for a few months. You can cancel it at any time.

Though it's not pleasant to be interrupted by another incoming call when on the line doing business, not having a second line might mean losing a commission. To alleviate the second line interruptions, quickly ask your present party to hold for a moment, then take a

I personally don't like call waiting because I hate getting interrupted by a second call. I feel it's discourteous to put the present caller on hold as well as disruptive to ones flow of thought. Often times it's a sales person interrupting with a sales pitch—very disconcerting! So what we have done at ArtNetwork is to get call forwarding attached to our main line. When the main line is being used, all calls get forwarded to an answering machine.

Caller ID is available at most locales now. For about $6 per month you can see who's calling you before you answer.

message on the second line by saying, "Hi. This is (company name). Can I take your name and number and call you right back? I'm on another line at the moment." Don't leave the original caller on hold very long.

Call forwarding
If you will be away from your phone for periods of time, call forwarding can come in handy.

Call hold
By pressing certain numbers you can put a caller on hold, even if your phone doesn't have that device.

Automatic callback/redial
Many phones have this convenience. It is especially good when trying to reach government offices or the IRS! If you have a speaker phone, it's even more convenient because your hands are free.

Optional residence telephone service
This could save you bucks. It allows you to make unlimited calls to nearby cities for a flat fee. Check with your local telephone company for specifics in your area.

Call screening
Having calls come in that repeatedly hang up? Dial * 69 and you will be connected to the caller (only if it's a local call). It costs 75¢ each time you use this feature. If you have harassing calls you can also disconnect certain numbers from calling into your line. Call your local phone company for details.

ANSWERING MACHINES

Yet another necessity to accomplish your business tasks is the answering machine. You will miss many opportunities without it. Business people don't have time to call you every hour for two days, getting no answer, only to find that you were away for a week on vacation.

If you are about to purchase an answering machine, consider:

➤ You want to have the message giver talk as long as he likes. These 30-second messages are no good.

➤ Purchase a machine with two tapes—one for incoming and one for

outgoing messages. On the one-tape message machine the beep gets longer and longer as more messages are left.

➤ Voices are hard to decipher on the newer digital machines.

➤ Get a remote retriever. Even though you don't think you'll need to retrieve messages remotely, you might in the future. You can also change your outgoing message remotely. Once you know how to use this feature, it's great.

The message on your answering machine should be brief and professional, with an upbeat tone. It should include your company name, a request for the caller to leave name, phone number (with area code) and a message.

If you don't want an answering machine (although it is the most economical option), there is an alternative. In most areas of the country, the telephone company will answer the phone for you. For a small monthly fee and setup charge, you can get voice-mail in a private mail box. You can have up to 30 messages of three minutes duration held for you. When you arrive home, you find out if you have a message by picking up the receiver and listening for a beep. You dial a number, insert a secret code and dial in for your messages. You can also do this when you are away from home. Call (800) 675 9005 to talk to your telephone representative.

FAX MACHINES

Almost every business needs a fax machine these days. Since the cost is now only about $200, there is no excuse not to have one. Act like a big business.

FAX TIPS

➤ Keep a copy of any form you fax often in a handy file by your machine.

➤ Purchase self-adhesive fax labels (small Post-it notes) that adhere to a memo and state the person's name and number. You generally don't need a full-page cover sheet.

➤ If you fax after prime hours, you will save a little money. But don't do this when someone has called for something and would appreciate it immediately. There is great satisfaction in receiving information directly after you request it.

If you get a fax machine, invest in a separate line—called a dedicated line—for your machine only. It will cost about $10 per month extra for that line and will save you a lot of headache. A fax line connected to your telephone line means that the person usually ends up calling you, you answer, they tell you they are trying to send a fax, you hang up, they call back, you let the fax machine answer. A real nusiance for both parties.

Read the instructions on your fax manual and set the machine to receive the fax after the first ring. It's irritating, when sending a fax, to wait five rings before the machine responds to the beep.

If you can't afford a computer, you can go to a service bureau and rent a computer by the hour. Service bureau computers have access to a variety of clip art, many fonts and good printers. You can save your work on a diskette.

COMPUTERS

Computerizing your art career is a must A small business without a computer these days is like a dinosaur. Computers are great for jazzing up your business presentation, resumés and letters and for doing bookkeeping, time management and many other tasks. You can even print professional-looking promotional pieces.

It will take some hours to learn how to use the various software programs on your computer. You will need these programs: word processing, bookkeeping, page layout, mailing list/file program, calendar planner, etc. Plan to spend a good month learning the basics.

There are many used computers for sale in the newspaper which would be quite adequate for your small business needs. If you decide to buy a new one, don't let a salesman talk you into an expensive model that you don't need. Talk to some friends and associates and decide what you want before you actually buy. We have an Apple MacIntosh 1986 model as well as a newer MacIntosh. At ArtNetwork, we still use the 'antique' 1986 model for many of the above-mentioned tasks. Used ones go for about $200-300 and often can include printer, keyboard and monitor. Another great buy is the I-Mac, as most necessities come already setup in the computer: internet access, modem, zip drive, software and more.

DESKTOP COPIERS

If you think you need a copier, there are desktop copiers available for less than $300. Remember fax machines also act as a copier. That could be sufficient for your beginning needs. Go to your local quick print shop for larger jobs.

THE INTERNET

The Internet/World Wide Web is off and running! I'd suggest you get caught up with it.

PREREQUISITES FOR CONNECTING

• a computer

• modem

• color monitor (no fun to look at art in B&W!)

• lots of paper

• lots of time to spare

• software

• server access (about $15 per month)

• instruction book

• a class

I would suggest that you locate an Internet cafe—a cafe that has computers connected to the Internet. You can rent time on their computers ($6-10 per hour). Perhaps your local library even has a connection for free! How about a friend who is already on-line?

Look up some of the sites listed on the next pages. Explore. Be ready to print out pages. Send e-mail to your friends. Reach your own conclusions! What did you actually accomplish in those hours? Hopefully you've at least fulfilled your curiosity.

Unless you know exactly where you're going and what you want, it's extremely easy to deviate from your original destination. There are many sites that arouse curiosity on the Net. You can learn lots, or you can waste a lot of time.

INTERNET ACCOMODATIONS

➤ **E-mail.** If you have foreign correspondents you'll save bucks.

➤ **Communication forums.** You can subscribe to forums where people who want to exchange information on a particular topic discuss their ideas. To find artist groups, search for "news.list newsgroup" and it will bring up various topics. Be sure to save the addresses you are interested in, or they might get lost to you forever.

Internet 101 for the Fine Artist: A User-Friendly Guide to Exhibiting, Promoting and Selling your Artwork On-line
by Constance Smith
This book addresses relevant topics including: web site design, generating traffic, cultivating media exposure, virtual and portfolio galleries, and auction sites. Sent to you via e-mail in PDF format for you to print out. $11.99.
Call (800) 383 0677.

Some art newsgroups:
alt.artcom
alt.postmodern
clari.news.arts
rec.arts.fine
rec.arts.misc
ci.fractals

39

INTERNET TERMS

Cyberspace

The on-line environment created by the Internet.

E-mail

Electronic mail; a message that is sent/received via the computer network.

Hit

A visit made to a Web site.

Home Page

The location where a company/artist has all their information for others to view—in essence a brochure.

HTML

The abbreviation for HyperText Markup Language, the programming language for the Web.

Search Engine

A piece of computer software that finds and retrieves data.

Server

A company that, for a service charge, hooks your phone lines up to the Net.

Site

A location on the Internet.

Surfing

Popular term for exploring cyberspace.

The Net

Abbreviation for the Internet.

WWW

World Wide Web, the multimedia resource on the Internet navigated by selecting hyperlinks.

➤ **Transferring files.** There are possibilities for downloading files onto your own computer: clip art, software, etc.

➤ **Travel.** Information about hotel chains, airline reservations, etc.

➤ **Banking.** At some banks you can verify cleared checks, bank balance, etc.

➤ **Looking at art.** You can view art galleries and museums in distant communities.

ON-LINE ART RESOURCES

*There are myriad places to surf to on the Internet—below are just a few to get you going. To find additional categories, conduct a search on any of the "search engines." My favorite is AltaVista, but you will find they all work fairly equally. When you do a search, put the words of your search in quotes, i.e., "your name" rather than **your name**. By putting quotes around the word(s) you will receive a more precise search and less fragmented results.*

www.artmarketing.com/Homepg/hotlinks.html

Look up all kinds of artworld professionals under the HotArtLinks page.

www.artwire.org

A program of the New York Foundation for the Arts that is an interactive computer networking project to facilitate communications within and among the national arts community. There is a monthly subscription fee. It will keep you updated on artworld events that might advance your career.

www.artsusa.org

You can visit their site and download fact sheets on a variety of topics of interest:

Accounting/Tax assistance	Artist communities/colonies
Artist-in-Residence programs	Artists with AIDS/HIV
Emergency funds/loans	Health and safety
Group health/fine art insurance	Living/working outside the U.S.
Legal assistance	National visual arts organizations
Public art programs	Publications for artists

artumbrella.com

Has global information, services about art

www.dream.cc

Discussions, collaborations, education for all the arts

Sometimes you will need an experienced person to help you learn about some aspects of business. Contact one of the following groups and set up a consultation (usually free for new businesses) and get some direct guidance. By making a few calls, you should be able to find an expert willing to help with almost any business problem that you come across.

CONSULTANTS & COACHES

Constance Smith
800 383 0677 www.artmarketing.com/consulting
The author of this book offers consulting at $1 per minute ($15 minimum).

Geoffrey Gorman
505 989 4186 www.gormanart.com
The Artist Resource Training Program sets up the foundations for an artist's career for years to come by enabling the artists to define their artistic vision, set realistic goals, find their niche and develop structures that will support them throughout their career.

Taking the Leap
Cay Lang (510) 653 1655 www.takingtheleap.com
A comprehensive group program taking place once a week for six months.

RESOURCES

Small Business Administration/SBA
(800) 827 5722
Offer more than 100 business booklets for a nominal fee (most under $2) that address a number of business topics. Ask for a directory of publications.

SBDC
(202) 205 6766
Free counseling and workshops on getting financial assistance.

The Service Corps of Retired Executives/SCORE
(800) 634 0245
Comprised of 13,000 people with varying business backgrounds. Counseling is free and confidential. Special programs for women.

Government Printing Office
Superintendent of Documents, Washington, DC 20402
Many helpful publications available. Ask for a catalog.

LOCATING BUSINESS ASSISTANCE

artmarketingworkshops.com
Interactive classes taught via phone and Internet

Visual Artist Information Hotline, *sponsored by the New York Foundation for the Arts, has been providing artists with free information for years. Call (800) 232 2789 between 1-5 EST M-F or access www.nyfa.org/vaih/ vaih_factsheet.htm*

Salon 6 is a training program in career development and management, with emphasis on artists earning a living from selling their work. Contact Lisa Lodeski Fine Arts, 3 Collingwood, Aliso Viejo, CA 92656 (949) 425 9458 www.members.home.net/lodeski <lodeski@home.com>

ACTION PLAN

❏ Register with the County Clerk's Office.

❏ Apply for any necessary business licenses or permits.

❏ Open a business checking account.

❏ Apply for a sales tax permit.

❏ Investigate what insurance you might need.

❏ Organize a filing system.

❏ Create a marketing schedule with specific days and hours.

❏ Create an environment in which to do your business activities.

❏ Invest in a separate business telephone line.

❏ Get a fax machine and answering machine.

❏ Investigate your need for a computer.

❏ Go surfing at an Internet cafe.

RECOMMENDED READING

Business Etiquette _by Jacqueline Dunckel_

Conquering the Paper Pile-Up _by Stephanie Culp_

How to Organize and Operate a Small Business _by Clifford M Baumback, Kenneth Lawyer and Pearce C Kelley_

How to Start Your Own Business...and Succeed _by Arthur H Kuriloff and John M Hemphill_

Internet for Dummies _by John Levine_

Netlaw: Your Rights in the Online World _by Lance Rose_

Popcorn Report _by Faith Popcorn_

Running a One-Person Business _by Claude Whitmyer, Salli Rasberry and Michael Phillips_

The Whole Internet User's Guide and Catalog _by Mike Loukides_

Chapter 3
Number Crunching

Keeping records

Income and expense ledgers

Profit/loss statements

Tax preparation

Budgets and projections

Personal budgeting

In art, economy always is beauty.
Henry James

KEEPING RECORDS

As you are learning, there is more to the business of art than being creative with the paintbrush! You are also, hopefully, realizing that it is the same for any inventor, writer or performer—the creative process does not sell the product.

This chapter will only touch upon the topic of money and bookkeeping. You will be informed of the most important aspects of record-keeping for your small business. As your business progresses, find a more detailed book on this topic. For now, however, we want to keep things simple. What you will learn here will suffice.

THE PURPOSE OF ACCOUNTING

Though the IRS requires all businesses to file tax returns calculated from appropriate backup documents, you need to understand that you are keeping records for your own good. Yes, for yourself! Once you learn to 'read' your accounting records, you will understand the full benefits of keeping good records. Good planning and budgeting are crucial in any business: they could mean the difference between success and failure.

ORGANIZING YOUR RECEIPTS

Saving receipts is the first aspect of record keeping; without them you won't be able to record any numbers. If you do get audited (about one percent chance), you also will be sharing these records with the IRS. You should save all your art-related receipts, both income and expenditures, for at least five years.

Also save calendars, appointment books, business cards of galleries you visited, copies of business letters you sent, schedules of galleries you sent slides to, press releases, awards, marketing plans, client lists, resumés, professional organizations to which you belong, auto-log—and anything else that seems appropriate. If you are ever audited you will need these records to prove that you were in business, i.e., attempting to earn a living.

Keep receipts in file folders, divided by the different tax-deductible categories. Use one color file for expenses and another color for income. You will also need file folders for such things as charge card receipts and bank statements.

TIPS

➤ If you are in your car a lot, keep an envelope in your glove compartment for receipts.

➤ When you have meal receipts, write the name of the person you took out and their business relationship directly on your receipt.

➤ If you paid cash, indicate that on the receipt. If nothing is written on the receipt, you can assume you used your business checking account or your business charge card.

➤ Keep one credit card for business and one for personal use. This will save you a lot of time and headache.

CHECKING ACCOUNT BALANCING

Look on the back of your bank statement for directions on how to balance your checking account. If you still can't figure it out, a customer service rep at your bank will give you free lessons. Once you get started, be sure you do it each month. It will then become simple to find errors.

ORGANIZING SOFTWARE

MarketingArtist.com
PO Box 1360, Nevada City, CA 95959 (800) 383 0677 (530) 470 0862
www.MarketingArtist.com <help@marketingartist.com>
This on-line software catalogs images and keep track of your artwork, what shows its been in, what gallery has it on consignment at the moment, etc.; maintains a calendar of appointments; creates an address books of buyers and suppliers; organizes client contacts, both e-mail and snail mail addresses; prints out mailing labels from your contact list; reminds you of telephone calls to make; reminds you of daily and weekly to-do's, upcoming appointments and events; sends e-mail about your upcoming shows and more.

If you're small and you stay small, you don't need to pay anything—ever! Once you realize how convenient and useful this software is to help run your business, send your e-mails and create labels for postcards, you will be using it daily. Try it out for free. There is no charge until you have over 50 listings.

Quicken is bookkeeping software that costs less than $50. It keeps track of your income, expenses, P/L statement as well as prints professional-looking checks. For the IBM or Mac.

45

INCOME AND EXPENSE LEDGERS

If you have become "enlightened" and purchased a computer and accounting sofware, you can skip the next few pages! Your computer will create all these charts for you.

All your income receipts will need to be posted to an income ledger. You can use a 20-column accountant pad. Keep this ledger updated monthly. You can divide your income into categories, on your ledger and in your file folders, such as:

Direct Sales	Consignment Sales	Royalties
Fairs/shows	Leases	Commissions
Gallery 'A' Sales	Gallery 'B' Sales	Prizes
Awards	Grants	Miscellaneous

January Income	Totals	On Account	Miscell.	Gallery Maxine	Rental/ Leases	Fairs/ Shows
Jan 7 Gallery Maxine	223—			223—		
15 Lorraine Dant	25—				25—	
15 William Marus	25—				25—	
15 STP Inc.	50—				50—	
22 Mark Summers	350—	350—				
30 Art Market Show	1022—					1022—
Totals	1695—	350—		223—	100—	1022—

Even if you hire an accountant at year end to file your tax return, you still have to complete the recordkeeping.

An expense ledger is similar to an income ledger, showing money you've paid out that is *tax deductible*. The ledger breaks down the type of expense, with totals by the month, quarter or year. The same 20-column accountant pad you use for posting income can be used for expenses; just use a different page. After you post the expenses from your receipts, you will file the receipts in the appropriate file folders.

January Expenses	check#	Total	Advertising Promotion	Art Supplies	Banking Fees
Jan 3 Jerry's Art Supply	1322	26²²		12¹⁸	
7 Bank of America	—	7.ºº			7⁻
11 YRCO (entry fee)	1323	15⁻			
12 Mr. Saxon	1324	150⁻			
13 Bank of America (checks)	—	13²²			13²²
13 PG&E	1325	16²²			
17 Pacific Bell	1326	22¹⁷			
18 American Express	1327	42⁴¹		19ºº	
22 Maxine's Printing	1328	73²²	73²²		
29 State Farm Ins.	1329	17²²			
30 USPO	1330	29⁻			
Totals		412¹⁸	73²²	31¹⁸	20²²

Dues/ Subscriptions/ Books	Fees	Insurance	Miscellaneous	Postage	Rent/ Utilities	Telephone	Travel
14ºº							
	15⁻						
					150⁻		
					16²²		
						22¹⁷	
							23⁴¹
			17²²				
				29⁻			
14ºº	15⁻	17²²		29⁻	166²²	22¹⁷	23⁴¹

DEDUCTION CATEGORIES

Use these categories as your "chart of accounts" that you will divide your expense items into. You can deduct expenses that you incur during the act of doing business, such as:

Accounting/bookkeeping/tax preparer fees
Admissions to art museums, trade shows, conventions
Advertising, business cards, stationery, brochures, etc.
Automobile expenses
Bank fees/bounced checks
Books (this one!), videos
Commissions to reps, galleries, etc.
Consulting fees
Donations to charities, museums, non-profits, etc. (consult your accountant)
Donations of artwork (consult your accountant)
Dues to art associations/clubs
Educational expenses related to art seminars, classes
Equipment/furniture/machines for your studio or office
Entertainment, business-related (consult your accountant)
Fees to enter competitions and trade shows
Gifts to potential clients (limited per year)
Insurance
Interest on business-related loans
Legal fees
Licenses, permits, copyright application fees
Mailing list purchases
Materials (paint, canvas, brushes, frames)
Moving expenses
Office supplies
Photographers for publicity photos, slides of artwork, etc.
Postage, UPS, Federal Express, packing supplies
Printing
Promotion costs (business-related dinner guests, wine for studio showing, etc.)
Protective clothing
Rent and utilities on studio or office (gas, electric, garbage, water)
Research and development expenses
Subscriptions to art/business-related magazines
Telephone
Travel expenses (airfares, hotel, food, car rental, taxi, etc.) to art events such as trade shows, gallery shows, seminars, conventions, fairs, etc.

AUTOMOBILE USE DEDUCTION

You should keep an auto-log in your car to record your business mileage. If you ever get audited by the IRS and have deducted usage of your car, you will need this log to validate your mileage. You can calculate your business mileage deduction in either of two ways: by the 'actual mileage method' or by 'per-mile method.' It's best to do both methods and see which one is the best deduction for you in any given year.

Actual mileage method

If you use the actual mileage method, you will depreciate the car (business % prorated) on IRS Depreciation Form 4562. You will also deduct, on Schedule C, your business percentage of usage deduction. Be sure to keep all your auto receipts: gas, repair, lube, etc.

Calculating % of auto for business use

A. <u>51,366</u> Odometer 1/1/97 B. <u>63,366</u> Odometer 12/31/97

C. <u>12,000</u> Total miles driven D. <u>6,000</u> Business miles
 calculated from your auto-log

Subtract A from B to get C. Divide C by D to get a 50% business use for the business year 1997. Use this 50% figure to calculate what portion of your 1997 auto expenses you can deduct. This calculation needs to be done each year as the 50% could rise or fall.

Per-mile method

This is a simpler method for deducting your business car use. Each year the government sets a per-mile deduction rate. After you figure out the total business miles from your mileage log (in this case 6,000), you multiply the miles times the government-set per-mile rate to get your mileage deduction.

HOME-OFFICE DEDUCTION

To establish a home-office deduction which meets the IRS requirements, you must be able to prove that your home-office is used both *exclusively* and *regularly* for business purposes. What a good reason to start marketing more! That requirement is absolute and must be met by every taxpayer who takes the home-office deduction.

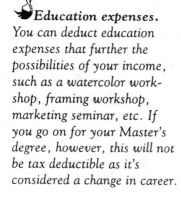

Education expenses.
You can deduct education expenses that further the possibilities of your income, such as a watercolor workshop, framing workshop, marketing seminar, etc. If you go on for your Master's degree, however, this will not be tax deductible as it's considered a change in career.

Be aware. Home-office deduction might evoke an audit.

Additionally, you must meet at least one of these three conditions:

1. Your home-office is your principal place of business.

2. Your home-office is a place where you regularly meet with customers or clients.

3. Your home-office is a separate structure not attached to your home.

If you can prove one of the above, you can take a home-office deduction. Home-office deductions cannot exceed the net income from your art business. Talk to your accountant about this, as it is not a simple matter.

If you rent, it is simpler to calculate the deduction for home-office, providing you qualify for one of the above. You simply write a check each month to the landlord for that portion of the home that you use as office and storage. That becomes your rent expense. For instance, if 100-square-feet of your 1000-square-foot house is your home-office (1/10), and you pay $500 rent, you would write one check from your business account for $50 (1/10 of the total rent) and one from your personal account for $450.

PROFIT/LOSS STATEMENTS

When you have finished one month's recordkeeping and have calculated the totals for each category of income and expense, you transfer these totals to a profit/loss statement, otherwise known as a P/L Statement or Income Statement. This statement gives you the bottom line on how much you made in any given month. When you put three months of totals together you have a quarterly P/L Statement, probably a more viable tool for analyzing your business.

This P/L Statement is the primary instrument used to diagnose your business's health, to note trends and growth in your business. You will be able to study where your income is derived from, as well as where your expenditures go.

It is a great help to know how to read your P/L Statement for planning future goals. If you are doing a particular project or promotion (i.e., having an open studio, doing a promo to publishers), classify all those particular expenses into special categories on your ledgers. When you read your financial statement at the end of the quarter, you will be able to see at a glance if the special promo was profitable.

P/L STATEMENT - JANUARY 1997

Income from sales

Gallery	$ 1,200	
Open studio sales	$ 400	
Rentals	$ 125	
Prizes from contests	$ 150	
Total income		$ 1,875

Cost of goods (supplies to produce artwork)		$ 375

Expenses

Advertising	-0	
Auto	$ 53	
Bank charges	$ 23	
Dues/publications/books	$ 19	
Entertainment/refreshments	0	
Entry fees	$ 25	
Insurance	0	
Interest	0	
Legal/accounting fees	$ 100	
Miscellaneous	$ 15	
Office Supplies	$ 45	
Personnel/Assistant	0	
Printing	0	
Rent	$ 150	
Rental equipment	0	
Seminars	0	
Shipping/postage	$ 15	
Telephone	$ 20	
Total expense		$ 465

Net profit $ 1035

BALANCE SHEET

A balance sheet is a picture of what you own and owe business-wise, a statement of your financial condition. It also shows what you have personally invested in your business. Assets = liabilities + proprietorship (what the owner has put into the business). Have your accountant help you prepare your first balance sheet.

A balance sheet shows what your net worth is. If you apply for a loan, your banker will want to see a balance sheet.

BALANCE SHEET

ASSETS		LIABILITIES	
Computer equipment	$2000	Auto loan (50%)	$2000
Office furniture	500	Computer	1400
Auto (50%)	4,000	Business credit card	450
		Total liabilities	$3,950
		Owner's proprietorship	$2,550
Total assets	$6,500	Total Liab & Prop	$6,500

FIXED ASSETS

A fixed asset is a major piece of office equipment, computer, furniture, automobile, etc. When you start your business, you should make a list of all major pieces of office property you already own and use in your business. You will then begin depreciating them at their present value. When you purchase new assets over $200 (under $200 they are considered an expense), maintain a log noting date of purchase and price paid. You will need to depreciate the purchase price over a period of time, determined by the type of equipment. You will use the IRS Depreciation Form 4562.

TAX PREPARATION

Your business and personal (Form 1040) tax returns are filed at the same time —April 15.

If this is the first year you will be filing a business tax return (Schedule C), I recommend you hire a professional tax preparer. You can actually lose money by doing it yourself if you complete the forms inaccurately.

When you go to an accountant, have all your papers in order for him, most importantly the year-to-date profit/loss statement. You don't want to pay him to do your bookkeeping, only your taxes. Don't bring in a box of receipts.

If you decide to do it yourself, the IRS does provide instruction brochures to help you. You will need to file Form 1040, Schedule C (Profit/Loss from Business/Sole Proprietorship), SE (self-employment tax) and possibly Depreciation Form 4562.

AUDITS

If audited, you must be able to convince the IRS that you are running a business, not simply a hobby. The records you've been keeping will prove that you were actively engaged in creating and marketing your artwork.

Many artists worry about taking a loss for more than three years on their Schedule C. Such cases have come before the courts. When the artist kept in-depth and accurate records and *was actually doing business*, their continuous losses were considered valid. For instance, if you studied art, sold some of your work, approached galleries for shows, kept a mailing list, had articles written about you, got a grant, taught art—all these validate that you are attempting to make a living at art. Don't feel guilty about reporting a loss. You should see Bank of America's tax return!

RESOURCES

General Tax Guide and Recordkeeping Kit
AKAS II, PO Box 123, Hot Springs, AR 71902-0123 (501) 262 2395
http://akasii.com <akasii@aol.com>
Easy to use, written for artists by artist/attorney Barbara A Sloan. These kits are updated throughout the year. Reasonably priced. Call, write or e-mail for a free brochure.

IRS Publications

(800) 829 3676

Most of these are free. Ask for an order form.

#334 Tax Guide for Small Business

#463 Travel, Entertainment and Gift Expenses

#505 Tax Withholding and Estimated Tax

#508 Education Expenses

#530 Tax Information for Home Owners

#533 Self-Employment Tax

#534 Depreciation

#535 Business Expenses

#536 Net Operating Losses

#538 Accounting Periods and Methods

#539 Employment Taxes

#541 Taxes on Partnerships

#542 Tax Information on Corporations

#545 Deduction on Bad Debts

#547 Casualty Losses

#551 Basis of Assets

#560 Retirement Plans for the Self-Employed

#583 Taxpayers Starting a Business

#587 Business Use of Your Home

#589 Tax Information on S Corporations

#936 Home Mortgage Interest Deduction

#910 Guide to Tax-Free Services

#911 Tax Information for Direct Sellers

#916 Information Returns (non-employee payments)

#917 Business Use of a Car

#921 Explanation of Tax Reform Act for Business

#946 How to Begin Depreciating Your Property

ESTIMATED TAXES

Once you decide to go into business, you will be self-employed. The IRS will then require that you pay your estimated annual tax liability one-quarter at a time. They will send you the proper forms to fill out each quarter. Use your quarterly profit/loss statement to determine estimates of income for the year.

Keep in mind: you can be employed and self-employed at the same time. If this is your case, you might not have to make quarterly estimated tax payments. Your employer is already taking taxes out of your paycheck. Consult with your accountant or the IRS to resolve your personal situation.

FORM 1099

If you receive more than $600 in any calendar year from a company or individual, you should expect to receive a Form 1099-Misc from them. Since many companies do not know about this rather new requirement (and also think it's a lot of extra paperwork) they do not file Form 1099. There is a large fine imposed, however, when a business does not file appropriate Form 1099s. The IRS is trying to crack down on the underground who don't pay taxes.

Likewise, if *you* pay someone over $600 in any calendar year for services rendered (i.e., work-for-hire, a printer, landlord, free-lancer, etc.) you need to:

➤ Report this on Form 1099-Misc by January 30 of the following year to the person to whom you paid the funds.

➤ Send a summary report, Form 1096, to the IRS by February 28.

If you anticipate making no more net profit (after expenses) than $2-3000 annually on your art business, you probably do not have to pay quarterly estimated taxes.

BUDGETS AND PROJECTIONS

Projections help you to see psychologically what you need to accomplish physically. All profitable businesses use projections. Use the familiar 20-column ledger pad to do a quarterly projection for the entire year.

A projection statement is very similar to a financial budget. You will try to predict what income you will have in the near and distant future as well as expenses for that same period of time.

Let's say you have been accepted by Bank of the Mediterranean for their one-person show for January. Project the amount you expect to make from this exhibit, both on-site and with follow-up. Of course, you don't know exactly, but create some aims. It could help you close a sale! You will be able to see if you have within your budget: funds to hire a salesperson from the local gallery, to send postcards to clients, for refreshments, etc.

PROJECTIONS

January 1, 1997 - March 30, 1997

Sales

Bank Exhibit	$ 1500
Personal/past clients	$ 500
Cards/prints	$ 200
Patrons @ $100 per month	$ 600
New patrons @ $100	$ 300
Projected income	$3100

Expenses

Bank Exhibit	
Mailers/invites	$200
Reception	$100
Salesman	$350
Overhead	$900
Printing of greeting cards	$250
Printing of letterhead	$150
Projected expenses	$1950

Total projected income $1150

If you are not content with the outcome of $1150 projected income, then it's time to think of what you can do to make it higher—either you must lower expenses or try for more sales.

PERSONAL BUDGETING

Whether in your private or business affairs, it is very important to learn how you spend, as well as why and when. The following task is not pleasant for most people—perhaps that's why, if you try it, you will learn so much.

In order to see exactly how, why and when you spend, you must go through the task of keeping track of *every expenditure* for at least three months. When you finally keep track for three months, you will be able to see your addictions and weaknesses regarding spending. You must write down every cent you spend: the 25¢ for morning coffee (whoops, 75¢ these days), $1 bridge toll, $1 to beggar, $5 for shoe repair, etc. I guarantee that you will be surprised by the results when you calculate your totals for weekly, monthly and quarterly expenditures!

BUDGETING POINTERS

➤ Use only cash or check; no credit cards.

➤ Use another page of your 20-column pad to keep track of your personal expenditures. Title each column: rent, dining, food, auto, entertainment, etc. Use whatever categories you might personally need, i.e., your personal addictions. Under the miscellaneous column, be sure to note exactly what each miscellaneous item is. This will be an important part of your analysis.

➤ Make a summary, similar to your P/L statement, at the end of each month, as well as at the end of the three months. Once you make this analysis, you will need to aim at curbing certain spending tendencies that are out of hand.

RESOURCES

Money: The Feisty Woman's Plan Ahead Guide
WCA, Moore College of Art, 20th & Parkway, Philadelphia, PA 19103
A great book to help you learn more about planning, estates, spending, etc.
$10.

Most people have no idea of how much they spend monthly. Using credit cards makes it even harder for individuals to balance their income and expenses each month. This exercise will help you spend wisely and leave time and money to invest in your art business.

Calculate what you pay each year from bounced checks, other bank fees, interest, past due charges. You may be shocked.

ACTION PLAN

❑ Start keeping all business receipts.

❑ Balance business checking account monthly.

❑ Use a separate charge card for business purchases.

❑ Make an income/expense ledger.

❑ Produce a profit/loss statement monthly and quarterly.

❑ Start an auto-log. Keep it in the car.

❑ Prepare a balance sheet.

❑ Start a fixed asset log.

❑ Create a quarterly business projection.

❑ Analyze personal expenditures to see addictions.

RECOMMENDED READING

The Budget Kit *by Judy Lawrence*

How to Turn Your Money Life Around *by Ruth Hayolen*

Keeping the Books: Basic Recordkeeping and Accounting for the Small Business *by Linda Pinson and Jerry Jinnett*

Living More with Less *by Doris Longacre*

Julian Block's Year Round Tax Strategies *by Julian Block*

Small Time Operator *by Bernard Kamoroff*

Straight Talk on Money *by Ken & Daria Dolan*

Your Income Tax *by JK Lasser*

Your Money or Your Life *by Joe Dominguez and Vicki Robin*

Your Money, Your Self *by Arlene Modina Matthew*

Chapter 4
Legal Protection

Copyright

Legal rights

Contracts

> *User-friendly agreements*

Finding the right lawyer

No! No! Sentence first, verdict afterwards.
 Through the Looking Glass, *Lewis Carroll*

COPYRIGHT

*The sale of your artwork does not give the buyer the ownership of copyright. If they want this additional benefit, they must pay for it and have your written agreement. You should never, however, give up your copyright, unless you are being paid **very well**. It is the most valuable asset for your business and for you as an artist.*

Any new business must investigate legal rights related to their particular needs: an artist is no exception. If you know your legal rights, you will be a wiser negotiator and a better business person. If you know these rights from the start, chances are you will not be taken advantage of.

This chapter cannot possibly cover all the details you will need to know to understand any given legal matter, but we can inform you about some of the basics with which you need to become acquainted. Even when you do take care of your legal business, it is likely you will encounter some legal problems. Even the most precautious person cannot prevent these occurrences.

BASIC COPYRIGHT

Copyright is your form of protection, provided by law, for the creation of original works. As owner of your copyright, you have exclusive right to do (and to authorize others to do) the following:

➤ Reproduce the work in copies.

➤ Prepare derivatives of the work.

➤ Distribute copies for sale to the public, by rental, lease; sell (you can transfer this for a period of time if you wish).

➤ Display the copyrighted work publicly (i.e., include in a motion picture, etc).

COPYRIGHT REGISTRATION

Since 1979, you are not required to put the copyright © symbol on your work to protect it. You still have to prove it is your original creation, however. So how do you do that? You could take snapshots or slides and get them printed with a date on the photo. This is some proof. But this *will not* hold up in a court case. If you don't file copyright formally in the Copyright Office in Washington, DC, you cannot sue someone for infringing the copyright. When you register you become eligible to receive statutory damages and attorney's fees in case of an infringement suit.

You can sell rights—they are not ususally "lifetime" or "complete"—to a copyrightable piece without selling the original. Each type of right will require a separate legal agreement.

Formal registration costs $30. For this fee, you register one published work (i.e., print, poster, card) or a group of 20 unpublished works. These 20 pieces must be of the same style and medium. Completion of a standard Form VA is also necessary.

COPYRIGHT LAW OF 1976

Under the copyright law of 1976, any work created on or after January 1, 1978 is protected by common law copyright as soon as it is completed in some tangible form. As the creator you have certain inherent rights over your artwork, including the ability to control how it is used. You have the exclusive right to reproduce, sell, distribute and display your artwork publicly. This protection lasts until fifty years after the artist's death. It can be renewed by an artist's heir(s). You also have the right to transfer the copyright to heirs in your will. You can transfer part or all of your copyright through a sale, gift, donation or trade. You must do this in writing. This is *not* the same as selling or transferring ownership of an artwork. You can sell a first reproduction right to one company, say for greeting cards, and a second reproduction right to another, say for a calendar, as long as each contract allows you to do that.

To be copyrightable, a work must be both original and creative; it must be a physical expression of an idea. It can be a logo, illustration, fine art work, oil painting, transparency, photo, chart, diagram, video, filmstrip, motion picture, slide show, computer software program, typeface, etc.

INFRINGEMENT

Infringement occurs when someone derives a work of art directly from a work by someone else. If you derive a painting from a photograph clipped from a magazine, for example, you might be infringing. With computer art, this has become an increasing concern. If you copy from a pre-existing image, you need to alter your work to the extent that a casual observer would not notice a resemblance.

RESOURCES

Copyright Hotline

Library of Congress, Copyright Office, Washington, DC 20559
(202) 707 3000 (202) 707 9100
For recorded information. Also ask for Copyright Basics (Circular 2), The Nuts and Bolts of Copyright, Highlights of the New Copyright Law, New Registration Procedures, Deposit Requirements for Registration of Claims to Copyright in Visual Arts Materials, as well as Form VA.

An international copyright that will automatically protect an artist's works throughout the world does not presently exist. Protection against unauthorized use in a particular country depends on the country's laws.

American Way
2000 M St NW #400, Washington, DC 20036
*Protecting Artists and Their Work: A Summary of Federal and State Laws
by People. 1993 edition is $6.95.*

Superior Rubber Stamp & Seal Inc
PO Box 2258, Wichita, KS 67201 (316) 682 5511
*A copyright stamp can be made with your custom wording to stamp photos or
the back of a canvas or watercolor paper. Ink dries in 15 seconds.*

INVASION OF PRIVACY ACT

LEGAL RIGHTS

If you do a portrait of someone, be sure you obtain a model release for future use of this painting in your brochure, newspaper article, publicity, for sale at an exhibition, etc. Without this you cannot reproduce it or exhibit it in public without the possible threat of a lawsuit.

Invasion of privacy doesn't apply after someone dies; however, an estate may have the right to all images of any given celebrity.

- The Marilyn Monroe Estate controls the image of Marilyn Monroe. When an artist executed a painting and had 5,000 prints made, the estate caught wind and took the artist to court. The artist tried to give the estate a royalty, but they would not accept the offer. The artist was told by the court to destroy all remaining prints. The estate personnel made certain this was done by going to the artist's studio and assisting him!
- Another artist had a wonderful offer from an art publisher. The publisher wanted to reproduce the painting which she had created by copying a photograph originally taken by a professional photographer. She called the photographer to find out if he would sign a release to allow her painted portrait to be published. Even when he was offered a royalty, he refused to give her permission. She had infringed on the photographer's rights by copying his artwork.

MODEL RELEASES

If you hire a model for photography or live drawing, get a model release, even if you think you won't be using the photographs or drawings in the future. Any failure to obtain such a release can be construed as a violation of the rights of privacy of the individual who served as the model. When the model is a minor, the written consent of a parent or guardian is necessary.

Models can also object to altered images. If your model release form does not cover altered images, the model may bring an action under an invasion of privacy or publicity rights statute that enables the model to control the use of his/her name, likeness, voice, signature, or photography in connection with the advertising of goods or services. The model need not show injury to reputation.

Don't neglect to ask your model to sign a model release while posing. After the fact, you might not get it, or you might have to pay for it!

MODEL RELEASE

On _____ 199__, I posed as a model for artwork (to be) created by
_____. In consideration of the payment of the sum of $ _____ at the conclusion
of this modeling assignment, I hereby grant the irrevocable right to the use of my likeness in any and all
media and in any and all manners including composite or segmented representation for the preparation of
works of art or any other lawful purpose. I hereby waive my rights to approval/rejection of the completed
works which may incorporate my image, and hold harmless the Artist and the Artist's representatives
against any and all liability arising herein.
I am an adult living in the State of _____. I have read this model release and understand its contents.
Date _____ Model _____
Address _____

If the model is a minor

As Parent/Guardian of the above-named Model, who is underage, I hereby consent to all the terms stated
above and accept in behalf of the Model the consideration set forth above.
Date _____ Parent/Guardian _____

MORE LEGAL RIGHTS

➤ Under California law, any gallery, representative or owner who
sells a work of art must inform the artist, upon request, of the
name and address of the new owner.

➤ California has also enacted a law to help protect artists when
their work is resold, entitled Resale Royalties Act. It enables
artists to continue receiving a share of royalties when their
artwork is passed from one collector to another. For an emerg-
ing artist, this might not calculate out to much money. When
you become known, however, as in the case of Thiebaud, and
your works are being auctioned, you will appreciate this law!

➤ Under federal law the artist must be given proper credit when
his/her work is exhibited or displayed. The piece exhibited
cannot be a distorted or altered version of the work unless pre-
approved by the artist.

➤ Only artists who can prove tribal membership can be advertised as
Indian or Native American. Fines may be as high as $250,000 for

the dealer or artist who does not comply with this regulation.

➤ Most states have statutes requiring dealers to provide a certificate of authenticity or a similar document disclosing pertinent facts about multiple editions. This certificate must be given before or at the time of the sale, and certainly upon the buyer's request. This disclosure must also appear in promotional materials regarding limited editions. Failure to provide a certificate or to properly disclose information entitles the buyer to rescind the transaction and receive his money back with interest. An artist who sells his works directly is considered a dealer.

➤ Many publishers are purchasing large numbers of paper prints and reprinting them onto canvas and reselling them without the artists' permission. This is a violation of the artists' rights. Dealers in such works will subject the printer, publisher, gallery or framer who creates or sells such works to liability. In one lawsuit, a widow of a famous artist sued a publisher who was engaged in the business of mounting prints of her husband's work, taken from books, onto ceramic tiles and selling them. This was found illegal.

In almost all cases, the creator of a commissioned work owns the copyright, not the person who commissioned it. Only certain types of commissioned work are treated as works-for-hire.

ESTATE PLANNING

If you plan correctly, your work can survive your death. Should you become ill, or be at the age where you would feel more comfortable with estate planning, here are some pointers. If you have not done your homework throughout the years, however, it will be much more difficult to get your records in order.

➤ Your work needs to be organized, documented, and inventoried.

➤ You will need to decide, if the works are in your possession when you die, who will be responsible for finding a good home for them. Don't name any person, public facility or company as a recipient of your work unless you have talked to them first.

➤ Hospitals and libraries are two public institutes that would benefit from donated artwork. You don't want your art stored away. It does nobody good in storage.

➤ You need to prepare a will which indicates your desires. Be sure to note in the will who will own the copyright. It is best to pass the copyright ownership along with the artwork; otherwise your heirs might have more taxes than they planned.

The Marie Walsh Sharpe Art Foundation
830 N Tejon St #120, Colorado Springs, CO 80903 (719) 635 3220
<sharpeartfdn@uswest.net>
*A Visual Artist's Guide to Estate Planning was published in 1997.
$10*

WORK-FOR-HIRE

Work-for-hire occupies a special category under copyright law. If you are employed or apprenticed and you create a work of art through the scope of your employment or apprenticeship, your employer or master owns the copyright to your work. The copyright owner of works-for-hire is the person who does the hiring. The creator has no rights to the work whatsoever, unless he/she and the employer have agreed in advance to the contrary. Any such agreement must be written and signed by both parties.

A commissionable work is not considered a work-for-hire since you are not employed. Artists confronted with "work-for-hire" imprinted on the back of checks received from "employers" should cross out the wordage to mitigate the attempted rights overtake.

WORK-FOR-HIRE AGREEMENT

Agreement made this _____ day of _____ 199 __, between _____ (hereinafter "Company") and _____ (hereinafter "Artist") for the preparation of _____ artworks for the _____(hereinafter "Project").

Witnesseth: NOW, WHEREFORE, in consideration of the mutual covenants and promises set forth herein, the parties agree as follows:

1. Artist will create _____ artwork for the forthcoming Project.

2. Artist shall submit the artworks in finished form no later than _____ 19___.

3. Company will pay the artist the sum of $ ____ for each artwork, to be paid one-half upon delivery of preliminary studies and one-half upon delivery of the finished artwork.

4. Any and all artwork created pursuant to this agreement shall be considered a work made for hire and Company shall be the sole owner of the original artwork and all rights, including copyright in and to the work for any and all purposes throughout the world.

5. Artist warrants that he/she is the creator of the artwork specified here, that the work has not been published previously, that it does not infringe on any rights of copyright or personal rights and rights of privacy of any person or entity and that any necessary permissions have been obtained.

6. Artist agrees he/she is working as an independent free-lance contractor and will be responsible for payment of all expenses incurred in preparation of the artwork.

IN WITNESS WHEREOF, the parties hereto have duly executed the agreement the day and year first above written.

Company _____ Artist _____

There are two types of contracts you can use in your business. When dealing with another art professional, i.e., a gallery, consultant, museum curator, publisher, etc., you need to have a formal contract. When dealing with a small-time private collector, you can have a user-friendly agreement.

Artworld professionals will often have a standard contract that they want you to sign. Take time to look it over. See if you have questions. Make sure you ask them about anything that you do not understand or anything that you disagree with. Do this in writing so you have a record of what you asked and what they answered. If you don't like what they answered, then propose an alternative idea. If that doesn't get approved, then another compromise will have to be made. You both must be content upon signing. Do not give up rights that you shouldn't, but don't get stuck on small details.

CONTRACTS

If a gallery says they don't sign contracts with artists, run out of there like a rabbit. Don't have anything to do with them.

CHECKLIST FOR CONTRACTS

Listed below are frequently-used points in a contract between a gallery and artist. Only in the cases of very successful artists, where large amounts of money and complexities of arrangements are involved, are all these points used. Use common sense. Protect your rights, but don't be lunatic.

❑ Parties involved

Gallery: Continuity of personnel, location. Assignability.

Artist: Extension to wife, children. Estate.

❑ Duration

Fixed term, contingent on sales/productivity. Options to extend term. Different treatment of sales at beginning and end of term.

❑ Scope

Media covered. Past and future work. Gallery's right to visit the studio. Commissions. Exclusivity. Territory, studio sales, barter or exchanges, charitable gifts.

❑ Shipping

Who pays to/from gallery. Carriers. Crating.

❑ Storage

Location, access by artist.

❑ Insurance

What's protected, in-transit/on-location.

(continued)

- ❏ Framing

 Who pays for framing; treatment of expense on works sold.

- ❏ Photographs

 Who pays, amount required (B&W and color), ownership of negatives/transparencies, control of films.

- ❏ Artistic control

 Permission for book/magazine reproduction. Inclusion in gallery group exhibits. Inclusion in other group exhibits. Artist's veto over purchasers.

- ❏ Gallery exhibitions

 Dates. Choice of works to be shown. Control over installation. Advertising. Catalog. Opening. Announcements/mailings.

- ❏ Reproduction rights

 Control prior to sale of work. Retention on transfer or sale of work. Copyrights.

- ❏ Damage/deterioration

 Choice of restorer. Expense/compensation to artist. Treatment for partial/total loss.

- ❏ Protection of the market

 Right of gallery to sell at auction. Protection of works at auction.

- ❏ Selling prices

 Initial scale. Periodic review. Permission discounts. Negotiation of commissioned works. Right to rent vs. sell.

- ❏ Billing and terms of sale

 Extended payment; credit risk, allocation of monies as received, division of interest charges, qualified installment sale for tax purposes. Exchanges/trading up. Returns.

- ❏ Compensation of the gallery

 Right to purchase for its own account.

- ❏ Income from other sales

 Rentals. Lectures. Prizes/awards. Reproduction rights.

- ❏ Accounting/payment

 Periodicity. Right to inspect financial records. Currency to be used.

- ❏ Advances/guarantees

 Time of payment. Amounts and intervals. Application to sales.

- ❏ Miscellaneous

 Confidentiality of artist's personal mailing list. Resale agreements with purchasers. Right of gallery to use artist's name and image for promotional purposes.

- ❏ General provisions

 Representations and warranties. Applicable law. Arbitration.

USER-FRIENDLY AGREEMENTS

A user-friendly agreement is a letter, usually on your business stationery, that states in simple terms the rights of the artist. It is an informal way, at the outset of a relationship, to inform all parties of what is occurring.

The first time I wrote an agreement as an art agent (for a portrait commission), I made two major mistakes. Firstly, I gave the contract to the client about two-thirds of the way into the commission. Actually, a contract should be signed previous to the start of any work by the artist. Partial payment accompanies the signing. Secondly, being new to the realm of contracts, I copied verbatim a contract from a legal guidebook for artists. Within a day I received a call from a frantic client with several hesitations. I was unable to answer her questions as I didn't know what the contract meant! Needless to say, I was embarrassed. After doing some research and resolving the matter successfully, I learned to draw up a user-friendly agreement. I also learned to study and understand what my contracts mean.

ITEMS TO INCLUDE

➤ Right to reproduce

➤ Right to photograph

➤ Right to reacquire the work for a retrospective

➤ Royalty on re-transfer of artwork

➤ Share of rental income

➤ A limitation regarding exhibition of artwork

Whenever you send an agreement through the mail, register it with a return-receipt attached. You will then have a record that it was received.

. .
. .
. . The following user-friendly agreement suffices for a bill of sale.

June 17, 1998

Dear Mr. Tyler,

I appreciate your interest in my artwork. I am shipping Blue Heronry to you today via Federal Express COD, per your request.

The price of this piece, as we agreed, is $804.38 which includes the California sales tax. I have added on $45 for shipping to total $849.38.

I like to inform my clients of the terms of conditions of sale as follows:

- All works are originals, unless otherwise indicated.
- All works are certified to be free from all defects due to faulty craftsmanship or faulty materials for a period of twelve months from date of sale. If flaws shall appear during this time, repairs shall be made by me.
- Copyright of work is held by artist.
- Resale or transfer of work requires that I be informed of the new owner and the price of sale. Should the price be more than $1000 over the original price stated herein, according to California state law, 10% of amount over original price shall be given to artist by seller.
- Artist shall have right to photograph piece, if necessary, for publicity or reproduction purposes.
- Artist shall have right to include artwork in retrospective show for a maximum of 3 months.
- If artwork is rented out by purchaser, artist will receive 25% of rental income.
- Artwork cannot be exhibited in public without written approval of artist.

Sincerely,

Artist

As an artist with a legal question, you don't want to hire a lawyer who specializes in real estate or accident law. If you are working out a licensing or royalty agreement, you want an "intellectual property attorney" who specializes in copyright and publishing law.

Understand the lawyer's pricing structure, i.e., how much you will be charged for speaking to him for five minutes on the phone, etc. If you have a big project, it's a good idea to evaluate your lawyer's resumé. See what cases they have worked on that might be similar to yours.

RESOURCES

Allworth Press

10 E 23rd St, New York, NY 10010 (212) 777 8395 (212) 777 8261 Fax
www.allworth.com <pub@allworth.com>
Protecting Your Heirs and Creative Works: An Estate Planning Guide for Artists, Authors, Composers and Other Creators of Artistic Works *is only one of the many legal books this publisher compiles. Call for their brochure.*

Law Arts Seminars

1223 Broadway #203, Santa Monica, CA 90403 (310) 990 9877
Avoid costly mistakes, lawsuits and legal fees. Get the information you need with Seminars on Tape ($29); Video ($69) or Comprehensive Handbooks ($99); Copyright Basics, Art Law Basics, Licensing Rights, Visual Art in Movies, TV

Martindale-Hubbell Law Directory

Lists lawyers by areas of practice. Reference in your library.

Volunteer Lawyers for the Arts

1 E 53rd St #6Fl, New York, NY 10022 (212) 319 2787
This organization, with divisions all over the country, provides artists and art-related businesses with legal assistance—sometimes free, sometimes for a nominal fee. Many of these groups publish informative newsletters and excellent books about legal issues. Some hold seminars and classes related to legal rights for artists.

FINDING THE RIGHT LAWYER

You want to feel confident and comfortable with the lawyer you choose.

ACTION PLAN

- ❑ Study your legal rights.
- ❑ Copyright your work at the copyright office in D.C.
- ❑ Prepare a standard, user-friendly agreement.
- ❑ Prepare a standard model release.
- ❑ Contact the Volunteer Lawyers for the Arts in your area and attend a seminar.
- ❑ Always have signed contracts when selling to private ` clients or artworld professionals.

RECOMMENDED READING

Art Law in a Nutshell by *Leonard D DuBoff*

The Art Law Primer by *Linda F Pinkerton and John T Guardalabene*

The Artist's Friendly Legal Guide by *Floyd Conner, Peter Karlen, Jean Perwin and David Spatt*

Business and Legal Forms for Fine Artists by *Tad Crawford*

Copyright Handbook by *DF Johnston*

Legal Guide for the Visual Artist by *Tad Crawford*

Make it Legal by *Lee Wilson*

Visual Artists and the Law by *Shane Simpson*

Chapter 5
Pricing

Pricing methods

Maximizing your value

A fool and his money are soon parted.
Anonymous

PRICING METHODS

Your aim is to set a price that strikes the consumer as fair, at the same time enticing them to buy.

Think of your artwork as having a price-range, not just one price. You'll determine an average price-range, and then price according to size, subject, media, framing costs and importance of work. It is desirable to touch upon many segments of the marketplace when you have an exhibit, so you need to have a variety of prices for your public to choose from. You'll have to do some research in order to find out what this price-range should be for your work.

When you do a show, you will find out that pricing an artwork at $175 or $225 will often get the same results. You might see that if someone can pay $100, they most likely will be able to pay $150-175, but not $200. Products or services are bought on the basis of perceived value in the minds of buyers and not on the basis of what it costs you to produce a product.

TIME AND OVERHEAD PRICING

Most working artists will have to be able to complete at least five original works a month. This doesn't mean you will sell all five pieces each month, but you need to build a stock so your clients have a variety to choose from. If it takes you a month of working eight hours a day to finish one painting, this probably means you will have to get involved in the print market and forget about selling your originals.

1. Calculate total business expenses for the year (dues, education, utilities, publications, postage, etc.) to figure the per- month overhead. $4200 per year = $350 per month

2. How many pieces do you complete in a month on the average? 5

3. Divide the number of pieces you complete in a month by the monthly overhead. $350 ÷ by 5 = $70 per piece overhead

4. Decide on an hourly rate of pay for yourself. $15

5. How many hours to complete an average painting? 17

6. Add a 10% profit margin.

7. Add a 100% commission.

8. Add the frame cost. If you do the framing, this price would include your labor but no mark-up, i.e., the same cost as a frame shop.

$ 70	overhead cost
<u>255</u>	labor cost
$325	sub-total
<u>33</u>	10% profit margin
$358	Subtotal
<u>358</u>	commission
$716	retail price

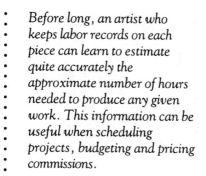

Before long, an artist who keeps labor records on each piece can learn to estimate quite accurately the approximate number of hours needed to produce any given work. This information can be useful when scheduling projects, budgeting and pricing commissions.

To this you would eventually add tax, shipping and if the artwork is framed, the price of the frame.

MARKET VALUE PRICING

A second method to calculate price range is to go into the actual marketplace and see what other artists with the same type of background are selling their artwork for. Do verify that these artists are selling—not just exhibiting! Maybe they are charging too much and not selling a thing.

Where do you go to compare? You don't go to the most expensive gallery in Beverly Hills. You go to juried shows, outdoor shows, smaller galleries, open studios, etc. in your local area. Most prices in the artworld are related to the price paid for similar work sold in the recent past. When you do this research, you are studying the market value.

When comparing pricing, keep in mind the aesthetic and technical merits of works, the style, medium and reputation of the artist and intrinsic costs of production.

After you have done some research and calculations, consider the following:

➤ From your research, does the time and overhead price of $716 seem to be in the appropriate range?

➤ If you are selling through a dealer and receive $358 (overhead, labor + 10% profit margin), will you make it financially?

It's generally a mistake to base your prices *solely* on the amount of hours spent creating a work. It's good to know, however, if the time you spend creating and the prices you are charging make it possible

Regular collectors like to see a little movement in an artist's prices over the years. Gradual growth is the way to go. If the market softens, you won't find your prices out of line.

I often think something is wrong with a piece, or don't value it much, if the cost is less than what I feel is its fair market value.

for you to earn a decent living. Perhaps you cannot earn $15 per hour when you start out. If that rate were lowered to $10 per hour, the price of the piece would drop to $532. Is this closer to your perceived market value? This is the type of thinking and research you need to do before you set your prices.

It's amazing how often artists forget to include the cost of their labor in a project. If you don't fully recoup your labor and outside costs, you are basically subsidizing collectors. Why would you want to do that? In dire times a sacrifice might be necessary, but to make it a practice is downright stupid.

PRICING TIPS

➤ When you have an exhibit, always have at least one piece priced high above the others, perhaps twice the price of the next highest piece. Perhaps you don't want to sell this piece, as it's your favorite—though this is the piece that often sells first!

➤ People expect a small work to be priced less than a large one. Though this does not make sense to an artist, as miniatures are more time-consuming to produce than large pieces, this is the psychology of the general public. If you don't feel you can price smaller pieces for less, create large pieces.

➤ The price that you charge from your studio and the price your dealer sells for must be the same. You get to keep the commission when you sell a piece from your studio. Some collectors mistakenly expect your studio price to be 50% less, but it never should be.

➤ Develop a long-term strategy connected with the pricing of your artwork. As you sell more, your prices will, of course, rise. Soon your pricing will establish itself, rising slowly—no more than about 10% per year. As your prices increase, have smaller works or prints available in the lower price range. Keep your work affordable to all your previous clients.

➤ Studio inventory should always be at least 10 pieces. If you only have four pieces in stock, it might be because you're selling at too low a price.

➤ Always note the retail price on your price list. No net pricing. Net pricing is selling your work at a wholesale/net price, allowing your

dealer to charge whatever he wishes at resale. This creates havoc in your pricing. Don't do it.

➤ Your prices should not vary from state to state—perhaps by a slight amount, but nothing noticeable.

➤ Don't undersell your work. You must feel comfortable with the prices you decide on; otherwise you will feel resentful.

➤ Never prepare a proposal or model of a piece for anyone unless you are being paid for it. This is customary for architects and interior designers, and, as an artist, you need to make it customary, too. Clients respect the artist more if this is done.

➤ Make sure your clients are aware that the price on the tag does not include sales tax, packing, shipping and possibly framing.

➤ Know your prices. When you have studied the market and know the various factors of costing a product, you will have more confidence when someone questions a price.

The Golden Rule
Don't sell anything that you wouldn't want to have known as your work. It might reach the wrong hands and bring you bad publicity someday. Be proud of every piece you sell.

A gallery owner wanted a lower price on a work by an artist I was representing. Since it was a rather simple-looking piece, he thought he could get me to come down on the price by asking me how long it took the artist to paint it. It was my favorite piece and the artist's first in a series, as well as the best of the series. I answered the gallery owner that it took the artist 60 years to paint. That was true. The artist was 60 years old, and until he painted that picture he could paint none like it.

DISCOUNTING POLICY

Did you know that it is illegal to charge one customer a lower price than another customer on the same product? The Robinson-Patman Federal Act is designed to prevent unfair price discrimination. There are ways around this policy, however.

➤ Discount second pieces.

➤ Discount for cash payment—versus credit card, monthly installment plan, etc.

➤ Discount with cash in hand, usually 2%. In all other cases (i.e., check, credit card, money order), the full retail price is paid.

You need to have a reason for sale prices to be less. Don't give the idea of selling something inferior, old, not wanted. Instead of a sale, have a Special Buy.

77

MAXIMIZING YOUR VALUE

It's a good idea to keep B&W prints of all your pieces for documentation purposes. B&W prints are the best archival reproduction of your work.

Art Office has forms you can photocopy for in-office use to help you get your inventory documents in order. Available from (800) 383 0677.

If you are in the business of art, you must look at your career with a broad overview. Look ahead at least 20 years. Potential clients want to know you will be around for a while. Then they will be willing to pay more for your work. Many artists overlook the area of documenting their work. They don't realize how important documentation is.

It does take time and a bit of money to document your work. What happens when you are 65, and a big publisher wants to do a book on you? If you haven't kept track of your paintings, to whom they have been sold, you will have only current work for the book.

For this reason and others, you need to keep an accurate record of all completed works throughout your career. When you sell a piece, you want to keep track of the name and address of your new client. In the future, when you are ready for a retrospective, you will know where to go to find your important pieces. If a client, in turn, sells/donates/ gives away your piece, you want to be informed. Save your sketches and minor works, especially those that have developed into major works. These can be especially useful in a retrospective show.

Once you have your artwork reproduced in the form of slides/trans-parencies/photos, you will catalog them, similar to how a museum would do its collection. Your records should tell you:

➤ Date and title of artwork

➤ Inventory Number—develop a code, i.e., year completed, month, and number such as 971103 (March 11, 1997)

➤ When the work was completed and how long it took to complete

➤ Who owns a particular piece. If a buyer sells, put the new owner's address in your files.

➤ Price you sold it for, as well as subsequent prices

➤ Who sold it (you, gallery, rep)

➤ Record what inspired the work, costs of materials, specifics of materials used (perhaps even where you purchased them), frame type, etc. All this information could help in any future restoration project. When you become known and museums start buying your work, this will help them immensely with their archives.

One artist I know has an attitude I hope you will develop. He did not skip documentation. He knew since he was 18 that he would be an artist. He did graphic design at times, comics, and a myriad of other tasks related to art, which also helped his fine art career. Since he was 18 he took 8x10" transparencies of all his important works. This artist had the attitude that he would be well-known. He knew that someday a book would be published on his life, and these transparencies—slides would probably have been sufficient, but he wanted top-notch transparencies—would be needed to produce the book. When I met him at age 62 the stack was six feet high! He will soon have a monograph of his work published.

SIGNING WORK

Your signature becomes your trademark and validates the authenticity of your piece. People will begin to recognize it. When you become collectible, your signature will make it easier to decipher forgeries. You can sign a piece on the front or back. It's up to you. Be consistent with whichever you choose.

TITLING WORK

There are several reasons to give your work a title:

➤ For cataloging purposes

➤ To give the viewer a particular intellectual or emotional connotation

➤ To give a clue to some subtlety

➤ People remember titles and associate back to them when referring to a work of art

Case in point: while reviewing 1500 slides entered in the cover contest for the *Encyclopedia of Living Artists*, we had to choose from several strong competitors. For some pieces, it came down to being eliminated because of bad or non-interesting titles.

If you don't like one of your paintings, but you can't bear to destroy it, don't sign it. It might come back to haunt you!

ACTION PLAN

❑ Research and calculate your price range via time and overhead.

❑ Research and calculate your price range via market value.

❑ Sign your work.

❑ Title your work interestingly.

❑ Document your work to maximize its value.

RECOMMENDED READING

Pricing & Ethical Guidelines *by Graphic Artists Guild*

Chapter 6
Shipping and Displaying

Packaging

> *Crating procedures*

Shipping

Framing

Hanging artwork

> *Labeling*

Care of artwork

I have a predilection for painting that lends joyousness to a wall.

Renoir

PACKAGING

As your career expands geographically, you will need to learn more about proper packaging and shipping of artwork.

PACKAGING TIPS

➤ When unframed graphic work is shipped, be sure to mark it clearly. Works on paper could be mistaken for packing materials and discarded.

➤ Mark the exterior of the box, "Fine Art," "Fragile," "Handle with Care," or "Glass."

➤ Mark clearly on the inside of the box the name of the gallery and the particular show at which your piece is being exhibited. Sometimes more than one show is occurring, or an agent is handling more than one show, and things get confused. The date of the show can also help.

➤ Put a small label on the back of your artwork with the title of your piece, your name, address and phone number.

➤ Put instructions for return mailing (i.e., packing provided; return carrier, etc.) on back.

➤ If you package more than one piece in one carton, put them back-to-back or face-to-face with a piece of corrugated cardboard placed in-between. When taking them in a car a short distance or carrying them in a box, remember that screw eyes and other protruding objects on one piece may damage the other. Either remove these screws or bulging areas, or pad securely between the two items.

MATERIALS FOR PACKAGING & CRATING

These companies carry a variety of packaging supplies that you can order through the mail. Call them for a free brochure.

Airfloat Systems
PO Box 229, Tupelo, MS 38802 (800) 445 2580
They sell double- or single-wall corrugated lightweight cardboard boxes in various sizes, lined with three layers of polyurethane on the inside. The foam suspends the art within the box which provides protection. Reusable boxes. Substantially less expensive than a wooden crate.

MasterPak

145 E 57th St, New York, NY 10022 (800) 922 5522 (212) 586 6961 Fax
http://www.masterpak-usa.com <mpak@masterpak-usa.com>
Offers archival materials for packing, shipping, storing and displaying fine art.

Pro-Pak Professional Packers

527 Dundee Rd, Northbrook, IL 60062 (800) 397 7069 (847) 272-0408
www.propakinc.com (propak@interaccess.com>
Art Carton Series is a product made of double-wall corrugated cardboard which protects fragile framed and glass-covered artwork. Comes in a variety of sizes. Custom designs can also be ordered.

FLAT PRINTS

Flat prints should be placed on a foam board and shrink-wrapped. Package the foam board in heavy cardboard so nothing can puncture the piece. This is also an excellent way to display your pieces at a show—you'll avoid fingerprints and torn corners.

SHRINK-WRAP

Printers, art associations or framers in your area will know where you can have a piece shrink-wrapped locally for a nominal fee. If you will be doing a lot of wrapping, a shrink-wrap system can be purchased for between $300-500. It is small enough to set up on a desk. It comes with a heat blower to shrink the plastic wrap tightly around any product.

SHRINK-WRAP MACHINE VENDOR

Pictureframe Products

34 Hamilton Rd, Arlington, MA 02474 (800) 221 0530 (781) 648 7719

MAILING TUBES

You can roll prints, watercolors, and even some oil and acrylic paintings into tubes purchased at art supply stores. They are made of heavy cardboard, plastic, or, in some cases, metal, an excellent shipping method. Ten watercolors wrapped together can arrive undamaged in this manner.

SHIPPING TUBE VENDORS

Ace Paper Tube
4918 Denison Ave, Cleveland, OH 44102 (800) 882 9002
www.acepapertube.com

Yazoo Mills
PO Box 369, New Oxford, PA 17350 (800) 242 5216 (717) 624 8993

CRATING PROCEDURES

Proper crating is crucial to protect the artwork from damage. Most shippers recommend the use of wooden crates rather than cardboard. Most carriers discourage shipping glass-framed artwork. In fact, you can remove the glass and have a new piece reinstalled for much less than it would cost to insure it.

All work should be wrapped in plastic sheeting to prevent water damage. Framed works should be further protected. Rolled-up newspapers are a good way to protect the corners. The ends of the rolled paper should be stapled to the back of the frame.

A larger painting might need a wooden crate, side bars for protecting borders, and a liner to protect the canvas. If you have to go this way, allow two inches of space on each side for packing bubbles or materials. Buy some "corner mounts" from your local shipping or frame shop. They protect the corners of artwork, even when it is moved in a van, etc.

When shipping framed, glassed works, it is important to tape the glass so that, in the event of breakage, it does not damage the work. Masking tape is strong enough to prevent pieces of glass from coming loose. Never use tape requiring water, as it could damage the work.

First tape a large ✕ on the glass. Then tape horizontal and vertical rows a couple of inches apart. Do not overlap the frame. Works framed with Plexiglas need no tape because it is unbreakable.

A wooden box is the best crate. The crate should be about 2 inches larger than the picture. The same size is not good because a diagonal shock can break a corner of the frame. You can build a crate. The top and bottom of the crate must be able to resist puncture. Museums usually recommend $^6/_8$- $^7/_8$″ thick pine, but less expensive boards are as good as the more expensive. Masonite is not desirable because it can be punctured. Construction board is adequate for the sides of a crate.

Cut a piece allowing 2″ leeway all the way around the work. Butt longer boards against shorter sides and nail together with $2^1/_2$″ resin-coated box nails about $1^1/_2$″ apart. Measure the outside dimensions of the frame sides and cut the top and bottom panels for the crate accordingly. Nail the bottom of the crate to the sides ($1^1/_2$″ plasterboard nails work well for this). The top of the crate should be screwed on with either six or eight 1″ flat-head screws.

If you wish to reinforce the corners of the crate, use 1x4″ board cut to the width of the two sides, top and bottom. These eight pieces should be nailed to board ends before crate assembly. Longer nails are required here—$3^1/_2$″ are good. On the longer sides these boards should overlap enough to butt against the braces of the shorter sides which are flush to the end of the side. Be careful not to leave nail heads protruding into the crate. Bend them into a U shape rather than just turning them, and hammer them into the sides.

Once the sides and bottom of the crate are assembled, a sheet of corrugated cardboard should be placed in the bottom. Put in the

painting. Wedge strips of corrugated cardboard around the corners of the picture on all sides until the painting cannot move. If the sides of the crate are significantly higher than the painting, add an additional piece of cardboard and two or three boards across the inside of the crate. This will prevent the painting from shifting—the most common cause of damage.

It might be best to take the first piece that you need shipped to a 'pack and ship' company that does professional packaging. Watch how they pack your work—or unpack it after they finish—and learn what they did to make it secure.

Whenever you ship a piece, consider:

➤ **Timing.** Start early so you don't have to pay an overnight rate.

➤ **Rates.** Compare carriers.

➤ **Insurance.** Be aware of what coverage you already have.

➤ **Weight.** Learn restrictions.

➤ **Size.** Learn restrictions.

➤ **Extras.** Does the shipper also package or pick-up?

AIR FREIGHT

Commercial airlines are fast, dependable, and price competitive. Ask them about the points noted above. Airline and cargo services are less expensive than air freight companies, but airlines do not pick up and deliver, as do freight companies. Some airlines won't handle ceramic pieces because of their extreme fragility.

BUS LINES

Rates are quite economical. Greyhound and Trailways offer door-to-door pickup and delivery. Bus lines will accept crated artwork up to 100 pounds and five feet in length. They will insure up to $500 for in-state delivery and $250 for out-of-state. They generally accept glass.

POST OFFICE

The post office will handle artworks but has a 70-pound weight limit and a size limit of 84" combined length and girth. You can purchase a return receipt which will tell you exactly when a piece arrives at its destination.

UPS

Though UPS is slower than some other methods, it costs much less. UPS requires that an artwork have a certified appraisal within a year or proof of insurance value claimed if a claim is filed. Normal coverage is $100—for higher coverage you will need to pay slightly more. Articles can be no larger than 132" (combine length, and twice bothv width and height) weighing no more than 150 pounds. UPS will pick up and deliver. A wooden box can be used, but the box itself will not be insured and costs $4 additional. You can purchase a return postcard to verify delivery date. Glass pieces can be no larger than 8x10". If you plan right, this could be your best bet. (800) 742 5877.

SHIPPING

Shipping artwork is something that many artists don't think about until it's too late, i.e. they have sold a piece and neglected to charge for shipping. Be sure you make it clear to your clients that it is their responsibility to pay for shipping and handling. Know the approximate cost to package and ship a piece, and offer that information to your client at the time of purchase.

*Some artists offer free installation and delivery within a 25-mile radius of their studios. This can work out well—you get to know the clients a little more intimately and you see what they have hanging on their walls. You might be able to give input
not only for the piece you're helping to install, but perhaps suggest another piece for another bare wall.*

MOVING COMPANIES

They usually have a 500-pound minimum charge. Cross-country time is several days to several weeks. Vans will pick up and deliver directly to galleries, museums, and private homes and will uncrate articles for an additional fee. Items without glass can be packaged in special van containers.

OVERNIGHT SERVICES

Federal Express
(800) 238 5355
Insures up to $500 for artwork. Packages can weigh up to 150 pounds. You must call to confirm delivery. Check with your local drop-off point for specific details..

DHL Worldwide Express
(800) 225 5345

California Overnight
(800) 334 5000
Ships within California only.

TRUCK RENTAL

If you intend to transport an entire one-man show, consider renting a truck and driving it yourself!

SHIPPERS

Shippers consolidate shipments to different parts of the country. If you are shipping several paintings/sculptures and can't drive yourself, it probably is more cost-effective to go with a packer/shipper than a courier like UPS or Federal Express. This is the way to go for international shipments also.

INSURANCE

No carrier treats packages gently. Insure all goods to the maximum value of your retail price. Various carriers set different maximums for the insured value. The process of reimbursement can be difficult. If a carrier finds that the artwork was extremely fragile or was not packed carefully, the insurance company may reject the claim. The artist must prove the value of his piece by providing sales receipts for objects of similar size or materials.

TIPS

Will you be driving a van, a car, shipping via a courier? Whichever way you transport your artwork, do it securely. You'll have many opportunities to ruin frames, break glass or cut yourself.

➤ If you can, place paintings upright (instead of stacking them on top of each other). If you must stack the paintings on top of each other, you need to separate them with something that will not damage them. This material must be as large as the largest painting it is touching and stiff enough to support it. Stack the largest piece on the bottom and work towards the smallest. If one or two small paintings are shipped along with large works, it is important to put the larger works in first and cushion them along the sides with strips of cardboard. Smaller works should be laid next to one another and stacked evenly. It may be necessary to provide compartments for small pictures.

➤ When transporting glass by car, you will need blankets for protection. Take the time to do this. Wouldn't you hate to ruin a painting because some glass has broken and torn the paper or canvas?

➤ Plan the arrival of your artwork about two weeks before any deadline or show. In case problems arise, there will be time to take care of the repair or search for a lost package.

➤ Don't expect to get compensation for damage to your work from a gallery because of their poor packaging. They will never take the blame! You have to hope for the best.

➤ Start saving packing materials from direct mail orders that you receive. Recycle!

RESOURCES

Gallery Association of New York State
Box 345, Hamilton, NY 13346-0345 (315) 824 2510
This organization has several publications available: What a Way to Go *is a publication explaining in detail how to pack your pieces. $10.*

Smithsonian Institution Traveling Exhibition Service/SITES
1100 Jefferson Dr SW #3146, Washington, DC 20560-0706 (202) 357 3168 ex 117
Good Show *is a practical guide for temporary exhibitions. $22.50 + $4 shipping.*

Don't wait until the last minute to ship. You will have to pay twice the amount!

Crating, Packing and Shipping Art is a 80-minute color video produced by New Arts Program Resource Library available for $39.95. Send a check to NAPShopper, PO Box 082, Kutztown, PA 19430-0082.

FRAMING

A frame is a tool for protecting an artwork. It also should complement the color and texture. It should never overpower the art.

Study framing by going to frame shops, galleries, museums—see what you like and don't like. Make notes: you'll be sure to forget the important details if you don't. Since framing is costly, you'll want to train your eye before you spend money. Find a good framer who is knowledgeable and helpful. Before you decide to work with a framer, examine some examples of his/her work.

Many artists these days avoid framing altogether. They wrap their canvas around their stretcher bar, paint over it and call it a frame. For some styles this works quite well. Smaller pieces, or artwork completed on paper or other material are incomplete without an appropriate frame.

Deciding on the frame for your own artwork (providing you have an eye and desire to do so) is really the best way for a client to have a piece framed. If you decide you want to do this, it will take time on your part. Consider, however, that the buyer might not like the frame and might not want to pay for it, either. She might want a discount or for you to take the artwork out of the frame. You could suggest to the client that this frame was made especially for the piece, designed by the artist.

FRAMING TIPS

➤ Go to the frame shop or art store and pick out some ready-made frames that go well with your style of artwork. What sizes do they come in? What standard sizes do mats come in? Buy canvases the appropriate size to fit these standard frames. Complete most of your pieces in these standard sizes. When you do a piece other than standard size, charge more.

➤ The wire in the back should be neither too taut nor too loose. You don't want it to hang beyond the top of the frame. If it's too taut it's hard to hang on the hook. Ideally, the wire should be between one-third and one-fourth down from the top of the frame.

➤ Simply done or elaborately contrived, the mat must complement the artwork and not detract from it. Matting can be an art form in itself. Don't try to enhance a carpet or sofa when framing; the mat color or frame should enhance the artwork. You might need to teach your clients this, too.

➤ To prevent degradation or damage to paper, only acid-free mat board should be used. The best mat board is made of 100% rag.

DO-IT-YOURSELF FRAMING

Fortunately, about 10 years ago, frame shops started popping up where you could go and use their cutting and matting facilities. If you are on a tight budget, this could be a way for you to learn the craft. You can also buy the tools and set up a small studio in your garage. This can be an investment, so make sure you are capable of such work.

If you do the framing yourself—not only choose the frame but physically cut it, etc.—you need to charge for your time. In essence, you should charge the same price a professional framer would charge you to get the same piece framed, providing you do as good a job. Do not add a commission to this part of the price.

RESOURCES

United Manufacturers
80 Gordon Dr, Syosset, NY 11791 (800) 645 7260 (516) 496 4430
Order your frames through the mail.

Cardcrafts
475 Northern Blvd #33, Great Neck, NY 11021 (800) 777 MATS (516) 487 7373
Quality mat boards, competitive pricing.

NAMEPLATES

A final and impressive touch for your frames could be a nameplate containing the title of your piece and name. A nameplate is a bronze 'tag' usually located on the bottom of the frame. You've probably seen them on museum pieces.

NAMEPLATES BY MAIL

Allyson's Title Plates
21 Cote Dr, Epping, NH 03042
(603) 679 5266 www.titleplates.com

Awards & Presentations
(800) 452 1052

Brassco Engraving
(800) 447 7712 www.brassco.com

Quality House
PO Box 740, Monroe, WI 53566
(608) 328-8381

Sherwood
2618 Briar Ridge, Houston, TX 77057
(713) 974 3700 <sherwood@pdg.net>

Signs by Gwynn
PO Box 708, Wichita falls, TX 76307
(940) 322 2565
www.signsbygwynn.com
<sbg@signsbygwynn.com>

Signs by Paul
11082 Milliken Ave, Conifer, CO
80433 (303) 697 8003

If you are having a one-person exhibit, it is important to frame your pieces in a cohesive way, giving a more professional look.

HANGING ARTWORK

Hanging artwork in a home or at an exhibition is not easy. It takes time, effort and a bit of knowledge to do a professional-looking job. Study outdoor art exhibits, large art expos, museums and galleries. Note the variety in approaches to exhibiting and hanging. Which ones do you like best? Why? Study the space you will be using before you begin to hang. What color are the walls? What size? Where will you hang what? Artworks should be both a part of the environment and separate from it. Don't make an art piece an afterthought. Choose the correct size piece for the space. It should be the most important item in a room.

➤ White surfaces are best for hanging. Some galleries and museums hang on blue or other colors. Brickwork can tone down the piece quite a bit.

➤ Hang artwork at eye-level, about 6'6" above floor to the top of piece. The average-height person will then look up at the work. Consider whether people will be sitting or standing while viewing the piece.

➤ A painting should be no more than a foot above furnishings so that you see them as a unit.

➤ Do not touch the surface of paintings; oil marks from fingers are difficult to remove.

➤ Do not carry a painting by the top of the frame. Carry with one hand underneath, the other at the side to support the structure.

➤ If you are hanging a large painting, share the task of lifting with a second person.

➤ When resting a painting on a floor, be careful that there are no abrasive surfaces.

➤ You should wear clean, old, white, cotton gloves when working with certain frames and delicate pieces, so as not to get marks on glass or frames.

➤ Don't hang in excessively cold or damp locations.

➤ No crowding or wall-to-wall art. It generally demeans pieces. Quality over quantity.

➤ If you can't put holes in the wall, try using gallery rods hanging from extruded aluminum ceiling moldings. Transparent fishing line can be used instead of unsightly wire.

➤ If you plan to group works together in an exhibition, the bottom edges of frames should remain on the same line. Place the strongest pieces at either end. There should be a flow and variety about the grouping.

➤ Lighting is an essential ingredient. Watch for glare on artworks framed under glass.

LABELING

Study labeling, whether it be at an art fair or a solo-exhibit in a gallery.

➤ Labels should all be the same. Use paper that will complement the wall. Some fancy paper can be very inexpensive and add a nice touch. You can lay out 10 labels per sheet. Use a computer laser printer to print labels—or use nice, legible calligraphy—no typewriters.

➤ When doing an art fair or show, post the price of your work. Yes, I know galleries most often don't, but you're not a gallery. Many people will think a piece is too expensive if the price is not noted and won't even ask about it. If they saw $600 posted on it, they might actually become more interested.

➤ Don't put a date on your label. For some mysterious reason, buyers think that a five-year-old painting has something wrong with it. They think you haven't been able to sell it to date, i.e., you're trying to "dump" it. Actually, they might be getting one of the artist's favorite pieces, which, up until now, you've not been able to part with!

➤ A label should include the title, price, name of artist, medium.

Valencia, Spain
Oil on canvas by Mary Smith
$700

Valencia, Spain
by Mary Smith
Oil on canvas $700

LABEL PLACEMENT FOR AN EXHIBIT

Place the labels on the same side of all individual pieces. It doesn't matter if labels are on the top right side, bottom left side, under the painting, but never above a painting. Have all labels be in the same position, as in the layout below.

Good placement

Bad place-
ment

Placement for a series

Never place labels between two pieces

Stacking framed pieces in this manner can work well, especially if you have limited space for display.

LIGHTING

The amount and duration of light are key factors when thinking about where to put an art piece or where to display your artwork in an exhibition.

Ultraviolet rays, found in all light and heat, escalate the aging process of dyes, pigments, oils, canvas and paper. Sunlight can also dry out or physically burn an artwork. Paintings should never be positioned directly in the full-flood illumination of a bulb. Artificial light, in the form of fluorescent tubes, incandescent bulbs and halogen lamps, can be as damaging as natural light.

Lighting experts have devised a plastic filtering sleeve, believed to screen out nearly all of the ultraviolet rays produced by a fluorescent tube. These are available at specialty lighting companies in most large cities.

All lighting systems produce light that in some way alters the way you see your art. Incandescent lights tend toward yellow, while fluorescent light is greenish-yellow; both produce an unbalanced perception of color. The closest approximation to noon sunlight is the halogen lamp. Move it far away from the viewer and don't over-light. Picture lights attached above a picture should be no greater than 25 watts and should be used sparingly.

TEMPERATURE

➤ Extreme changes in temperature should be avoided.

➤ Do not hang an artwork over a working fireplace, over a wall heater or near an outside door.

HUMIDITY

➤ Do not store prints in shrink-wrap for long periods as it might create moisture.

➤ Painted canvases should be rolled with the painted side on the outside, interlaid with silicone-treated paper and kept at around 70 degrees/50% humidity.

➤ Do not hang artwork in a bathroom.

➤ When cleaning a glass-covered picture, do not spray directly onto the glass—spray the dust cloth and then clean the glass.

CARE OF ARTWORK

Being informed about how to care for your artwork will benefit you throughout your career. When you inform your clients of care techniques, they may appreciate your work even more.

➤ Excessive dampness permits mold to flourish. The ideal climate for paintings on canvas is 50-55% relative humidity and a temperature of 65°. Works on paper can suffer irreversible damage with humidity over 70%.

CARE OF PAPER

➤ Do not store paper in tubes as they often cause acid and staining damage.

➤ Pieces on paper should be stored flat, protected by layers of cardboard and acid-free paper.

CARE CHECKLIST FOR CLIENTS

With any sales invoice/agreement, it's a good idea to include a sheet entitled, "Care of Artwork—Hanging and Storage Tips." Include some of the instructions below and any others you want!

CARE OF ARTWORK
HANGING AND STORAGE TIPS

✓ To transport, put in plastic bag, then wrap with padding for protection (sheets, towel, blanket). Plastic first because fibers and lint from fabric can stick to varnish.

✓ Do not place anything on surface of painting.

✓ Do not leave in a hot car, especially in the trunk. Varnish can blister.

✓ In the case of a painting on canvas, be careful not to lean the painting against anything sharp (corner of table, chair, etc.) that could cause denting, stretching or tearing of canvas fibers.

✓ Do not hang in direct sunlight.

✓ Do not hang over direct heat source—radiators, vents, etc. or too near a fireplace (smoke, ashes and heat damage artwork).

✓ Try not to hang in excessively damp or cold location.

✓ Never put water on the surface of any painting.

✓ Try not to touch surface of painting—oil marks from fingers are sometimes difficult to remove.

✓ If necessary, dust with a clean, dry, soft brush.

ACTION PLAN

❑ Learn about packaging methods.

❑ Know shipping methods and costs.

❑ Frame artwork.

❑ Have nameplates made for major pieces.

❑ Learn the proper method for hanging and displaying art work at an exhibit.

❑ Become knowledgeable in the care of artwork.

❑ Make a "Care of Artwork" checklist for your clients.

RECOMMENDED READING

The Art of Displaying Art *by Lawrence B Smith*

The Art of Showing Art *by James K Reeves*

The Care and Handling of Art Objects: Practices in the Metropolitan Museum of Art *by Marjorie Shelley*

Caring For Your Art: A Guide for Artists, Collectors, Galleries and Art Institutions *by Jill Snyder*

The Right Frame *by Henry Heydenryk Jr*

Chapter 7
Planning an Exhibit

The twelve-month plan

Painting isn't an aesthetic operation; it's a form of magic designed as a mediator between this strange hostile world and us, a way of seizing the power by giving form to our terrors as well as our desires.
<div align="right">

Pablo Picasso
</div>

12-MONTH PLAN

It probably has become obvious to you by now that an important aspect in marketing your artwork is making sure it gets seen by the buying public.

Planning an exhibition is an essential experience for every artist. It's also a major undertaking. "Shouldn't the gallery be doing this?" you ask. Before you get accepted to exhibit in a commercial gallery, you will probably need to exhibit in many other places.

Finding an exhibition space is a matter of being a bit creative. Local community event calendars and cultural newspapers can alert you to non-gallery exhibitions that are already being held in your area. Possible locations are:

Coffeehouses	Dinner clubs	Nursing homes
Your studio	Libraries	Non-profit galleries
Bookstores	Furniture stores	Theaters
Churches	Shopping malls	Hotel lobbies
Friend's home	Frame shop	Hospitals

You might need to promote and execute such an exhibit yourself. You will learn that procedure in this chapter. You also need to learn how to put on an exhibit so:

➤ You'll appreciate your gallery when they put on an exhibit for you. You'll realize why they are making 50%.

➤ You'll be able to assist your gallery and make it a more profitable opening.

➤ You might decide you like doing it yourself.

A group exhibit might be the way you'll need to go the first time, either due to cost or lack of experience. Don't fret. This can be to your benefit. You'll not only have someone to assist you, but you'll have more guests.

You will need to make sure each of your obligations and commitments is clear. It is best to write out a plan, so each party can see clearly who is obligated to do what. This might take a couple meetings, a little typing and a few photocopies. You'll decide who is best at, and therefore responsible for, publicity, installation, dismantling, handling sales, costs, invitation design, number of pieces each artist will show, etc.

Make your exhibit an annual event. It will be remembered more easily. If you can coordinate it with something occurring in the community, a festival or special event, this can help bring people to your exhibit. They are already out and about, and another stop can be fun.

12 MONTHS PRIOR

As galleries do, you are going to start planning your exhibit 12 months prior to your intended date! Concentrate your search efforts for a location in your immediate area.

Contact the spaces you've decided upon in your area. Keep trying until you succeed. Someone is ready for an exhibit! When searching for the ideal space, consider:

Insurance coverage	Safety of area	Wall space
Lighting	Parking	Accessibility for visitors
Restroom facilities	Cleanliness of exterior	Date of show

Consider the time of year and the day of the month or week you plan your exhibit. Between October and December is often good, due to the Christmas buying spirit. Springtime is good, too, because people are coming out of hibernation. An after-work/before dinner event, usually on a Thursday or Friday evening from 5-8, works best for many people.

Can the show be associated with a fund-raising event? It's likely to get more publicity if it can be.

One of the best exhibitions I've seen was at a private collector's home. This collector wanted to give a party for an artist he was fond of. He had the perfect Mediterranean house—indoor and out— for such an exhibit. He even hired a salesman to assist the artist. It was a cocktail party. No pressure was put on the attendees. Everyone had a good time. I asked the salesman (who I barely recognized as such) before I departed if he had sold any pieces. He said no, he does that in the next few days. I took his number to check up on the results. By golly! Three days later he had sold one piece, and one week later, two more. He had sold one piece to an interior designer who was interested in more for her clients, and the other two to a business person—one for her home and one for her office.

10 MONTHS PRIOR

THEME

Think of a theme for your show: a catchy idea may win you some press coverage. You'll be planning refreshments, invitations, flowers and music around this theme—maybe even your paintings!

BUDGET

You will need to consider monetary costs:

Refreshments	$_____	Framing	$_____
Hired assistant	$_____	Invitations	$_____
Photographer	$_____	Mailing	$_____
Advertising	$_____		

ADVERTISING

Free publicity receives much better responses than an ad. Only advertise if you've studied the publication, and it's very specific to your locale. Determine your target audience. You might be able to barter the cost of an ad or try to get a discount on a three-time rate.

A brochure is not necessary to make a show complete. If you do decide to print a flyer or brochure for your exhibit, make it look fantastic! It can be a great marketing tool, particularly if it is designed for a variety of audiences. Try to make the brochure generic so you can use it in the future. Read Chapter 14 for more information about brochure production.

8 MONTHS PRIOR

Confirm the date of your exhibit in writing with a user-friendly letter directed to the building owner or representative. Discuss your hanging plan, refreshment plan, timing, publicity. Make sure the owner of the space understands all the details you have in mind. Can you place brochures/postcards/business cards in an appropriate area when the opening is over?

CREATE YOUR INVITATION LIST

Previous clients	Friends	Art consultants
Art critics/editors	Relatives	Art school personnel
Patrons of the arts	Museum curators	Newspaper writers
Artists	Art councils	Local TV personnel

Visual images of your most typical work on a postcard is one of the most effective ways to entice new clients to your exhibit.

6 MONTHS PRIOR

Create a publicity plan. Include some wild promotion ideas as possibilities. Start creating your press release. Get help editing it. Do you want your press releases to coordinate with your invitation? You'll need to plan this out if that's the case.

INVITATIONS

Be creative! You don't need to spend a lot of money—perhaps a bit of time, however. Use your allotted budget wisely. You are starting to design this three months before you need to print it, so you can think and rethink your approach. It is no small matter to create an attractive marketing piece.

A simple postcard—even in black—can be very striking. Maybe you want to make a more formal invitation—one that's enclosed in an envelope. Many invitations are available these days that can be printed directly from a computer laser printer, likewise with postcards. It certainly would be less expensive than having something printed conventionally. Check this possibility out if you have a computer.

Don't forget the address of your exhibition, date and hours of the opening, dates and hours of your exhibit and directions to it.

Select your best B&W photo for your press release, and have it duplicated.

TICKLER POSTCARD

A tickler postcard is a promo that is sent in three or more parts. They are connected to one main idea/event and arouse your interest as you receive them through the mail. The final card generally resolves the question or problem that was hinted at in the beginning ones. This could be a fun idea for your small, selective group of clients.

A brief, handwritten note on an invitation always adds interest.

4 MONTHS PRIOR

Start framing your pieces. Have you allotted for these costs?

3 MONTHS PRIOR

Print the invitations.

Mail necessary press releases to monthly publications on your list.

Arrange for a salesperson to handle your opening.

2 MONTHS PRIOR

Address the invitations. Include potential and current clients, as well as new artworld professionals you want to entice.

1 MONTH PRIOR

Invite hotel bellmen, concierges, inn hosts, convention and visitor bureau volunteers and workers and others who deal daily with tourists in your area.

Mail press releases to semi-monthly publications.

Mail press releases to radio and TV stations.

Mail press releases to weekly publications.

Mail invitations.

Make phone calls to current clients and let them know about your exhibit. Ask them if you can send an invitation to any of their business associates or friends who might also be interested in coming—or send your clients some extra postcards to send to their friends.

Plan your opening reception: refreshments, flowers, music, napkins, plates, etc. Make it as simple and comfortable as you can. Stay within your planned budget. Know what printed materials you will have available for people to take home. Arrange for help if need be.

2 WEEKS PRIOR

Call the press (TV and radio, journalists, editors) to see if they can cover your exhibit.

3 DAYS PRIOR

Hang your artwork. Consider both natural daylight and artificial lighting when you hang your show. Allow yourself an entire 12 hours to look at the work in the various light conditions. If you can't see the artwork due to reflecting windows or too bright lights, how can you expect someone to be willing to pay $1500 for it?

DAY OF EXHIBIT

Be early! Allow plenty of time to set up and an extra half-hour, so you can relax.

Greet every visitor. Encourage interested guests to sign your guest book.

Keep circulating. Have fun. Have someone else do the sales.

FOLLOW-UP

Handle the dismantling of the show as efficiently as your hanging. The organizer will be very pleased and will recommend you to other venues.

Send a thank-you note to all who have assisted in making your exhibit a success.

Evaluate what worked well, what didn't. Get your mailing list in order. Write a note to special patrons you want to cultivate.

Celebrate! Your community has begun to view your art and become familiar with your name.

Did you notice that the hanging and prep work does not occur on the day of the opening, but three days before? This allows time for problems that arise to be resolved.

ACTION PLAN

12 months prior	___	Locate a place.
10 months prior	___	Develop a theme.
	___	Develop a budget.
	___	Do I want to advertise?
	___	Confirm you exhibition date.
8 months prior	___	Develop my mailing list.
6 months prior	___	Design invitations within budget.
	___	Select a B&W photo for PR.
4 months prior	___	Frame pieces.
3 months prior	___	Print invitations.
	___	Mail PR to monthly pubs.
	___	Find a salesperson.
2 months prior	___	Address invitations.
1 month prior	___	Mail press releases to semi-monthly and weekly publications, TV and radio stations.
	___	Mail invitations.
	___	Call current clients.
	___	Plan refreshments, decorations, etc.
2 weeks prior	___	Call press.
3 days prior	___	Hang work.
Day of opening	___	Arrive early.
Follow-up	___	Dismantle.
	___	Write thank-you notes.

RECOMMENDED READING

Artist's Guide to Getting and Having a Successful Exhibition
by Robert S Perskey

Good Show! A Practical Guide for Temporary Exhibitions
by Lothar Witteborg

Chapter 8
Creating an Image

Presentation elements

Business name

Logo

Tagline

Letterhead

Envelopes

Business cards

A fool is a man who never tried an experiment in his life.

Darwin

PRESENTATION ELEMENTS

If you expect first-class treatment from an artworld professional, you need to contact that person in a first-class manner.

In this chapter you'll learn that it pays to be attentive to the details of your presentation—from business name to letterhead.

The combination of the right business name, logo and tagline can make all the difference in the world for a company's success or failure. They are the three elements of your business that people see first—on a letter, on your portfolio or in a press release.

The presentation pieces should look like an extension of the artist's work. Don't take shortcuts with your presentation. In this world of competition, it can mean the difference between someone reviewing your portfolio or tossing it in the trash

Many artists fail to understand this. They might create great works of art, but their publicity, ads, and promotional materials are haphazard—even cheap-looking.

When I receive a well-made promo piece, postcard, flyer, letter or portfolio, it suggests to me reliability, seriousness and commitment. I receive a good first-impression, and I respect whoever sent it.

To lure certain groups of artworld professionals your way, you must look like you're in business—and in business to stay. No fly-by-nights wanted! If your flyer is haphazard, it's often assumed your artwork is also haphazard and that you are not serious about your career.

Marketing is an ongoing venture, occurring throughout the life of a company. As an artist, you need to plan a series of actions for a length of time. Self-promotion only makes an impression over time.

Let's start exploring the different elements that will make up the fantastic presentation you will soon create.

BUSINESS NAME

Your business name is the element from which all the rest of your presentation, from logo to letterhead, will spring. When choosing your business name, think of creating impact.

If you pick too trendy a name, chances are it might not mean anything in several years. You don't want to change your name, so try to use common sense when considering a cliché. Don't rush into some name you won't be happy with for a long time.

Examples of some good business names for artists to use are: European Expressions, Essence Art, Renegade Press, Spirit House, Art Focus, Visions Realized or Long Skinny Picture Company. They give you some sort of visual to help you remember the artist.

Not such good names for an artist might include Gordon's Art or Tristan Marketing. They don't say anything creative, fun or descriptive.

TIPS

➤ Make your name easy to say and spell.

➤ Make it simple to remember.

➤ Make it associative to the style of artwork you do.

➤ Have it create a visual image of what you do.

LOGO

A logo is the visual expression of you and your business. It must leave an impression on the viewer.

A logo is something that people often remember more easily than a word or name. It is an integral part of your public identity. Over time this logo will become more and more known. It needs to make sense and look good with your company name.

Your logo will be on all printed materials—letterhead, business cards, press releases—possibly even your paintings. It is your trademark. Spend time studying logos in the Yellow Pages or ask your librarian for a trademark directory to review.

If you fee unable to design your logo, find a graphic artist who is adept at logo design. If you're fortunate, you can do a trade with the designer for one of your artworks. Make sure you can communicate well with this designer. You should have a good idea, though not too rigid, of the direction you want the designer to go.

A GOOD LOGO:

➤ Photocopies well.

➤ Is easy to read, not too complex.

➤ Is distinctive and aesthetically pleasing and creates a positive reaction.

➤ Wears well over time.

➤ Has impact and is memorable.

TRADEMARK

For your logo (sometimes called trademark) to be legally restricted to your use only, place a ™ above it, i.e., ⟋⟍⟋ ™. You will also need to register your logo with the Trademark Office in Washington, DC. The cost to register is $245. Once you are officially registered, you change the ™ to ®. Your trademark is good for 10 years, at which time you have to renew. It will be published in the *Trademark Registry*. Others' use of it may be disputed by you.

Needless to say, it looks very professional to have this ® or ™ next to your company name. It subliminally creates a feeling of stability for your company.

You may think it is not important to register your business logo; after all, who would want to steal your name? If it's a catchy name or popular and clever wordage, a lot of people might want to steal it!

RESOURCES

Patents and Trademarks Office
(800) 786 9199
This is where you apply for logo trademarks. A tape recording has general information about trademarks.

General Information Services Division
Crystal Plaza 3 #2C02, 2021 S Clark Pl, Arlington, VA 22202
(703) 308 9000 (703) 308 4357
They have a free booklet called Basic Facts About Registering a Trademark.

Sourcebooks Inc
(800) 432 7444
How To Register Your Own Trademark by Mark Warda. $19.97 + $4 shipping (taxed in IL and FL).

Logo SuperPower
(800) 648 5646
A computer database of over 2,000 images that can be manipulated and combined to create professional logos in a matter of minutes.

For those who are confused: you copyright an artwork; you trademark a company name or logo.

TAGLINE

Use no more than 4-7 words when creating your tagline.

A tagline is similar to a "slogan" i.e., "The Un-cola." The tagline, along with the logo and company name, helps define your product (yes, your artwork has become a product if you are selling it). A tagline should note the physical features of your artwork, the emotional aspects and the special qualities. As an artist, you also want your tagline to help define the style and/or subject matter of your artwork, just as your business name and logo do.

SOME GOOD TAGLINES:

Paw Prints. This artist paints dogs.

Renaissance Artist. Doesn't say specifics, but does give a visual image.

Passionate Flowers to Smell. Sounds exotic.

These all give a specific image to the reader. The reader can relate to these descriptive words.

SOME BAD TAGLINES:

Fine artist. Doesn't say anything, except that you create art.

Watercolor artist. I want to know more than just the medium you work in.

Landscape artist. Let's be a little more specific. There are thousands of landscape artists.

Famous artist. How come I don't know about you?

These are too vague and unemotional. Be more creative! Remember you are trying to help the reader create an image of who you are and what you do, possibly without seeing your artwork.

A letterhead and envelope are often the first impression someone receives of your business. Quality means being taken seriously enough for people to open your package. It is, after all, amongst 20 others to choose from. Make it fun for them to open. Make the receiver stop dead in his tracks and desire to know what's inside your envelope. Of course, you will incorporate your business name, logo, tagline, address, telephone number, fax number, e-mail address and WWW home page onto your letterhead.

Make sure the typeface is legible, i.e., not too small. If you have a computer and laser printer, you will be able to scan your logo onto your computer and print your letterhead each time you write a letter. If you only have a small quantity (100 or less) of envelopes to print, and you have a laser printer, use that. If you have more to print, use your local printshop. Print envelopes at the same time as your letterhead.

One of the favorite letters I received was typed on pink cloud paper and inserted into a vellum, see-through envelope. I wanted to open this piece first, even though it did have a pre-typed laser label on it which showed it was not a personal message. It was impressive and effective. Did you know that there are even aluminum foil envelopes?

Even though people might not realize it, they are giving points to any piece of literature they receive by mail, points for design as well as content. When you next receive a piece of direct mail, notice yourself doing this.

PAPER COMPANIES

Ask for brochures from these paper companies. There is an abundance of nice paper these days. They are on the high side cost-wise, but you will not be using scads of letterhead. They also have matching labels, envelopes, business cards and folder covers.

Paper Access
(800) 727 3701

Paper Direct
(800) A PAPERS

The Write Touch
(800) 288 6824

LETTERHEAD

Start a file. Collect letterhead, brochures, any direct mail piece that inspires you. Use these for reference when it's your turn to design a piece.

Your envelopes will have the same logo and design as your letterhead, perhaps with a slight variation.

You can also get samples of different papers from your local printer. The paper you choose can greatly affect the cost of your printed materials.

ENVELOPES

Consider the economy of using window envelopes. Type the addressee information just once on the stationery, folding it so the address shows through the window. Once you start using the software program "Quicken" you can also print business checks from your computer with an address space that fits into the window. Looks professional.

LABELS

If you have a computer and printer, you will be able to print some professional labels that even match your letterhead. If you choose to go to a printer, there is a variety of shapes, sizes and colors to choose from. Visit your quick print shop to view samples.

LABEL COMPANIES

Interstate Label Company
PO Box 1239, Freeland, WA 98249 (800) 426 3261 www.interstatelabel.com
Custom and stock labels of all types.

Business Book
(800) 558 0220
Small shots photo labels—self-adhesive stamps can be made from photos of your artwork.

Reliable Home Office
(800) 869 6000
Avery ink jet glossy photo-quality labels of your artwork.

BUSINESS CARDS

Business cards are an essential part of any business. My favorite ones to receive from artists, and *save*, are those that have a four-color image of a work by the artist. What better way to advertise your work?

Keep your card a standard size, or it won't fit into the normal places people keep cards, i.e., wallet or rolodex. A Rolodex card can be a great idea, as almost everyone has a Rolodex.

If you decide to print in one- or two-color, go to your local printer.

You could also use a laser printer with one of the business card selections from the already-mentioned paper companies. Only use your laser printer for business cards if you need a small quantity or don't have funds for a large printing job. It is harder to obtain a professional, impressive final product with business cards from the computer. When they are separated on the sheet, fray marks are often left. For more about the printing process, see Chapter 23.

BUSINESS CARD PRINTERS

Clark Cards
PO Box 1155, Willmar, MN 56201 (800) 227 3658
www.clarkcards.com <info@clarkcards.com>
Good prices on high-quality cards—your design and layout. Call for free catalog and samples.

Dexter
(800) 641 3398
Rolodex postcards

Direct Promotions
23935 Ventura Blvd, Calabasas, CA 91302 (800) 444 7706 (818) 591 2071 Fax
<directpromotions@aol.com>
Plastic Rolodex postcards. We use these to promote ArtNetwork. We find customers keep them—being plastic they are hard to throw away, plus they never wear out.

Great American Printing Co
27102 Burbank, Foothill Ranch, CA 92610 (800) 440 2368 www.gapco.com

One artist has his business card printed on clear adhesive labels. When someone asks him for a card he pulls one off the strip and asks the person where he can place it. People remember this artist because of this trick.

ACTION PLAN

❑ Brainstorm for a business name.

❑ Brainstorm for a logo.

❑ Brainstorm for a tagline.

❑ Design letterhead and matching envelopes.

❑ Print letterhead, envelopes and business cards to match.

RECOMMENDED READING

The Best of Business Card Design *by Rockport Book Staff*

Business Card Graphics *by P.I.E. Book Editors*

Fresh Ideas in Letterhead and Business Card Design
by Diana Martin & Mary Cooper

Guerrilla Marketing in the 90s *by Jay Conrad Levison*

How to Design Trademarks and Logos *by John Murphy & Michael Rowe*

Letterhead and Logo Design *by Rockport Publishers*

Letterheads: One Hundred Years of Great Design *by Leslie Carbarga*

One Minute Designer *by Rodger C Parker*

Chapter 9
Resumés

Composing a resumé

Resumé categories

Statements

Works of art are indeed always products of having been in danger, of having gone to the very end in an experience, to where man can go no further.
 Rainer Maria Rilke

COMPOSING A RESUME

Read other artists' resumés. What do you like about theirs that could apply to yours?

Your resumé, sometimes called bio or vitae, is a list of vital statistics of your art career. You can format a rough draft of your resumé by simply making a list of art career activities, using the categories on the following pages as an outline. Once you have listed as many items under each category, sift through them to see which ones are the most pertinent for your final resumé. Resumés generally do not include all the categories listed. You need to select the ones you think are the most important to show off your career. The purpose of an artist's resumé is to provide the gallery director, dealer, curator, grant-making panel or reader with achievements and credentials in the art field. You want to entice them, show that other people have accepted your work.

THE 20-SECOND GLANCE

Most readers of a resumé give it less than a 20-second glance, maybe 30 at most! The physical appearance and layout, therefore, are extremely important so that it *can* be read quickly. You want to make it simple to inhale in one clean swoop.

RESUMÉ TIPS

➤ Be selective and list only key exhibits, awards and purchasers.

➤ At the very most it should be no more than two pages, one is better.

➤ Neatness counts. Type or computer-generate. No handwritten additions.

➤ Update every six months. Hopefully you will be marketing enough to add something every six months. As time adds more achievements, you will eliminate the less important ones and still keep it to one or two pages.

➤ No company name, just your personal name, address, phone and fax numbers, generally listed on the top.

➤ Proofread diligently. Be scrupulous about the accuracy of your typing. If someone does it for you, be sure to proof it again before photocopying.

➤ Photocopy on high quality paper. No letterhead.

➤ You might want to keep a documentary resumé that has all your achievements for your own files. This can be accomplished quite easily with a computer.

I was once asked by a photographer to try to condense her 17-page resumé (in very tiny typeface) to one or two pages. What a task! She was in her 60s and had been working all her life as an artist, so she had many qualified listings on her resumé. But who would read 17 pages? After much work, I condensed it to two pages and made the type larger, so you could see at a glance the history of her career. I kept only the most important national and international conquests of the artist, from all the periods of her life. It also stated on the bottom, "For a more complete compilation, please request my 17-page resumé."

RESUMÉ CATEGORIES

EXHIBITIONS

List the most recent exhibitions first, working backwards in chronological order. List date, title of exhibition, sponsor's name, city and state. If you've been in a lot of exhibitions, you can divide them into types of exhibitions—group shows, one-person shows, invitational shows, juried shows, upcoming exhibitions, touring exhibitions, museum shows, etc. If you have fewer than three exhibitions, it's best not to break them into smaller groups.

Selected exhibitions (*indicates one-person exhibition)

 1996 *Maximum Times*, Matrix Gallery, San Jose, CA

 1995 *Beyond Time*, Scarborough Museum, Norwalk, CT

 1993 *Now*, Soho Gallery, New York, NY

COLLECTIONS

You could divide this into private collections, corporate collections, library collections, permanent public collections, etc. A collector is anyone who owns a piece of your work, not necessarily a purchaser of it. For instance, you could donate one of your pieces to a museum and list it here.

 JP Rundige Museum, Anaheim, CA

COMMISSIONS

List the date, title of the commissioned work, sponsor and location.

1994 *Benoit Park Sculpture*, San Francisco Art Commission, San Francisco, CA

BIBLIOGRAPHY

List all the publications in which you have been mentioned or reviewed, any articles that you have written or that mention your work. Quotes about your work can go here. Book entries should include author's name, title of book (including subtitle), title of series, pages of article, city of publication, publisher's name and date.

"It is not surprising that our city has taken such a liking to Flence!"
San Francisco Chronicle, 1993

1990 *Artwork at Bank of America*, San Francisco, CA; page 34, E.P. Dutton, Inc.

AWARDS AND HONORS

List all awards and honors related to art: recognitions of merit, prizes won in competitions, project grants, artist-in-residence programs, fellowships.

1995 *Purchase Award for Painting*, San Francisco State College

1987 *Emerging Artists*, First Prize. Juror: Fisch, National Arts Club, New York, NY

TEACHING AND LECTURING

Art-related only. Guest lectures, workshops conducted, professorships.

1996 *Artist-in-Residence*, San Francisco Art Institute

1980 *Instructor in sculpture and painting*, San Francisco CC

AFFILIATIONS

List art organizations you belong to or community art activities you have participated in.

1990 *Crocker Art Museum Liaison*, Sacramento, CA

Gallery owners are the people most interested in a resumé. If you have nothing to put on your resumé for a gallery, you probably aren't ready to show your work there!

EDUCATION

If you are a recent graduate, this category would be your first or second; otherwise, it is listed at the end, in some cases not at all. List your educational credits in the following order: undergraduate degrees earned; graduate degrees earned; other institution of higher education; notable artists you've studied with.

1967 San Jose State College, San Jose, CA BFA

EMPLOYMENT HISTORY

Generally this will not be needed if you are looking for a gallery or exhibition. If you use this category for a job search, include the employer's name, address, telephone number, name of supervisor, exact dates of work, duties and responsibilities, skills utilized and accomplishments.

EXTRACURRICULAR ACTIVITIES

Art-related only. These can lead you in new directions. Give the same detailed information here that you would under the employment history category.

OTHER POSSIBLE CATEGORIES

Be creative. There are no rules carved in stone. Artist-in-Residence, Scholarships, Guest Speaker Engagements, Workshops Conducted, Featured Artist, Finalist, Broadcasts, Board of Directors, Professional Memberships are just some possible examples.

You have never exhibited and have nothing to put on your resumé? This book should get you going! You need to start exhibiting and exposing your work—entering competitions, juried shows, private studio openings, etc. Read the section on marketing savvy! You could list student shows under Exhibitions, scholarships and teaching assistantships under Awards and Honors. Be creative but honest!

MARLENA PARTONSON

12245 Leibacher Road
Norwalk, CA 93422
(818) 693 1444

UPCOMING SHOWS
1996 *Galleria Pace*, Milan, one-person show

ONE-PERSON SHOWS
1995 *Bianca*, Milan

1992 *Academy Museum*, Saleno, California

GROUP EXHIBITIONS
1992 *Studio Trisorio*, Naples

1991 *Galleria Pace*, Milan

1990 *More Nucci*, Milan

1989 *Academy Museum*, Saleno, California

1987 *Continental Galleries*, Los Angeles, California

COLLECTIONS
Academy Museum, Saleno, California

De Pasquale Collection, Milan

Various private collections in Chicago, London, Rome, Venice, Amsterdam

PUBLISHED
Arte, October 1988, November 1988

Encyclopedia of Living Artists in America, 1987-1997

COMMISSIONS
1991 *Wall murals (in egg tempera)*, private villas in Naples and Capri

1990 *Pair of folding screens for stage set*, Milan

EDUCATION
BA *Newcastle-upon-Thyme*, Graphic Design and Art History

As your work develops and you are ready to exhibit, you need to develop a statement. A statement is a written dissertation of the idea behind your artwork. It is not carved in stone and can change over time. Your statement is your philosophy—the aim of your work or working process. It is not a place to tell your life story.

Essentially you will be expressing in writing what you have expressed in your art. A statement is meant to help others understand what your aims are. It helps give collectors and interested patrons a better understanding of your work.

Statements can be helpful to reviewers and editors who do an article about your exhibition. They provide psychological material for them to draw from.

If you don't have a long resumé, a well-written statement can sometimes influence a buyer in your favor. You want to show that you know what you are doing, understand your personal creative process, and believe in your work.

Brief statements—even one sentence—are fine, if that is what you ultimately decide to convey. The ideal length is no longer than four sentences or one paragraph. The shorter it is—one or two sentences—the more likely it will be read! Your statement can be printed on a separate sheet or combined on the same page with your resumé.

Regardless of the length, it must be well-composed. Have an experienced writer edit your statement.

CREATING A STATEMENT

Start by just writing, rambling on about your philosophy, the reason behind your artwork. Don't think about what a statement "should be." Just write. You can condense it later. You'll not be able to compose a final statement in one sitting, so don't even try. It will take about a month or two of various sittings. Look at it every few days. Ask others to look at it. Ask a writer friend to edit, condense, make it more concise.

STATEMENTS

Your statement should have a strong effect, open emotions and get to the heart of why you are an artist.

If you have a problem writing about your own work/ideas, perhaps you can find another artist to work with. You can write about him and he can write about you. Try whatever works. Remember, this can be changed at any time and is a work in progress—just as your artwork is changing and progressing

Be intentional about the words you use. For example, 'organized' is more powerful than 'put together.' Other good verbs to use are:

achieve	administer	advise	complete
coordinate	critique	develop	direct
establish	execute	formulate	gather
generate	improve	implement	initiate
instruct	introduce	invent	launch
lecture	manage	plan	research
review	select	solve	utilize

COMPOSING A STATEMENT

➤ Why have you chosen to create your particular imagery?

➤ What is the role of the color, texture, motion in your work?

➤ What medium do you use? Is there anything unusual about the way you employ it?

➤ Does emotional, social or political content play a part in your work?

➤ What does your art say about your ideals?

➤ How do you feel when creating?

➤ How do you want others to respond?

➤ What are the key themes and issues of your work?

➤ Is there something that people don't understand about your work that you want to address?

TIPS

➤ Non-artists will be reading this, so don't use jargon and clichés.

➤ Avoid 'really,' 'very,' 'however,' etc.

➤ Be direct and concise.

➤ Keep it simple. No poetic flights of fancy.

THREE SAMPLE STATEMENTS

Art is the expression of a personal, sensual experience. An artist may communicate information, simple or profound, across time and space to the viewer, regardless of his background or epoch. My paintings have had success with an international audience from Rio to Tel Aviv. Do we speak the same language?

My artwork is dedicated to the vanishing species in Africa.

Five hundred years ago a group of men working in Italy produced a genre of painting never since excelled. These painters from the Renaissance period subsequently influenced in one form or another every painter since. They firmly believed that Art's greatest role is to inspire and create higher ideals in people, to civilize humanity and to nourish and protect the different ideas and myriad forms of culture. Anyone calling himself an artist today needs to have these thoughts at the back of his mind every time he begins a painting. Whatever happens during and after the efforts are made—if shaped by these ideals—can truly be called and acknowledged as Art.

ACTION PLAN

❏ Develop a resumé.

❏ Develop a statement.

RECOMMENDED READING

Elements of Style *by William Strunk and EB White*

Chapter 10
Photographing Artwork

Doing it yourself

Hiring a photographer

Reproduction methods

Photo/slide duplication

Labeling slides

"That's the reason they're called lessons," the Gryphon remarked, "because they lessen day to day." Alice in Wonderland, *Lewis Carroll*

DOING IT YOURSELF

Remember, your reputation rests on your slides.

Your slides/photos are sometimes the only way a juror, gallery owner or consultant will see your artwork. Poorly-presented slides will make a gallery owner wonder, "Why are they even bothering?"

Updating your slides is an ongoing process. Each time you complete a new group of works, you will need to photograph as well as copyright them.

If you failed photography class, you probably shouldn't try to take your own slides. If you must take your own photos due to monetary restraints, here are some general guidelines.

GENERAL GUIDELINES

1. Purchase the correct film for the light under which you will be photographing. The camera store can help you if you don't know. Most experts agree that 160 ASDA Tungsten Ektachrome film is best for general purposes.

2. Try to photograph your artwork before it is framed. If you cannot, use a polarizing filter for your camera.

3. Use a tripod. Square up the picture before you snap the shutter.

4. If photographing in daylight, avoid tree shadows, cloud shadows, or patterns of light filtering through houses. Natural but not direct sunlight is best (unless you have extensive lighting equipment).

5. Eliminate the background if possible. Viewers want to see the art piece. Use a simple, clean, neutral background or wall. For smaller drawings, use a larger stretched canvas behind the drawing for a background.

6. Take several slides of the same piece—at least five. Duplicate only the best slide. Keep the originals. Send out *only* the duplicates.

7. Stop down as much as possible. The higher the number of the f-stop, the more in focus your slide will be.

8. The camera should be exactly parallel to the artwork's surface and at the exact center. If not, you will get distortion and an angled reproduction.

9. Use a 35-mm single lens reflex (SLR). For small artworks you will need a close-up attachment.

10. Use a gray card to check lighting.

Don't get glass-mounted slides. They often break when they are shipped through the mail.

128

HIRING A PHOTOGRAPHER

If you've decided you are not capable of photographing your own artwork, you will need to look for an appropriate photographer. You not only need to find a photographer but one who specializes in fine art!

➤ If you live near a college, see if the art department has a photography division. You might find some very good photographers at a reasonable price.

➤ Look in the back of your local art newspaper. Usually you will find an ad for a specialist in the field.

➤ Ask an artist friend: they love to recommend good photographers.

➤ Call a local gallery or museum.

THE HIRING PROCESS

Hiring a photographer is expensive, so you don't want to make a bad choice. Here is a list of things to find out before you actually hire someone.

➤ Get references. Check them!

➤ Look at samples of his work. Has he photographed two-dimensional works before?

➤ Know the fee specifics before photographing begins. Does the quote include the film? Is there an extra charge for developing and printing? The standard price these days is $35-65 per hour, with a minimum of two hours. Some photographers charge by the roll. Get the quote in writing.

➤ Make sure that you own the negatives and the copyright after the photo session. Get this in writing.

➤ Find out if the photographer has a customer satisfaction agreement.

What is a bad photograph? It's blurry, has light reflections, is not full frame, the background is distracting or the color isn't anywhere near the original. What about that slide that shows a painting in an alley next to a trash can, the cat running in front of the artwork? Or the one with the foot coming out the bottom of the slide, hands on the side and head on top. It's all humorous but doesn't get the job done.

129

REPRODUCTION METHODS

Rule #1: Never send an original slide to anyone except a duplicating service!

TRANSPARENCIES

A transparency is a transparent positive image. Transparencies are more expensive than 35mm slides. The most common sizes are 4x5" and 8x10". The more the work is enlarged, the larger you want the original transparency to be.

Keep transparencies in mind if you are going to be doing a print, if you sell a work and feel it might be hard to track down, or if you have money to invest.

For small-size reproductions, i.e., cards or calendars, a 35mm slide is, most likely, sufficient. After 10 years of reproducing artwork in the *Encyclopedia of Living Artists*, we have found no difference between a transparency reproduction and a 35mm slide reproduction, as long as both have been well-taken, have no glares, and the enlargement is no larger than 7x10".

COLOR PHOTOGRAPHS

Artworld professionals often prefer to see photo prints of your work rather than slides for the first viewing. Photos can be glanced at in a second. If they are interested in your work, they will then request slides so they can view them more precisely through a projector.

B&W PHOTOGRAPHS

When you hire a photographer to take photos of your artwork, have him also take B&W photos of all your pieces. B&W is the best archival reproduction—it will keep the longest.

After they are developed, you will need to choose which pieces look the best in B&W. Some artwork looks like a big blob without color. Get only the good ones reproduced for your press release mailings.

The size to send a newspaper is 5x7". Before sending, you will need to label the back of the photo. Do not write directly on the back of the photo—it might leave marks on the front. Write on a label, then adhere this label to the back. You will want the title, your name, medium, ©, and date.

PHOTO/SLIDE DUPLICATION

Pick the best slide/photo for duplication purposes. This is your original. Mark 'ORIGINAL' on the slide so it doesn't get confused

When sending slides to a contest or juried show, do not tape or bundle slides. Simply put them in a slide sleeve, cutting the sleeve to the necessary size.

with any of the others. Either dump the other four slides of the same piece, or if they are good, but not the best, save them in a back file just in case something happens to the original slide.

If you are taking a slide of a square piece, there will be some background within the slide that you want to crop out. A special Mylar tape for cropping slide images can be purchased at a photo store. This tape is very thin and adheres well. When putting this tape on the slide, slip the film out of the slide frame. Using a light box to see where the image ends, very carefully put the tape at the border line to darken the unwanted parts. Press very firmly and then insert the film back into frame. Have duplicates made from the original slide <u>after</u> the silver tape has been applied. The duplicates will have a black background.

DUPLICATING AND IMPRINTING SERVICES

Mail services which sell slide and photo reproductions seem to be the best priced, ranging from about 15-20¢ per slide for 100. This service is also quick and easy.

Citizens Photo
(503) 232 8501

Holland Photo
(800) 477 4024

K&L Custom Photographics
(212) 661 5600

Visual Horizons
(800) 424 1011

World in Color
(800) 288 1910

LABELING SLIDES

Each contest you enter, each exhibition you apply for, might have different labeling requirements. Artworld professionals are not trying to be difficult with their concept of labeling; they just have different purposes that require a particular format. Follow specific requirements. You can buy new mounts if some of your older slides have been relabeled too many times to be readable.

When labeling slides for your portfolio mailing, have your name, address and telephone number, as well as title, media, size and an arrow indicating up direction. Options to include are date of execution and © symbol.

Label slides with name, address, telephone number, title, medium, dimensions, year produced and arrow indicating viewing direction.

When using pressure-sensitive labels, request plastic (not cardboard) slide mounts from your processor.

PRESSURE-SENSITIVE LABELS

One handy item that you can use is the small pressure-sensitive labels which fit on the wide part of a slide carrier. You can hand-print, type or put them through the computer. They lift off the sheet and adhere to your slide. They are made by Avery and are available at your local office supply store or through mail order.

You can also buy little, red dots to put on the mounts when a juried show requires that. Usually you put the red dot on the bottom-left-hand corner for slide projector insertion. They can be removed in the future if need be.

SLIDE LABEL RESOURCES

Quill
(800) 789 1331

TransFix
PO Box 10425, Glendale, CA 91209 (818) 403 1295

DIRECT IMPRINT LABELING

Many companies have emerged that can imprint slides. The printer connected to their computer is specifically set up to type all your requested information directly on the slide frame. Generally, places that dupe slides also do this procedure. You can often get them labeled at the same time you order dupes.

STORING AND SENDING SLIDES

Whether in your studio/office or on their way to a consultant or client, your slides have to be protected. In your office you can use a metal or cardboard slide box. When sending your portable portfolio through the mail, you'll need to use 'slide sleeves.' Use the archival-quality sleeves—polyvinyl chloride (PVC)— that hold 20 slides, commonly purchased at a photography store. Avoid plastic sheets.

STORAGE EQUIPMENT AND SUPPLIES

20th Century Plastics
(800) 767 0777

Graphic Dimensions
(800) 221 0262

Image Innovations/Slide Scribe Products
7685 Washington Ave S, Minneapolis, MN 55439-2417 (800) 345 4118
www.slidescribe.com <sales@slidescribe.com>

Visual Horizons
180 Metro Park, Rochester, NY 14623 (800) 424 1011
http://www.storesmart.com <info@storesmart.com>

SLIDE LIST

Many competitions or galleries will ask you to include a 'slide list.' This simply means to list on a separate piece of paper, in the order of the slide sheet you enclose, information about the slides you are sending. Usually you include the title, medium, size and price.

When you make up your printed price sheet, keep in mind the proper way to note the size of your artwork: first the height, then width. The inch marks are only put after the two dimensions, with no spaces surrounding the 'x', i.e., 26x38" not 26"x38". If you are using a computer, put the inch marks in 'italic'.

SAMPLE SLIDE LIST

1. Tulips in Bloom	Acrylic	72x48"	$950
2. Reckoning with Dawn	Acrylic	36x48"	$780
3. My, My	Acrylic	24x36"	$550

ACTION PLAN

❑ Take color photos, color slides, and B&W photos of all important work.

❑ Duplicate slides.

❑ Label slides.

❑ Create a slide list of your marketable works.

RECOMMENDED READING

How to Photograph Using Natural Light
Idaho Commission on the Arts, PO Box 83720, Boise, ID 83720-0008
(208) 334 2119 ext 28
A video for $19.95ppd.

Photographing Your Artwork by Russell Hart
F&W Publishing (800) 283 0963

Photographing Your Artwork
Chicago Artists Coalition, 11 E Hubbard #7FL, Chicago, IL 60611
(312) 670 2060
9-page brochure for $6.

Tips for Successfully Photographing Your Work
400 Sibley St #200, St Paul, MN 55101-1928
(800) 8MN ARTS (651) 215 1600
Call for a free copy.

The Artist's Handbook for Photographing Their Own Artwork by John White

Chapter 11
Presentation Finesse

Portfolios

Types of portfolios

Cover letters

Video portfolios

CD-ROMS

Criticism is easy, art is difficult.

Destauches

PORTFOLIOS

You must come across as a pro, not an amateur. People will be sizing you up fairly quickly.

A portfolio is a complete visual presentation of your work and includes a cover letter, resumé, statement, price/slide sheet, and 5-10 photos/slides or high-quality color photocopies. The portfolio should give a brief, easy-to-digest, visual overview of your artwork. It should be assembled to create a specific perception in the mind of the viewer. Collectors, consultants and gallery owners don't want to see a variety of styles—even if they are magnificent. They want to see consistency. This portfolio should be an artwork in itself. It doesn't have to be expensive, but you do need to spend time designing it.

OPTIONAL MATERIALS TO INCLUDE

➤ B&W photo of you and/or your artwork, or you creating your artwork

➤ Testimonials

➤ Brochure/flyer

➤ Photocopies of newspaper or magazine clippings

➤ Announcements of openings

Do not include original artwork or any original articles and news clippings.

Be selective about whom you send a portfolio to. First find out if a particular person deals in your style of artwork. After you send materials for reviewing, follow up in about four weeks to see if they received them. If you want them back, be sure to include a self-addressed stamped envelope big enough to hold everything you sent! Note in the cover letter that you would like them to send back everything they cannot use for their files.

TIPS

➤ Art directors and gallery owners don't have time to sift through a lot of extraneous material.

➤ The artfulness of the exterior hints at the quality of the work inside.

➤ Delete any items that emphasize your limitations.

➤ If you are showing three-dimensional sculpture, you should include photos taken from different angles.

➤ All pages should be formatted the same and should look cohesive.

➤ All photographs should be trimmed to the same size.

➤ Enclose a SASE with appropriate postage.

A university was reviewing portfolios for a new position at the college—Assistant Photography Professor. So many people applied that there was a 6x12-foot stack of portfolios! It was kiddingly determined who would be the next professor by observing the outside covers of the portfolios from this large stack. It turned out that the person who was picked for the best exterior was also the one with the most outstanding work. He was hired. His presentation was so good you could see it amongst this huge stack of portfolios!

TYPES OF PORTFOLIOS

You need to create all three types of portfolios outlined below. Each is an offshoot of the other.

1. APPOINTMENT/DOCUMENTARY PORTFOLIO

This portfolio should be no larger than about 9x12″, an easy size for carrying and showing. It should have a durable, permanent cover—a cover created by the artist is best. You have only one copy of this portfolio, so you *never* leave it with anyone. You might have a second version if you have a rep working with you. Create a visually pleasing and unique presentation. Some galleries have this type of book lying out in their showcase for potential clients to review.

The first page will have a strong visual—perhaps your name nicely written—but no other copy. The following pages will contain photoprints of your best pieces. As time passes, you will add new photos, at the same time removing outdated ones. Have them be consistent in size, large enough to see, and laid out pleasantly on the pages. It should look good enough to place on a coffee table.

After you have displayed an appropriate amount of your current artwork via photos (10-20), you will have your resumé and statement. Interspersed in this last part can be photocopies of press releases, color reprints from magazine articles and, finally, a slide sleeve with 20 slides.

2. FLIP-CHART PORTFOLIO

This portfolio has a much more casual style and is best no larger than 3x5". It should be carried with you *at all times*, in your car, briefcase or purse. When people ask you what you do, you say "I'm an artist," then, if appropriate, pull out this portfolio. Many artists use a photo carrier purchased at a photography store. I personally like to see artists create their own "flip-chart" portfolio. Have no more than 20 photos to show. You don't want to overwhelm people. If they are interested in seeing more, invite them to your studio.

3. PORTABLE PORTFOLIO

As you begin to make contacts with artworld professionals, you will need to have a portfolio to send to people you cannot visit personally. Due to its light weight and compact size, I call this type of portfolio a portable portfolio.

This portable portfolio can be from 5x7" to 8½x11". For convenience, don't make it any larger. It should fit into an envelope. It will be enclosed in a lightweight folder to keep all the materials together. It should contain at least five color representations of your work in a format other than slide—photo or color photocopy is best—a resumé, statement, price and slide lists, press clips and a cover letter.

Make up 10-15 of these portable portfolios and have them circulating through the mail. If you want the portfolio back, you will need to enclose an envelope with the correct return postage. Colorful envelopes of the appropriate size for mailing, as well as for your SASE, can add to your overall presentation.

RESOURCES

Exposures
PO Box 3615, Oshkosh, WI 54903-3615 (800) 572 5750
www.exposuresonline.com
A catalog of sources to help in constructing your portfolio

Light Impressions
PO Box 22708, Rochester, NY 14692-2708 (800) 828 6216
All types of portfolio items.

This is only an introduction to your work. You are enticing the art professional for a personal interview or studio visit.

One artist used 5x7" color photocopies and bound them with spiral binding at her local print shop. Though this wore out after some months, it was economical and showed off her work quite well.

Quill

(800) 789 1331

You can now buy folders that can be printed on a laser printer. After printing the cover, you adhere the back to the front. Very professional-looking.

One artist charges $50 for his portfolio. The $50 is refundable. He notes that he has never had anyone return it. He feels if someone is interested in his work, they can spend $50 to explore his background more. He includes: a color flyer advertising his prints, 20 slides in a slide sleeve, resumé, statement, cover letter, two magazines with stories on him and miscellaneous goodies.

COVER LETTERS

Final touches of a cover letter can be subliminal, but they give you points.

During your career as a fine artist, you will be writing a lot of letters to various folks: letters of introduction, thank you letters to the press, follow-up letters, introductory letters to potential clients, etc.

A cover letter should be brief and to the point. Most people don't want to spend more than 15 seconds reading a cover letter. It is a short introduction to your presentation package (i.e., portable portfolio).

It states that you want a person to review your work. Note in your letter why you feel your work is particularly suited to their venue. Do you have a particular theme in mind for a show? Briefly state that idea.

Your business letter is speaking for you. If it is awkwardly worded and poorly expressed (or rude), the harm it does can be permanent. Draft a letter, preferably on a computer, and wait a day or two to reread and re-edit it.

TIPS

➤ Create a business-like atmosphere.

➤ Use your letterhead for the final copy.

➤ Make your request brief and direct. No history: it's in your resumé.

➤ No strange typefaces that are hard to read. Make it large enough to read easily.

➤ Simplify every phrase and sentence so people will want to read it.

➤ Read your copy aloud to find the gaps and faults.

➤ Don't repeat the same adjective.

➤ Ask, "What does the reader need to know that he doesn't immediately find out?"

➤ State that you will call on a certain date, mark that date on your calendar and follow up with a call.

As you become a more established artist, you might want to replace or expand your paper portfolio with a video.

Not much can impress more than a compelling video. It can present your philosophy directly from your lips, instead of from a silent piece of paper. Having a video brochure is a wise idea, although it will cost to produce a well-edited piece. A 10-15 minute production—and you don't want it any longer for impact purposes—costs around $5000. If you do part of the production (script, use pre-existing footage, forego narrative for music, work with a group), you can save money. I have seen several artists' videos, and only 25% of them are worth taking the time to watch! These 25% were professionally produced and edited. It's the *only* way to get someone to watch it—and after all, isn't that your aim?

VIDEO PRODUCTION COMPANIES

So where do you find a professional video producer? You could try USC, UCLA or your local university film department. These students would certainly be better than your Uncle Pete.

Mark Ireland Productions
158 Pleasant Point Rd, Topsham, ME (207) 725-7302
$5-10,000 for a 15-20 minute video.

Rank Video
555 Huehl Rd, Northbrook, IL 60062 (800) 800 7265

Medialink
708 Third Ave, New York, NY 10017 (212) 682 8300

Bryant Productions
5184 N Blythe #103, Fresno, CA 93722 (800) 984 3367

CRAVEN HOME VIDEOS

Michael Craven produces videos for artists averaging a cost of $1000 per minute. A five-minute production is the shortest time-span he recommends. These videos are broadcast quality and magazine style. Not just talking heads: he has dubs, overplays, etc. He goes to the artist's studio, does a walking tour with voice-over, and an on-camera interview. He has also produced a great set of videos to teach artists how to market. The set of 12 videos includes topics such as: Art in Public Places, Art Law, The Art Critic, Artist Agents, Art Publishing, and more. See if your local art center, library or university library can

VIDEO PORTFOLIOS

If you decide to have a video done, you must hire a professional video maker.

I fell asleep during one video that an artist sent me because it moved so slowly.

Keep your video short, sweet and to the point. This makes the best impression.

purchase the set at $295. A new set of 30-minute videos, one which highlights an interview with Patrick Nagel. This rare footage, shot two years before Nagel's untimely death. You will see his quality work in these productions. Contact Craven at PO Box 4012, Hollywood, CA 90078 (818) 562 1739.

VIDEO DUPING SERVICE

American Sound and Video
15702 Mitchell N #104, Irvine, CA 92614 (949) 417 8900

RESOURCE

Book, Boxes & Portfolios
(800) 828 5539
A book by Frank Zeier. $36.95.

CD-ROMS

The rapidity of technological advances is amazing. It's even possible for an artist to create his own CD-ROM these days. Receiving a CD-ROM of an artist's work in the mail could prove impressive.

The most straightforward and inexpensive method of putting your 35mm slides and color negatives onto a CD in digital format is to send them to a Kodak photo CD processor. The cost ranges from $1.25 -5.00 per image, depending on the size of the film and quality of the scan.

The recipient must use a Kodak Photo CD player, which costs about $200 and connects to most TV sets. He can also use a CD-ROM drive and a computer, along with software called "Photo Access," which is available from Kodak.

To make a CD, all you need to do is select your slides—as you would select them for a slide show—place them in archival slide sleeves and ship them to a processor. They are returned in just a few days. You can fit about 100 35mm slides onto one CD-Rom.

One benefit of CD-ROMs is their archival quality. As slides get older and become faded, you no longer have a true reproduction of your work. With a CD-ROM they have become a digital stream of information etched permanently onto a disk. The life of the CD is believed to be about 100 years, possibly longer.

You can also open up the scans in "Adobe Photoshop" and manipulate the image, correct color, create montages, crop, and do a variety of other things. You can bring the image into any page layout program and create a color brochure, postcard, or whatever you need. You can also record data onto VCR tapes, as well as get reprints easily and quickly.

If you have a portable Kodak Photo CD Player or color-screen lap-top unit attached to a CD-ROM player, you could have an incredible presentation on the road (or at a show). Ask a dealer to demonstrate what a photo CD looks like on a TV or computer screen. Call Kodak at (800) 235 6325 for a list of processors and general info about CDs.

ACTION PLAN

❑ Photocopy necessary items for portfolios: resumés, statements, clippings, price/slide list, etc.

❑ Buy envelopes to send portfolio in, as well as for return of portfolio.

❑ Create a unique flip-chart portfolio and carry at all times.

❑ Create a unique cover for portable portfolios.

❑ Prepare a master cover letter.

❑ Prepare a documentary portfolio to show to gallery owners.

❑ Consider producing a video or CD-ROM for promotional purposes.

RECOMMENDED READING

Business Letters for Artists *by M Stephen Dougherty*

Chapter 12
Marketing Plans

A personal plan

Setting goals

Short-term goals

Long-term goals

No one ever regarded the first of January with indifference.
Charles Lamb

A PERSONAL PLAN

Each January set one or two major aims for the coming year.

A business plan is a requirement in any business if there is to be hope of success. Without a plan, results will be erratic at best. This plan is your personal road map to success. The professional artist cannot afford to be complacent about a plan.

Developing a marketing plan does not have to be an overwhelming task. It does take thinking and soul-searching—sitting down in a quiet mode and concentrating on your business. You will be writing down your inner thoughts so you can view them more concretely, putting them into an understandable order so you can follow them step-by-step.

You must have realistic goals, taking into consideration your cash flow and time constraints. Do not compare your marketing plan with someone else's. This is ludicrous. If you have only four hours a week to market, you cannot compare yourself to the person who is devoting 20 hours a week to the same task.

Any business must be thought of in the long-term. There is no short-term business unless that business doesn't have a plan. You must have a good overview of what your aims are, although they will certainly change over time. It will be some time before you see any results, especially monetary profit. This is how it is with any new business!

You probably don't like the idea of creating a business plan, but try to understand why you must devote some time to this project.

➤ It helps you think in a particular direction and attracts what you want.

➤ It diagnoses difficulties you'll need to overcome in order to reach your goals.

➤ It helps you budget better by anticipating the future

To develop a plan you must know your target market, your budget, understand the benefits of your product and be aware of techniques to reach your particular market.

RESOURCE

Art Charts
Sue Viders, 9739 Tall Grass Cir, Littleton, CO 80124 (800) 999 7013
<viders@worldnet.att.net>
A set of ten 11x17" charts suitable for hanging on your studio wall. These charts show you how to structure your promotional efforts through a variety of marketing options. Use them to brainstorm and get motivated. $19.95 + shipping. Free phone advise also available.

FIVE FACTORS FOR SUCCESS

These five factors came about by studying successful artists' approaches to daily tasks. As you make your goal-setting chart, keep these five factors in mind.

1. Continally contacting people

Make it an aim to call four people a day—whether they be new prospects or current clients. It's guaranteed that not only will you become quite good and efficient on the phone, but your business will flourish.

Clients are the mainstay of any business. To call four people a day could take 15 minutes. Don't make them long conversations; in fact, they should be short, with a specific aim in mind. You could ask for referrals, invite the person to visit a future opening or exhibit, invite him to your studio to see your new series of works, thank someone for a recent purchase. Be creative!

Add to this list of four phone calls four post cards, and you have eight contacts a day to get a total of 40 contacts a week! If you try this for two months (320 contacts or recontacts), you will be amazed at how your sales increase.

2. Follow-up

Not only do successful artists follow up after they send out a package of slides, but they follow up even if they receive a rejection. This means that they send out a postcard with one of their images on it, photoprint, announcement of an exhibition, whatever it is—at least every 6-12 months to all prospective clients and galleries and to former purchasers. The rule in direct marketing is: you must contact people three times before they respond! As an artist you won't have a huge mailing list; it will be quite intimate, perhaps 100-400, so the cost to do a mailing is not overwhelming.

3. Innovative marketing

Successful artists are always thinking of innovative ways to market. They are willing to take a risk if they feel a new idea might work. For instance, new places to exhibit—an orchid show, an interior designer show, a real estate show, a music conference, a sci-fi convention—whatever they think might work for them! Presentation is always consistent and top-notch, of course.

4. Press coverage

Successful artists consistently receive press coverage. Although she might not get direct sales from this press coverage, a successful artist knows that in the long run it means many people see her name, artwork and progression over the years. This means a lot to potential buyers. It also means that the newspaper/magazine approves of you. Name recognition is of the greatest importance in any business.

5. Long-term goals

All the successful artists I know have had long-term goals. This means they did not make it overnight. They planned and strategized and suffered to get where they are today in the marketplace. They never gave up. They knew their aim, and they knew there would be down periods, as in all businesses. Aims and goals are the mainstay of any business. You are in business, and you must have a business attitude to win at marketing!

SETTING GOALS

It is said that 90% of businesses that don't have a formal written plan, fail. Do you want to be among these 90%? If you don't have a plan, how will you know when you get there?

There are different theories about setting aims. Some people advocate setting aims that you can easily reach so you won't fail. Others recommend setting aims that are a bit beyond the normal realm of what you think you can accomplish. You need to see what approach works best for the type of person you are.

The first type of aim mentioned might limit your possibilities. How do you know you can't do more if you don't try?

The second direction could drive you to be more creative, pushing you into new territory and risks.

If one doesn't reach a particular aim, it doesn't imply failure. It could mean that one is not ready to accomplish that aim; maybe it will take a little more time, or maybe it's not even a suitable aim to have!

TIPS FOR DAILY SUCCESS

➤ Focus on top-priority tasks everyday. It you are able to accomplish your number-one task, then you've had a productive day. Strive for a balance between quality and quantity.

➤ Use a weekly and daily 'To Do' list. Cross out tasks that you've completed on your daily list. If need be, stamp "completed" on it. That really gives one a feeling of accomplishment.

RESOURCES

Miles Kimball
(920) 231 4886
Three-Year Calendar Diary 8¹/₂ x 11" spiral-bound with handy divider tabs. $4.98 +shipping.

Great Papers
PO Box 8660, North Mankato, MN 56002-5660 (800) 447 0219
(507)386 1044
Large variety of pre-printed papers for letterhead, newsletters, etc.

AN EXERCISE

Goal-setting is not something you can just sit and think about. You must write down your ideas. Brainstorm and see what new ideas you can come up with.

Let's think about general goals and directions for your art business, and then about particular aims as steps to reach those goals. You can use the ideas you've already read about. Fill in the action plan at the end of each chapter. Following are some aims to consider. Add some of your own.

GOALS TO CONSIDER

➤ Dedicate as much time to marketing as you do to your creative art each week.

➤ Write down every idea you have. Make a file section called *Ideas* for future reference and creativity. One file of ideas on the business of art, one on the creation of art, one on wild marketing ideas, etc.

➤ Set aside a specific day and time each week for marketing.

➤ Create your own work space.

➤ Don't consider an artwork finished until it is titled, framed, signed, copyrighted, etc.

➤ Buy index cards and start collecting names for your mailing list.

➤ Upgrade your portfolio; make it unique and impressive.

➤ Photograph any artworks that you consider finished. Create a comprehensive slide file of artwork, press clippings, etc.

➤ Call 5-10 artworld professionals each week.

➤ Organize a solo exhibit.

➤ Spend one day visiting local galleries.

➤ Subscribe to an art publication for one year and *read* it.

➤ Decide on your company name, design your logo and print your business cards and stationery.

➤ Enter a competition.

➤ Attend an outdoor show to check it out for possible sales next year.

SHORT-TERM GOALS

Once you have set in writing your strategies, take out your annual planning calendar and break them down to the month, then week, then day. Give yourself time to accomplish each task, but not too much time!

1. Become a legal business.
2. Prepare an outstanding portfolio.
3. Find an interior designer to buy my work.
4. Find an art consultant/rep to work with.
5. Hold an exhibit in town.

STEPS TO REACH GOAL 1

1. Decide on company name/logo.
2. Design business cards/stationery.
3. Get business license/sales tax permit.
4. Market 10 hours a week.

STEPS TO REACH GOAL 2

1. Take slides of all artwork and label them.
2. Prepare a resumé.
3. Buy a leather folder for a portfolio.
4. Write a new statement.

STEPS TO REACH GOAL 3

1. Look in Yellow Pages/call five interior designers.
2. Get an appointment with an interior designer.
3. Study *Decor, Art Business News, Interior Designer Magazine*.
4. Explore a merchandise mart.

STEPS TO REACH GOAL 4

1. Procure a list of consultants in the nearby area.
2. Call consultants.
3. Give an open studio.
4. Buy a national directory with art rep listings.

STEPS TO REACH GOAL 5

1. Explore galleries.
2. Call galleries in order of preference.
3. Enter a competition.
4. Get on at least one gallery's mailing list and go to openings; network; try to meet an artist and get a referral.

The biggest step in becoming successful is to start working your plan!

FIVE-YEAR GOALS

1. Get accepted into a San Francisco gallery as one of their stable of artists.

2. Earn $25,000.

3. Exhibit at ArtExpo.

4. Get printed by an established publisher.

FOUR-YEAR GOALS

1. Invite 200 people to an Open Studio.

2. Donate a piece of artwork to charity; use this opportunity for new contacts.

3. Earn $20,000.

4. Exhibit at three fine art fairs.

THREE-YEAR GOALS

1. Have a mailing list of 30 purchasers as well as 200 possible purchasers.

2. Earn $15,000.

3. Investigate art publishers.

4. Exhibit at an art show.

TWO-YEAR GOALS

1. Invite 100 people to an Open Studio.

2. Advertise in the Yellow Pages.

3. Make $10,000 this year.

4. Complete a group of 20 artworks.

LONG-TERM GOALS

Long-term goals need to be revised annually. They will change periodically as your business grows and you learn.

ACTION PLAN

- ❑ Note three main goals for years 2-5.
- ❑ List five main goals for next year.
- ❑ Break down these goals into five steps each.
- ❑ Update a marketing plan each quarter.

RECOMMENDED READING

The 90-Minute Hour *by Jay Conrad Levinson*

Swim with the Sharks without Being Eaten Alive *by Harvey Mackaey*

Your Business Plan *by Dennis J Sargent and Maynard N Chambers*

Chapter 13

Navigating the Art Market

Setting the stage

Research

 Mailing lists

The art of the telephone

 Client status sheet

Networking

 Targeting your market

I owe all of my success in life to having always been a quarter of an hour beforehand. Horatio Nelson

SETTING THE STAGE

Great marketers always make some mistakes because they are willing to experiment.

Planning your initial marketing takes time, effort, aim, commitment and knowledge. You need to discover as much about the art world as you can. To meet potential collectors, the aspiring artist must learn to 'swim the waters.' All kinds of information about galleries, publishers, shows, competitions, portfolios and press releases will be useful in the progress of your career.

To set the stage means to attend art events and openings where you meet other artists, art patrons and the art press. Start to cultivate a support system with fellow artists and art organizations to keep feeding your aims.

It's important to keep a notebook and files on marketing ideas, aims, and goals. Look at it periodically to see if you have been attempting to put any of them into action.

Few people are born with business knowledge. Good businessmen and business women have studied, read books, attended seminars, workshops and trade shows. They belong to associations and continue to discover new methods and approaches to their particular market. Make this quest for new marketing knowledge part of your monthly activities. With practice you'll become a confident marketer.

MAKING SURE YOU'RE READY

Besides the business factors we've gone over in previous chapters, your artwork must also be ready for the marketplace. Ask yourself some questions before you start your promotion:

➤ Are you able to produce artwork of a consistent quality and style?

➤ Is the quality of your work up to the standards of the market?

➤ Do you have a body of work ready to sell?

➤ Are you able to produce enough pieces per month (average of five for a full-time artist) to keep up with the future supply and demand?

➤ Are there any legal considerations in selling your product?

➤ Are you psychologically ready for the possible onslaught of criticism?

➤ Are you willing to part with your work?

➤ Do you consider the price you calculated in Chapter 5 an agreeable price at which to start selling your work?

BODY OF WORK

You must have a substantial body of work available for sale—at least 20 or more pieces that meet the standard of quality you have set for yourself. In order to be taken seriously by artworld professionals, these pieces must have a consistent, cohesive style with a well-defined sense of direction.

This style must be easily recognizable. For example, 10 artists each put 20 slides into a heap. An art consultant should be able to separate these 200 slides into 10 groups of 20 'matching' slides. If your work cannot be picked out of the heap in this manner, chances are most artworld professionals will not consider it for review.

A common mistake is to be too random in selection of style. Galleries want to see consistency. To be marketable, an artist must have a definite personal style—a vision that sets him apart from everyone else—sometimes called a voice. This can take some artists years to develop.

As an artist, your paintings should not exist solely as individual entities, but as songs from a musical—each relating and expanding on the other.

RESEARCH

If you can't find a book in your local library, use the 'interlibrary loan service.' Libraries will trace a particular book and then send it to your local library so you can read it at home.

Once you determine that your work is ready for marketing, you'll need to concentrate on locating your target market.

Research is an essential ingredient for all businesses. Keeping on top of the marketplace assists you in outsmarting the competition. Familiarize yourself with the staff of your local library. College libraries often offer extensive resources. When you go to the library, carry a notebook and some dimes for photocopying.

Become acquainted with reference guides and directories. There is an endless variety of resources in the reference section of your library. Many directories are available to find target markets: *Standard Rate and Data Services/SRDS*; *Yellow Pages*; *IMS Directory of Publications*; *Gale Directory of Publications*; *International Yearbook*; *Media Guide*; *Thomas Register of American Manufacturers*; *Encyclopedia of Associations* and many more being compiled each year.

Read all the art-related magazines you can get your hands on. The library will have many. To receive a complimentary copy of many publications, all you need do is write to their advertising department on your letterhead, asking for a "sample issue and rate card."

MAILING LISTS

Create a list of potential candidates for contacting. Throughout your research you will be building your personalized mailing lists. You will use these lists throughout your career, so guard them closely. Try to contact everyone on your list at least once a year. The aim is not to have the biggest list, but the best—the most specific to your personal marketing needs.

You already have a list in your personal phone book to start with: family, friends, doctor, dentist, bookkeeper, insurance agent and all the other professionals you deal with.

You can keep your mailing lists on computer, a Rolodex system or index cards. As an artist, you will have categories such as:

Architects	Art councils	Art critics
Art organizations	Businesses	Collectors
Galleries	Interior designers	Museums
Publications/editors	Publishers	

Keep track of your best clients by coding your lists: #1 collectors/ buyers, #2 interested parties, #3 persons to 'court,' etc. The main idea is to know the importance of each client, the ones you want to contact the most.

FILE CARDS

If you are using file cards to keep your lists, you could color code them: i.e., yellow for private buyers, blue for publishers. Also number code each.

Sam Bush #1 Collector
16 Clement St
SF, CA 94118
415-692-5432

9/23/97 Purchased *Setting Sun* at Sausalito Art Show $1900
10/25/97 Sent postcard re opening

John Smith #2 Gallery owner
13777 Pine Hill Rd
Wales, TX 76445
800-692-5773

Great gallery for my work!
11/20/97 Called to inquire about requirements for showing
12/10/97 Sent in photos, bio, pieces noted on client contact sheet

It's said by most businesses that 80% of their business comes from 20% of their customers. This 20% is the group of people you will contact the most often.

THE ART OF THE TELEPHONE

Using the telephone is a learned art.

Many artists have difficulty using the telephone to call a stranger. Believe me, even salesmen start out with this problem. The way they overcome this fear is to practice calling on the phone. The telephone is one of the handiest tools in an office. Let's face it: you can't run a business without it. With it you can do a great deal of research without leaving your chair.

You must attempt to develop a positive attitude towards using this great tool. Once you get used to talking on the phone, it will become second nature. As with most new tools, you just need to practice. Don't expect in one month to be an expert. Your expertise will improve every time you talk.

Don't think you have to sell over the phone. With a phone call, you are generally informing a person of your whereabouts, the possibility of viewing your work, perhaps asking for an appointment.

Know what you want to accomplish before you call. Write it down in a brief outline—a script if necessary. Envision your goals. Call from a quiet room without distractions. Rehearse your presentation and anticipate people's responses.

GETTING PAST THE RECEPTIONIST

One of the main responsibilities of a secretary is to screen calls. Some executives even give their secretaries the power to decide which calls to refer to them and which to stave off. Show the secretary respect—the same that you would show her boss. Your aim should be to become "friends" with her. She can be key in introducing you to her boss. If she likes you, you will come highly recommended!

PHONE TIPS

➤ Answer your business phone (yes, you do have a separate line for your business!) with an official business greeting, i.e., "Hello, ArtNetwork. Can I help you?" You could follow this greeting with your name if you want to be more personal. Just saying "Hello" is *not* a business greeting.

➤ Have a 'phone zone' where you are ready to take a message, fill out your client status sheet, not have interruptions.

➤ Get a portable phone or one with a 25-foot cord.

➤ Don't allow your children, spouse or friends to answer your business line unless they can do it in a professional manner.

➤ Always answer the phone with a smile and an upbeat tone.

➤ If you are in the middle of a project, let the answering machine answer.

➤ If you spend a lot of time on the phone, have two lines—one to call out on and one to take messages.

➤ Don't answer so fast that the caller can't understand what you are saying. This happens quite frequently when I call a business. This is sloppy as well as frustrating. If you have an employee, make sure she is answering the phone pleasantly and clearly.

➤ When you call, don't waste people's time—they'll appreciate that. Ask immediately if they are being interrupted; if so, is there a better time to call back?

➤ Introduce yourself to the person you call, and make it clear who you are and where you met or who referred you.

➤ Choose your times intentionally. Don't catch your client right before lunch!

➤ Stand, rather than sit, during a conversation with a challenging client.

➤ Don't expect to reach the person you need the first time you call. Use an intermediary (such as a secretary) to get as much information about the primary person as you can.

➤ Use a script outline if you feel more comfortable, but use it only for the moment when you get nervous and need prompting.

➤ Take notes on important facts and issues you've talked about. Keep these on a client status sheet. This is called smart-calling. You will impress your client with what you've remembered!

➤ Let the customer lead. Does he want to chat? Is he in a hurry?

➤ If you leave a message, make it clear as to *why* you are calling.

CLIENT STATUS SHEET

As you begin to make more phone calls and contacts to artworld professionals, it will become increasingly more difficult to remember who is who. Start keeping a notebook, listed alphabetically, adding client status sheets as you learn about new clients. As you contact these people and get to know them, add their personal information to the sheet. When someone contacts you, pull out your notebook and familiarize yourself with your history of him or her.

CLIENT STATUS SHEET

NAME _____

ADDRESS _____

CITY/STATE/ZIP _____

PHONE _____

FAX _____

PERSONAL DETAILS:: _____

ART INTERESTS: _____

DATE	TIME	PHONE/LETTER/CALL	NOTES	FOLLOW-UP

FIRST CALL

Your first call is an introduction, perhaps to verify an address or to make sure the person is interested in reviewing slides of your work. Try to start to recognize by their tone how interested they are. Add this information to your client status sheet for future reference. If the person is not interested but seems to be friendly, always ask "Could you recommend a more appropriate gallery, consultant, publisher, etc.?" Often they do know of a more appropriate company but just didn't think to tell you.

FIRST FOLLOW-UP CALL

After you have sent out your portable portfolio to an interested person, you will need to make a follow-up call to see what the potential client thought about your work. You want to be mentally focused when you make this call. Before the call, brief yourself on different possibilities of what the conversation might lead to. Don't dwell or spend too much time on this prepping or you'll get too nervous. The first few times you do this type of follow-up call, you will make errors, get nervous, etc., but after several times of this you'll learn the knack.

Make a follow-up call about five days after you think they've received your material. After you've reached them on the phone and introduced yourself as "the one with the yellow envelope," ask if they've had a chance to review your material. Perhaps it has arrived, but they've been very busy, out of town, at meetings for two weeks, etc. If they haven't reviewed it, which is often the case, remind them it's the yellow one and ask them if you can call them back in three days or so? They will give you a polite 'Yes.' This gives them a time-frame to review the work. You mark it on your calendar and call back in three days.

SECOND FOLLOW-UP CALL

In three days when you call back and get their answering machine, leave a brief message with your phone number, but say you will call back in a couple of days. This could go on for some time. Keep trying every few days. At some point, if they don't return your call and don't send back your packet in the SASE, you can act a little more aggressive but not nasty when you leave a message.

Sometimes their call will precede yours. This is an excellent sign, but don't show too much excitement or enthusiasm! Don't think this

Practice makes perfect.

161

One of the most common "mistakes" from any new entrepreneur is that they do not realize the importance of a follow-up call. To make a sale or to get an editor interested in coming to an opening usually takes more than one contact.

means "Yes, I want to exhibit your work in my gallery." This is only one step in the process of building a business relationship. Take one step at a time.

CALLING TIPS

➤ Set up a schedule for making calls—at the same hour of the same day each week. This will help you get in a routine. Routine is often what you need in order to do something you don't like to do. Set a goal as to how many prospects you will call during this time—say 5-10 calls each sitting. Reward yourself after the session by doing something you like!

➤ Try warming up your telephone voice by calling a couple of friends or relatives first.

➤ Call from a quiet place free of interruptions.

➤ Prepare a checklist of points to follow.

➤ Rehearse.

➤ Anticipate responses and write down answers.

➤ Know your topic and have all the facts at hand.

➤ Be psychologically prepared and centered.

➤ Know who you are calling and why—i.e., this is not a cold call: you have done research.

➤ Did someone refer you? If so, mention that at the beginning of the call.

➤ Make sure your work is appropriate for the particular venue.

➤ Don't spend time explaining your style.

➤ Don't justify your work, or *anything*, for that matter.

➤ Know the benefits for this person of doing business with you. Make a list of them before you dial.

➤ Have your calendar handy for preparing a meeting date.

➤ Speak clearly and concisely.

➤ Be positive. Be prepared for objections.

➤ Always thank the listener for his or her time.

RESOURCES

Make Your Phone Work for You
Briefing Publishing Group, 1101 King St #110, Alexandria, VA 22314
(800) 888-2086 (703) 548 3800
A video for $69 + $5 shipping.

Powerful Telephone Skills
Career Press (800) 227 3371 (201) 848 0310
A book for $8.95 + $4 shipping.

Time Savers
1 Daniel Burnham Ct #1600, San Francisco, CA 94100 (415) 284 6115
Sells a directory of area codes for $8.95. With the charges from the telephone companies these days for looking up the multitude (declare illegal in California) of area code changes, this directory is a bargain.

Carrier Confirmation
(700) 555 4141
Listen to the recording and it will confirm what long distance carrier you use.

SAMPLE PHONE CALL

Artist: This is Constance Smith calling from ArtNetwork. Could I speak with Mr. Goulding?

Sec: Mr. Goulding is in a meeting. May I take a message?

Artist: Yes. Are you Mr. Goulding's Assistant?

Sec: Yes, I'm his secretary.

Artist: Hi. My name is Constance Smith and yours?

Sec: Sheila Black.

Artist: Would you know if Mr. Goulding received a 9x12 bright yellow envelope in the last few days? I sent him my resumé and slides and wanted to know if he had time to review it yet?

Sec: Yes, I did see such an envelope, but I don't know if he reviewed it yet.

Artist: Would it be possible for you to leave a message that I called with that information?

Sec: Sure.

You then give Sheila your telephone number and thank her for her help. Keep her name on the client status sheet you have created for Mr. Goulding. You will be talking with Sheila Black again!

9 WAYS TO KEEP CUSTOMERS COMING BACK

by Sue Viders and Constance Smith

1. Service

In today's tight economy, personal services and contacts are the only way to survive! Spend more time with your client discussing color, texture, ideas, whatever is necessary to give him special attention. Follow-up with a call to see how he's enjoying his new art piece. Talk to him.

2. Remind them you exist

Send clients a postcard of your newest painting and let them know who purchased it. Collectors like to know that other people are buying your work: it makes you more credible. Send them invitations to openings you are having, even if they are miles away. They want to know you're a success! Call to invite past clients to your opening. Remind them to bring their wife, friend or business associate.

3. Network

Go to other artists' openings at galleries and exhibition spaces. Get involved with your local community art organizations. Get acquainted with the directors of your local arts council.

4. Toot your horn

Attempt to get press coverage in your local area on a continuing basis. People like to see your name in the paper and on TV. They want you to be a success because their investment will rise in value. They can say they helped discover a new artist!

5. Make it easy for the client to buy from you

Endorse a lease program. This is especially good for business clients. Start a patron program. Start a 'look' program where you allow previous customers to 'sit' with an art piece in their home or office for a short time before they finalize their decision to buy.

6. Stay organized

Don't forget people's names, what they purchased, what they like. Return phone calls, confirm appointments and follow up on every contact, referral and press coverage with a thank you note.

7. Stay educated

Search out classes and seminars to help improve your business techniques. Go to trade shows to see what's current. Read business magazines and books to keep abreast of trends.

8. Offer extras

Extra service builds goodwill towards future possibilities. Offer to hang the piece they purchased in their home or office. When you see their home, you will be able to make suggestions for other pieces that would complement their setting. Many times people need help in this area. Offer discounts for multiple purchases within a given period of time. Offer something special: customized framing suggestions, free delivery, home consultations, whatever it takes for them to value you and your artwork. They in turn will tell their friends, who will become great leads for future sales. Make it simple and easy for the customer. People who have money to buy art often don't have much time to spare.

9. Pay attention to your clients

This is the best way to know what to offer someone in the future. Most people are a reflection of many people's ideas and attitudes, so by listening to one person's views, you will be able to see what many people might want.

❧

Sue Viders is author of *Art Marketing Charts* and *Producing and Marketing Prints*. She is also Color Q's art consultant and can be reached at (800) 999 7013.

NETWORKING

The best salesman for any item is a pleased buyer. Pleased customers validate your work.

Networking is the most common way of entering and remaining in the marketplace in any business. If you can get "in" with any group of people, that group will sell your work for you.

There are 'Networking Groups' in almost every civic community these days. They usually consist of business owners who meet once a month for cocktails, just to get to know each other. You can join these as an artist—no different from an accountant, dentist, newspaper writer who has joined. If you meet these local people through networking and they hear of someone who needs artwork for their office, new home, etc., they might recommend you. People generally prefer to patronize people they know. If you get to know them better and they like your work, they might offer you a show at their house.

TIPS

➤ Networking is a two-way situation—giving and receiving.

➤ Always carry your business card or a flip-chart portfolio with you. Everyone you meet could be a potential client—or at least knows someone who is.

➤ Don't be shy. When you pick up your dry cleaning and pay your money, hand them your card. When anyone asks what you "do," have a business card to hand them—maybe even two so they can give one to a friend. Let everyone in your community know who you are. Pretty soon you will be famous!

You need to know what is special about your work. If you don't know, you won't be able to tell anyone.

➤ Join different groups—Chamber of Commerce, network groups, artists' group, PTA, etc. Serving on a committee, such as on the local arts council or art organizations, is a great way to network and meet new people.

WORD-OF-MOUTH PUBLICITY

Word-of-mouth is your largest advertiser, and this is what will start occurring once you have reached enough people in a closed community. If a customer is to refer you to another potential client, of course, you must have happy customers. You want someone to say, "She even came to my house and helped me hang the piece! It looks great."

➤ Ask for a referral. If someone really likes your work, she will be more than happy to give you a lead to a friend or business associate.

If you ever get a referral, be sure you thank, by card or phone, the person who gave it to you—even if you don't make a final sale. You want to have any excuse you can to call someone who was nice enough to give you a referral—that way they'll give you another!

Try to see the world from your customer's point of view.

➤ Give a little extra, and people will start talking about you. Install a piece of artwork at someone's home and there are bound to be stories about 'the artist.'

➤ Keep giving those business cards out.

➤ Keep sending pictorial reminders to your clients.

TARGETING YOUR MARKET

There is a myriad of directions from which to enter the art marketplace. Think about your marketing ventures with creativity. Artists who are making it do just that—they're always developing new ideas on where and how to market their work.

Fill out the following chart. It will help you to brainstorm various alternatives for selling your specific genre of work.

As you start the actual search for places to sell your work, remember that your main aim is to get your work out there for the public to see. If they don't see it, they can't react—nor can they buy. Your first aim should not be a New York gallery—or any gallery for that matter. If that's your aim, you're hoeing a difficult path. Make a gallery your priority only after you have gained a reputation.

A target market is the group of people you will concentrate your sales efforts toward. Many artists overlook sales opportunities that could be quite profitable to them and think only of getting into a gallery. Artists I am acquainted with who are making a living from the sale of their art earn most of their income from sources other than a gallery. We're going to attempt to find those "other places."

NICHE MARKET

After filling in the data on the next page, you will have a better understanding of the specific people who might like your artwork, where to find them, how to attract them. This is your niche market. Don't be misled to think that the larger the niche market, the better off you will be. Word spreads fast in a smaller niche market group.

WHO IS ATTRACTED TO MY ART WORK?

❏ Men ❏ Women ❏ Children ❏ All

Marital status: _____

Ethnic background: _____

Age group: _____

Religion: _____

Living environment: _____

Income level: _____

Education level: _____

How are they like me? _____

How are they different? _____

Values/tastes: _____

How do they spend their leisure time? _____

What do they read?_____

Impression I want to make? _____

Where do they 'hang out'?_____

Where am I most likely to get their attention? _____

Potential clients in order of priority:

_____ _____

_____ _____

What are their reasons for buying my art:

_____ _____

_____ _____

What organizations do they belong to:

_____ _____

_____ _____

Specific region of the country to sell to:

_____ _____

Describe exactly what I am selling: _____

Define more specifically my target market:

Features of my artwork:

_____ _____

_____ _____

Benefits to buyer. Can I offer something more, something different, something better than my competitors?

_____ _____

_____ _____

Who is my competition?

_____ _____

What can I learn from them?

_____ _____

Experience, authority, expertise—why someone would trust me:

How will buying my artwork make the customer's life better?

How can people pay for their purchase (credit card, check, terms)? Will this satisfy my target market?

Am I able to produce enough original pieces for potential buyers in my target market?

Are there any legal considerations in selling my product to this (or any other) market?

ACTION PLAN

- ❑ Create a body of work.
- ❑ Research and start a mailing list.
- ❑ Use a client status sheet during daily calls.
- ❑ Conquer fear of the phone.
- ❑ Start networking locally.
- ❑ Treat customers as lifelong clients.
- ❑ Search out a target market.

RECOMMENDED READING

Homemade Money *by Barbara Brabec*

Positive Impressions: Effective Telephone Skills *by A W Hitt and Kurt Wulff*

Power Calling *by Joan Guiducci*

Target Marketing for the Small Business *by Linda Pinson and Jerry Jinnett*

Chapter 14
Promo Pieces

Postcards

Newsletters

Brochures

Basic components of a brochure

Direct mail

Where my heart lies, let my brain lie also.
Robert Browning

POSTCARDS

Printed promotional pieces come in a variety of shapes, sizes and formats. The more inventive yours are, the more you'll catch your potential clients' attention.

A four-color brochure is not really necessary for the beginning marketer; your portfolio will accomplish all you need. When it is time to go forward with your first printed promo project, make a budget. If you end up spending too much, you might drive yourself out of business. Until you are well-established, stay with the postcard, which can be a fairly inexpensive way to get your visual image out to clients. Many artists use postcards as invitations to an exhibition. Others use them to keep in contact with clients.

As in most promotions, it pays to be unusual. You want people to keep your postcards? How about an oversized postcard that people can post on their bulletin board and use as a small poster? Make your promo hard to toss into the wastebasket. Make it valuable enough so the recipient will keep it.

You don't necessarily have to have four-color postcards printed for an exhibition or opening announcement. I've seen some beautifully designed one-, two- and three-color cards. In fact, some of these designs can be very fun. Card stock does not have to be the conventional 10pt. With paper prices rising, lighter-weight stock such as 8pt is common and fills the postal requirements. For spot-color cards you can usually find an economical local printer. Being creative is the important factor here.

If you decide to print four-color postcards with images of your artwork, it's best to use a specialized printer. It's as easy to deal with out-of-state specialized printers as it is with your local one. Get quotes from at least three printers to compare costs.

One artist I know goes travelling a lot. Her artwork is of foreign scenes, and so she sends postcards from distant places. I love to receive them, as do all her collectors and potential clients. Because she does this, I remember her and have taken a special interest in her work. In this manner she keeps me informed of how her career is advancing. This is called smart marketing!

FOUR-COLOR POSTCARD PRINTERS

1-800-POSTCARDS
(212) 271 5505 www.1800POSTCARDS.com

Clark Cards
PO Box 1155, Willmar, MN 56201 (800) 227 3658
www.clarkcards.com <info@clarkcards.com>

Color Card
1065 Islip Ave, Central Islip, NY 11722 (800) 875 1386
www.afullcolorcard.com

Mitchell Graphics Inc
2363 Mitchell Park Dr, Petoskey, MI 49770 (800) 583 9405 (800) 841 6793
www.mitchellgraphics.com <joshw@mitchellgraphics.com>

Modern Postcard
1675 Faraday Ave, Carlsbad, CA 92008 (800) 959 8365
www.modernpostcard.com
This company will compile and send your mailings for you—a great deal at a great price.

Pine Barrens
351-1 Old Riverhead Rd, Westhampton Beach, NY 11978 (516) 288 5200
www.pinebarrensprinting.com <pinebarrens@peconic.net>

Post Script Press
2861 Mandela Pkwy, Oakland, CA 94608 (800) 511 2009 (510) 444 3152
www.psprint.com <info@psprint.com>

Treaty Oak Press
14761 Memorial Dr, Houston, TX 77079 (800) 327 2162
www.TreatyOakPress.com <top@TreatyOakPress.com>

World Market Products
2011 E Fifth St #4, Tempe, AZ 85281 <afalk@nuparts.com>
Make a photo into a postcard with 'Photobackers.' Photobackers adhere to back of photo, enabling it to be used as a postcard.

Don't put any type one inch from the bottom of postcards—the post office sprays a bar code there and any message will be covered up.

NEWSLETTERS

Newsletters, in fact, have become a fad. If used wisely they can enhance your sales.

Companies are constantly on the lookout for innovative and economical ways to remind their customers of who they are. Many companies these days use newsletters as a way of updating their clients on the company's happenings.

I've only seen this technique used by one artist, although it is used widely by many other types of businesses. Customers, especially potential buyers, can be impressed and reassured by artistic achievements you note in a newsletter.

Take a look at the sample newsletter on the next page and see what your response is. Here's mine: this artist is very active, so many other people have accepted her. She's in business to stay; she's a true artist.

If I was one of her previous buyers, my confidence level in her work would have skyrocketed! The newsletter was simple—black ink on 11x14″ recycled paper—but clean and clear. No typos. Nothing irritating. Easy to read.

COMPOSITION TIPS

➤ Put a tip or hint in the newsletter that will entice the recipient to keep it, i.e., how to clean a frame, where not to store unframed works, etc.

➤ Note new purchases by customers. People love to see their name in print.

➤ Note any experiences with customers you might want to share. Did one of your private patrons have a show for you at their house? Let the other customers know how fun it was. Maybe you can get more patrons to offer shows to you.

➤ Know your purpose—to inform, sell, inspire—and your goal—to create interest in your work—when you write the copy.

RESOURCES

Newsletter Resources
6614 Pernod Ave, St Louis, MO 63139 (800) 264 6305
Resources to assist you in compiling a newsletter.

RECENT ACTIVITIES

13 x 13 BY THIRTEEN EXHIBITIONS
Since 1992 I have participated in a traveling exhibition with 12 other artists who have created artwork within the dimensions of 13" by 13". The group shares responsibilities for scheduling new shows, promotion, installation, and more. Recent shows of 13 x 13 BY THIRTEEN included the December 1995 exhibition at the Egg and I Restaurant (University Avenue) in Minneapolis and in January 1996 at the North Hennepin Community College. The college exhibition was featured on Dave Moore's Sunday Morning show.

Volcanic Rock, from 13 x 13 by Thirteen

GRUMBACHER AWARD
The Great River Road Arts Coalition, made up of artists residing near the Saint Croix River, sponsored a 1995 juried show, Images of the River at the Phipps Art Center in Hudson, Wisconsin. Minnesota and Wisconsin artists were eligible to participate. Two of my paintings were accepted in the show, one of which, Still Waters Run Deep II won a **Grumbacher Silver Award in recognition of excellence in a painting medium.**

SUZANNE KOHN GALLERY SHOW
Gallery owner Suzanne Kohn and gallery assistant Clair Selkurt hosted their final exhibition at the International Design Center in Mpls from **March 7 to April 14, 1996.** Kohn is retiring and closing her galleries. I was pleased to be selected for their last show, The New Generation: An Exhibition of Work by Emerging Minnesota Artists. My painting, Black Dog Power Plant, was featured in a Mary Abbe review of the exhibition in the March 30 Star Tribune.

RCA BOARD MEMBER
In July 1995, I began a three-year term on the Board of Directors of Resources and Counseling for the Arts (RCA). This non-profit provides management information, consulting and training services for artists and cultural organizations. Recently Barbara Davis, RCA's Executive Director, decided to resign and I am chairing the search committee to find her replacement. RCA will soon move to a new office in the Northern Warehouse building in Lowertown. I am fortunate to be a part of an organization so vital to the artists' community.

PART-TIME JOBS
To support my artmaking and allow time to paint, teach and travel, I have two part-time jobs. After working full-time at the Walker Art Center*since 1986, I went to part-time in 1993 when I began graduate school. Serving as Benefits Manager, I can be found at the Walker on Mondays and Tuesdays. In January, I began a second part-time job at the Minnesota Relay Service for the Deaf as a Communication Assistant. On Fridays and Saturdays I relay calls for deaf, hard-of-hearing or speech-impaired callers.

Last July, I also worked briefly as a Panel Helper for Arts Midwest's annual fellowship competition for photography, sculpture, and crafts. I helped file and project 10,000 slides for the panel of jurors. Quite the experience!

*See the Walker Art Center World Wide Web Site at:
http://www.walkerart.org/

ADDRESS CORRECTION REQUESTED
PLEASE FORWARD

Wendy Lane, Artist
275 East Fourth Street
Studio #820
Northwestern Building
Saint Paul, MN 55101

Share with a friend!

ARTIST'S UPDATE

A periodic newsletter highlighting the creative endeavors of visual artist Wendy Lane

For further details on any of the enclosed information call 612.227.3234 (voice)
or write wendy1@alumni.mcad.edu (email) or visit 275 East Fourth Street, Studio 820,
Northwestern Building, (Lowertown) Saint Paul, Minnesota 55101.

Spring 1996

Printed on recycled paper.

UPCOMING EVENTS

NEW! ART CLASSES AND WORKSHOPS AT THE MINNESOTA VALLEY NATIONAL WILDLIFE REFUGE
(July and August 1996)
I am excited to announce new art classes offered from programming I developed specifically for the Minnesota Valley National Wildlife Refuge in Bloomington, Minnesota.
This summer, I will teach the following:

Drawing Outdoors With Pastels; and **Painting Outdoors With Acrylics**
These six-week courses will take place every Thursday from July 11 to August 15. The drawing course will run from 10 a.m.-12 noon. The painting course will run from 1-3 p.m. Each course costs $150, payable to the MVIA (MN Valley Interpretive Association). The first meeting of both classes will be held at the Visitor Center in Bloomington, and subsequent classes will meet in the Bass Ponds area of the Refuge.

Ponds and Pastels: Drawing Outdoors
This workshop will be repeated three times: June 30, July 28 and August 18, on Sundays from 12:30-4:30 p.m. Each workshop costs $40. Students will meet at the Bass Ponds parking lot.

Plan to register early as all classes are limited to 15 students. **You may register by calling the Refuge at 612.335.2323 or 612.854.5900.** Beginning and advanced artists, ages 12 to adult, are welcome. The Visitor Center and Bass Ponds are wheelchair accessible.

THREE-WEEK MINNESOTA RIVER TRIP
(June 1996)
I am planning a plein-air painting trip and vacation along the **Minnesota River** from **June 5-27** . . . part of my on-going relationship with the Minnesota Valley National Wildlife Refuge, which lies along 34 miles of the Minnesota River—stretching from Bloomington to Jordan, Minnesota. I learned of the refuge while in graduate school; My MFA exhibition* was held there last spring.

In June, I will begin by driving west from St. Paul to Big Stone Lake, the headwaters for the Minnesota River, near the border of Minnesota and South Dakota. I plan to follow the river by car across Minnesota to the confluence of the Minnesota and Mississippi rivers in St. Paul. Among the cities and towns along the route are Montevideo, Granite Falls, Redwood Falls, and Mankato. Lac qui Parle State Park, Upper Sioux Agency State Park, Lower Sioux Indian Reservation, Flandrau State Park, and Minneona State Park are a few of the many scenic and historic sites I'll visit and research. While camping along the route, I will write, photograph, draw and paint to develop a body of work for my next exhibition **at the Refuge Visitor Center, scheduled for June 5 through July 12, 1997.**

On a personal note, I got a dog named Fritz last fall for my 40th birthday to provide protection and keep me company when I'm painting alone outside. Fritz is a mixture of terrier and basset hound obtained from the Saint Paul Humane Society. Fritz will join me on this river trip.

*Check out the WWW site of the Minneapolis College of Art and Design: http://www.mcad.edu/ (Look for my art under Exhibitions: Inaugural MFA Online Exhibition).

DUCK STAMP JUROR
(April and May 1996)
The Minnesota Valley National Wildlife Refuge invited me to be one of five jurors for the Federal Junior Fish and Wildlife Duck Stamp competition for grades K through 12. **Jurying will take place April 18, with an awards ceremony May 4** at the Refuge Visitor Center in Bloomington. This program supports education through the arts, honors and recognizes talented youth through scholarships, and focuses on the importance of wetlands to biodiversity.

Check out the Fish and Wildlife Service World Wide Web Site at: http://www.fws.gov/

WILD LAND(E)SCAPES CLASS
(May 1996)
Artist Sally Brown, a dear friend and wonderful teacher, relocated her studio to the 700 North Washington warehouse in downtown Minneapolis last fall. Asked to teach a private art class through her studio, I created Wild Land(e)scapes, a course designed to help beginning and advanced students discover landscape art and their relationship to the environment through drawing and painting.

Utilizing teaching assistance from Catherine Reid Day, the class meets every other Thursday night from 6-9 p.m., October through May, 95-96. **A show of student work by the six talented women artists from this class along with students of Sally Brown will be held May 11 from 4-8 p.m. at the 700 North Washington Building, 3rd Floor.** Sally's classes are scheduled annually from October to May. She also teaches week-long summer classes on Madeline Island and a class for the University of Minnesota's Split Rock art program.

For information about classes through Sally's studio, contact me at 612.227.3234 or Sally Brown at 612.339.1593

MAEP SHOW AT THE MIA
(July and August 1996)
The Minnesota Artists' Exhibition Program (MAEP) is hosting a juried show at the Minneapolis Institute of Art (MIA). The show will be divided into 4 separate exhibitions using the following themes: earth, water, air, fire. One of my paintings was selected for the water theme show. **The water exhibition opens with a reception July 11 and closes August 22.**

THE ST. PAUL ART CRAWL
(October 1996)
Twice a year, during spring and fall, Lowertown St. Paul artists open their homes and studios for the Saint Paul Art Crawl. Last September, I participated in the crawl by opening my painting studio on the 8th floor of the Northwestern Building. I exhibited older artwork as well as more recent work and I was delighted to sell three paintings and one drawing. In 1996, the Crawl will be held April 12 and 13 and October 11 and 12. My studio will NOT be open in April, but I do plan to be open for the fall 1996 Crawl.

Check out the Crawl's World Wide Web Site under "art" at: http://www.stpaul.gov/

MINNESOTA LANDSCAPE ARTISTS
(December 1996 through January 1997)
I have been invited to participate in a curated exhibition, **Minnesota Landscape Artists, to be held at both the St. Paul and Minneapolis campuses of the University of Saint Thomas College. The exhibition will run from December '96 through February '97** and will include an exhibition catalogue. Watch for additional details about this show.

BROCHURES

Brochures can be used for a variety of purposes: traditionally, they are used to sell item(s), as an introduction piece, or in the place of a hand-constructed portfolio.

TERMS TO KNOW

Flyer. Generally one sheet, printed on two sides. It can be folded. Sometimes called tear sheets or sales sheets.

Brochure. Can be any dimension, the most common being 6x9″ and 8½x11″. Usually a minimum of four pages.

Catalog. Usually a larger 8½x11″ format with 8 pages minimum, often more. We're all familiar with direct mail catalogs.

If you do decide to print a brochure to replace your portfolio, it must be top-notch, thus expensive to produce. The paper stock, layout, copy, typesetting must be of superb quality to make it effective.

POINTERS FOR REDUCING COSTS

➤ Create a brochure that will fit a standard envelope.

➤ Make your brochure a self-mailer. This means it is folded in such a way that you don't need to put it in an envelope. By today's standards, this is quite acceptable. It's instant gratification for the recipient. Contrary to popular belief, it is rare that a mailer gets damaged because of not being enclosed in an envelope.

➤ Print on standard stock paper. This doesn't mean it's ugly paper. Generally there is a variety of grades and choices of standard stock.

➤ Get quotes before you design your brochure. After your initial quote ask more specific questions of the printers you are most interested in. Ask them specifically, for instance, "What do you suggest I change in order to cut costs?"

➤ Many printers have "gang-runs" to accommodate those people who plan ahead and are not under urgent deadlines. A gang-run means your piece is placed on the same paper with someone else's, thus saving start-up charges.

If you intend to design a brochure or flyer yourself, you should have some training as a graphic artist. You will need a computer and a page layout program, perhaps "Pagemaker" or "Quark Express." If you are not trained in graphic design and layout, try to do a trade with a designer.

BASIC COMPONENTS OF A BROCHURE

OPENING STATEMENT

An opening statement may or may not be necessary, depending on the type of brochure you are designing. It can include your logo and/or name and a simple description of your artwork. Sometimes this is written in an attached letter.

Use powerful and persuasive words when you compose your copy. Some words and phrases that are used regularly in brochures:

Bargain	Bonus	Check	Compare
Discover	Quick	Refundable	Safe
Save	Successful	Try	Get one free
Act now	Here's news	Trial offer	Never before
No obligation	You can trust	Special invitation	

Maybe you need to hire a writer for this special project. You'll be amazed at what professional writers can do!

BENEFITS

Keep in mind the audience you are addressing. You must appeal to them emotionally. Note the benefits of a purchase in the mailer. Why is your work special? Here are some examples:

➤ Honors and recognitions the artist has received.

➤ High quality of the printing process (if a print).

➤ The print will be shipped and packed to insure delivery in perfect condition.

➤ There's an additional 10% discount if ordered within a certain time.

➤ Prices include framing and delivery.

➤ Scientifically and accurately rendered.

➤ Guaranteed. If it doesn't fit your environment, return within 30 days.

➤ Lightweight and easy to transport.

TESTIMONIALS

Ask some of your previous purchasers to write testimonials for you. You can even tell them what you would like them to say—a statement that highlights one of your benefits, for example. Get testimonials from your happy customers. This builds buyers' confidence immensely.

IMAGES

Reproductions of your most representative piece(s) are a must. A photo of yourself can add emotional impact. A high-quality line drawing or clip art can add character to your printed piece.

STATISTICS

Name, address and phone number should be included on every piece of material that you print. It's very frustrating when an address or telephone number is lost because papers have become separated.

800 LINES

It's said that an 800 number on a brochure or flyer increases sales response levels. Many telephone companies these days can connect your telephone line to an 800 number for a nominal setup charge. You, of course, will have to pay for all incoming calls. Most companies charge from 21¢-29¢ per minute for incoming calls. This can add up quickly if you're not careful. The best way to arrange your business phone lines is to have one line strictly for order-taking (the 800 line) and one for regular calls. People calling for information would then have to use your regular toll number.

ORDER FORM

On the order form include space for your client to fill in her name, address, city, state, zip, telephone and signature. Do you need to collect tax? Is your telephone number printed on the order form? Can they call in with an order? Collect order forms from other companies and study them to determine which are the easiest to fill out. Have someone unfamiliar with your product look at your order form and place an order. What difficulties did they have? What didn't they understand?

It would take a book to teach you all the pointers of creating a good brochure. Be sure to do your research in this area.

ASK YOURSELF

✓ What is the purpose of my promo piece?

✓ What is my budget?

✓ Whom am I sending this to?

✓ Where do my customers hang out? Where can I place it for them to pick up?

✓ What is a design style that could shock them pleasantly?

✓ Which writing style would they understand?

✓ What image do I want to create?

✓ What's a special benefit that could 'catch' my audience?

✓ What is the type of testimonial that would appeal?

✓ What are some formats to consider?

✓ How will this be distributed to my target market?

CONSIDER

➤ **Ways to make your audience respond:** An order form, a postage-paid return postcard telling you they want to remain on your mailing list, or a request for an RSVP for your open studio, etc.

➤ **Ways to add authority:** A testimonial, a list of corporate collections or museums that collect your work.

➤ **Way to make your piece easy to remember:** A photograph of you, an unusual story, an unusually designed piece, a reference to a recent public occurrence that you were involved with.

➤ **Ways to make it useful and possibly saveable:** A die-cut Rolodex card, hints on caring for artwork, discount coupon.

➤ **Ways to make it relevant:** Touch an emotional cord , i.e., "You're missing a lot by not having original art in your home." "Support a living artist."

A common error made by ex-typists, and an easy way to differentiate a pro from a novice: leaving two spaces after the period at the end of a sentence. Only one space is used on a computer.

To make his one-color brochure into a four-color piece, one clever artist pasted his four-color business card onto the front cover in the framed area he had printed with his computer. I could hardly tell that it was a business card. It looked and felt like it was printed right on the paper.

177

First and foremost, don't make your piece look like junk mail!

Within your budget might be the following categories of expenses. At first, no doubt, you will do many of these tasks yourself. In that case, try to network with other artists and exchange critiques before the final piece goes to press.

Writing	Editing	Designing	Typesetting
Proofreading	Pretesting	Labels	Printing
Copying/stats	Paste-up	Mailing prep	Postage

RESOURCES

Erica Jeffrey
PO Box 2153, Marysville, CA 95901-2153 (530) 741-2025
Freelance writer, proof reader and copy editor.

Susan Ruble Public Relations
1686 N Morningside St, Orange, CA 92867 (714) 998 7926
<SueRuble@aol.com>

Editorial Free-Lancers Association
71 W 23rd St, New York, NY 10010 (212) 929 5400
Can help you find a free-lancer in your area.

DIRECT MAIL

Four-color brochures are very costly, but how can you show artwork in B&W?

You distribute brochures at shows, exhibitions, in daily life, or you mail them to potential clients. A brochure should not be used for selling original work through the mail. If you don't have something other than original artwork to sell (i.e., prints, t-shirts, mugs, etc.), use your brochures for specific clients. Have you ever considered buying a $750 original painting through the mail? I certainly haven't! I would consider prints, posters, limited editions, note cards, miscellaneous accessories.

Direct mail marketing is one of the most expensive ways to sell multiples to retail collectors, but it can be successful if approached correctly. You probably are unaware of it, but many of the direct mail companies that you receive brochures from on a monthly basis have either gone bankrupt or are owned by a huge company that is supporting the loss until the company gets established.

If you cannot afford an expensive four-color brochure but want to put out more than a one-page flyer, you could go with a preformatted brochure. A preformatted brochure comes to you with a four-color design already on it. You lay your copy on top. Many companies have come out with quite a variety of this type of preformatted brochure.

PREFORMATTED BROCHURE COMPANIES

Paper Direct
(800) 272 7377

Queblo Images
(800) 523 9080

Paper Access
(800) 727 3701

Quill
(800) 789 1331

RENTING MAILING LISTS

If you decide to do direct mail, i.e., sending a brochure to a large quantity of unknown people, there are several important elements, the right mailing list being number one. Your in-house mailing list is, of course, your prime list. You have worked long and hard to gather this list, doing much research.

Mailing lists are generally rented for one-time use. List renters normally include a number of "seed" names in their lists (phony names to inform them of multiple use). Be ethical. If a renter discovers that you have used a list more than once, he may refuse to rent to you in the future.

Many organizations rent lists. If you've checked your target marketing chart out and decided on some specific genres of people you would like to approach, possibly there is a mailing list of those people out there. Remember, though, that it often takes more than one contact to get results. Ideally, you need to plan three mailings to any new group you send to. This can cost big bucks.

Your average mailing— say a one-page flyer— generally costs $1 or more per piece! A four-color mailer could cost big bucks.

An artist sent 1000 direct mail pieces to a specific area near where he lived, a very high-income residential area, after which he asked me for a consultation. I would never have recommended that he do this type of direct mail campaign. I wished he would have consulted me previous to this venture.

I received a call two weeks later, however, to find out that the artist had made two big sales—his originals sell for $9000—as well as evoked some interest from other parties. Needless to say, I was very surprised!

The factors that made his mailing different from most are:

✓ An exquisite brochure—11x17" folded in half and inserted in an envelope. The brochure probably would normally cost $1-2 each. He received this well-designed, but very simple, brochure free from his publisher.

✓ This artist was known in the area. He had been the poster artist for a recent, well-known art festival. He was also part of a well-respected gallery in town, a gallery which hadn't sold any of his work for ages.

✓ The gallery advertisements included his name—and his name was first because his last name began with the letter 'A'.

This steady exposure to a particular locale—the same that he had sent the direct mail piece to—paid off. If he continues to mail to the same people, they will start networking and do his sales and advertising by word-of-mouth!

ACQUIRING LISTS

Local arts council
Ask for a list of patrons.

ArtWorld Mailing Lists
(800) 383 0677 (530) 470 0862
ArtNetwork has over 20 varieties of lists of artworld professionals nationwide for rent.

Info USA
(402) 331 7169

FOUR-COLOR BROCHURE PRINTERS

American Color Printing
8031 NW 14th St, Miami, FL 33126 (800) 897 6175

Color Q
2710 Dryden Rd, Dayton, OH 45439 (800) 999 1007

Kolor View Press
112 W Olive, PO Box 440, Aurora, MO 65605 (800) 245 5023

FOREIGN PRINTERS

Sometimes called 'off-shore printers,' these companies have excellent pre-press and printing facilities. If you're not in a tight time-frame to print a four-color brochure, you might want to work with a U.S. broker in the Orient to save money. The price could be as much as 35-50% less than in the U.S. The time, however, takes 50-100% longer!

BROKER

Imago
1431 Broadway #Penthouse, New York, NY 10018 (212) 921 4411
<jbraff@inagousa.com>
Excellent service. They can help you with color books, brochures, catalogs.

Patron lists from your local museum could be a very effective tool to begin with, especially if you're somewhat known about town and these people will be familiar with your name.

AN INNOVATIVE STORY

A publishing company that prints posters of pool hall scenes sold the magazine *Billiard Digest* the rights to use an image on 1000 bags at the annual Billiard Congress of America trade show in Nashville, TN. They also did a direct mailing to 4000 pool halls and supply companies. The same publisher has a limited edition of a print called "Travesty of Justice." They will focus their direct mail campaign on criminal lawyers and advertise in legal magazines. They have found their target market, and their advertising and promotion works!

ACTION PLAN

❏ Create a simple postcard for an opening.

❏ Start creating a newsletter for clients on a quarterly basis.

❏ Keep in mind possibilities for future brochures.

RECOMMENDED READING

Editing Your Newsletter *by Mark Beach*

Everyone's Guide to Successful Publications *by Elizabeth W Adler*

Getting It Printed *by Mark Beach*

In Search of Excellence *by Tom J Peters and Robert H Waterman*

Newsletters from the Desktop *by Roger C Parker, Joe Grossmann and David Doty*

Publishing Newsletters *by Howard Penn Hudson*

Chapter 15
Sales Techniques

Learning to sell

 Handling objections

Closing a sale

After a sale

Special sales programs

Never complain and never explain.

Disraeli

LEARNING TO SELL

Art mostly sells itself.

Think of sales as introductions. "Sales" usually implies luring someone into a lair and selling them something they don't want. This is not the approach you want to take as an artist. It will surely backfire.

Most people will say that it's hard to sell art, that no one wants to buy art. There are people who want to buy art, want to improve their life-style, want to feel good about themselves and like art in their life. You need to find these people—where they hang out, what they do for their livelihood and hobbies. That's what marketing is all about—finding and contacting the right people.

People ask me all the time, "Where is the most active art market in the U.S.?" When I tell them their own city, they get really mad. They want to hear some magical answer, like Santa Fe, New York, Seattle. It's ridiculous to think that there is a better city than your hometown for starters. Within each city many persistent and active artists are selling lots of artwork, but they're not the artists asking that question!

The term 'marketing' is sometimes used incorrectly as a synonym for selling. Marketing is the sum of several different kinds of activities: promotion, intelligent research, planning, pricing, studying competition, as well as selling.

" The art market's down," is another commonly-used excuse. "You mean the auction market?" I ask. They don't know, they just heard somewhere the art market is down. If we're talking about the $20,000-plus range, this could be true. Are you in this category? No? Well, then don't believe this myth about the art market being down.

Art has been made out to be a thing for the rich. How absurd! I've bought many art works for under $250. Generally small, I still value them, even after many years of viewing them. When I go to outdoor shows, there are beautiful pieces ranging from $500-750.

You need to instill confidence in small-time buyers who approach your artwork. It could be their first such purchase. They've been under the myth of "investing in art" and just don't know if they're making the right choice. At this level, a customer is not investing in art and needs to be told this. He is simply purchasing a piece of art to improve his life-style, to enjoy, to receive energy from. Indeed, the works might increase in value, but if he wants to invest in art, he will need to make larger monetary purchases.

Knowing interesting information about an artist or the creation process can help a potential buyer become more interested, but he initially has to respond to your work—there is no convincing involved.

EXCUSES YOU MAKE

Everyone who comes before you is a potential customer. If you have excuses, it is because you don't want to make the effort to sell to them. When you are in a confident mood, you will not make up these excuses. Practice not having these excuses if this is your problem.

➤ He doesn't look like he has any money.

➤ He doesn't look like someone who buys art.

➤ She is not avant-garde enough for my art.

➤ Her fingernails are not polished. She doesn't have any money.

➤ No one off a tour bus ever buys.

New attitude to share with clients: Your are giving them an opportunity when they buy your artwork—an opportunity to add a new dimension to their life.

I was a juror on a court case. The prosecutor was a mild-tempered lawyer—you could barely hear his voice. The defense attorney was a power-infested madman. No one on the jury liked the defense attorney, although he appeared more like a winning lawyer. None of us wanted to listen to this disgusting defense attorney. I believe he lost his case mostly because people didn't like his personality. Likewise, if you sound like a car salesman, people will walk away from you in an instant. Be natural, honest and kind, and you will sell more art. Pretend you are talking to someone in your own home about your artwork.

SALESMEN

Keep in mind as you study the market which salesmen you would like to sell like. When you go to galleries, study how they do it. When you visit outdoor shows or an exhibit, see how they do it. Write your comments down. Make a special effort to study this topic. You will want to observe all types of salespeople and see how you react.

You will find some common denominators in the people that you can deal with comfortably:

➤ You trust them; somehow they have gained your confidence.

➤ You like them—you might even consider them as a future friend.

Learning your own buying style will teach you your best selling style—intuitively.

Your potential customers must have confidence and trust in you before you can sell them anything, let alone a $2000 painting.

When you hold a show, or exhibit at an outdoor show, the people attending are all potential customers. Perhaps, however, they've only purchased prints or limited editions previously. Most of the people you will encounter do not go into galleries. Galleries intimidate them. They go instead to outdoor shows or open studios where the setting is more comfortable, i.e., no salesmen.

Art is a unique commodity. People want to fall in love with an artwork. They want to show it off to their friends. If you know why it's good to own original art, it will be easier to convey this to new buyers.

SOLVING YOUR CUSTOMER'S PROBLEMS

Think of selling rather as solving a potential client's problem: some of them have an easier time letting themselves being rewarded with artwork, some don't. For some it is a new problem and they don't feel too confident. For others, someone else has imposed the problem; i.e., they have reached a certain financial status and people expect them to be owners of original artwork. They really don't know what they like, what they want. They want to be told, but want to trust the person telling them.

ESTABLISHING CONFIDENCE

Your initial presence and stature must insure confidence.

➤ If you sell at an outdoor show for several years standing, this insures confidence. You are not an art peddler: you are an art dealer, which requires a relationship on an ongoing basis.

➤ You've been referred by a friend or associate.

➤ Someone else has bought from you.

➤ The local arts council or museum has a piece of your work.

➤ They saw your name in an article in the local paper.

SELL THE BENEFITS

People want to be sold benefits. Buyers want to know the benefits of owning *your* artwork. So make a list of them—right now! A benefit generally saves time, energy or money while still appealing to the ego. Right color, right size, joyous feeling, the artist is collected by a loyal following, confidence due to critics saying good things about the artist, nicely framed with high-quality materials. All are benefits of owning a piece of your work.

Whether you are selling a poster for $10 or an original for $2000, it takes the same presentation. You have to make the same lines sound fresh each time. Your customers want to have fun.

HANDLING OBJECTIONS

Unless someone is ready to make a purchase, there will generally be objections to handing over the cash. As you proceed with your sales you will become more familiar with what is a normal objection and what is the difficult objection. One way to get around objections is by changing the subject and simply not answering them, or by asking another question.

➤ **Some people might not be sure if they actually like the piece.** They need reaffirmation—from a bystander, their mate, friend, etc. In this case you could offer to them a money-back guarantee. They can display it for two weeks in their home, of course with payment and the normal agreement. That way they'll have a chance to hear comments from friends and neighbors.

➤ **A common objection is, "The price is out of my budget."** Your answer would be, "How about a lease?" or "Why don't you join my patron program and pay by the month?" or "I do have a layaway plan." If you accept VISA/MC you might even feel secure with giving them the piece with three installments on a VISA.

➤ **Price is too high.** They are not familiar with the serigraph process and think it is a poster. Educate them. Suggest they compare your prices to the artist down the path, that you just sold a piece to so-and-so or that your prices have risen slowly over the years because you are more in demand.

➤ **The colors clash with my room.** Show them a different but similar piece. Teach them an art piece is what sets off a room, not the couch.

➤ **They don't feel they deserve such a fine piece.** This might not be said in words, but it is how some people have been trained to feel, especially new collectors who haven't had time to begin to appreciate art in their homes. Explain that everyone deserves to have a reviving impression to view daily.

➤ **I can't make up my mind.** Make them feel confident in their choice. Introduce them to the patron program.

➤ **Silent objection.** They won't look you in the eye, they have nervous energy, their arms are folded, they won't shake your hand. Make them feel confident in their choice. Show them your portfolio, explaining what museums collect your work.

Your work must be illuminated to the prospective customer, praised, explained.

Never ask a question of a potential client that can be answered with a simple "Yes" or "No."

187

CLOSING A SALE

Selling must be practiced, just like the art of the phone, or tennis or bowling.

When it comes down to the nitty-gritty, you have to feel comfortable with your closing. You have to do what is natural for you. Adding a little intelligence to the matter never hindered. Don't be too passive during the closing moments. People can like a passive, timid type, as he or she is less threatening.

CLOSING LINES

➤ Did you want to pay with VISA or Mastercard?

➤ Did you want me to help you choose a frame?

➤ Can I help you hang it at your office?

➤ Which one can I reserve you for? I have a red dot you can put on it.

➤ I think you are making a wise choice. Did you want to pay with a check?

➤ Why don't you take both works since you can't decide? We can do a three-month payment through your VISA.

➤ If you want this work, I would advise you to at least make a deposit so I can hold it 30 days for you. Otherwise, it might sell.

After you close the deal, shake hands and shut up! Let him say the next words!

Desire is one of the strongest motivators there is. If you have the desire to sell something because your rent is due tomorrow, you will be much more successful. Aggressive salesmen seldom accomplish more sales. Even car dealerships are finding this out. When a person likes a car, he decides without assistance if he's going to buy it or not.

SALES RESOURCES

Take a look at a few magazines such as Inc Magazine, Personal Selling Power Magazine, Success Magazine.

A Manual for Art Sales
(800) 697 8935 (760) 806 7699 (760) 806 9622 Fax
www.tbfa.com <todd@tbfa.com>
Other books written by art dealer Todd Bingham include Keeping Your People, Painting the Picture, *and* The Web for the Art Business, *each $24.95 plus shipping.*

Persistence is what makes a good salesman. An outstanding salesperson contacts a prospect an average of three times, usually within a three-to-six month period. The outstanding seller makes five to seven contacts each day.

Follow up a short time after a sale is made with a friendly call to your client. Yes! He's *your* client now. He's moved up the ladder to #1 code on your mailing list. Call to see if all is going well with his purchase. Tell him briefly about your new paintings, prints or Iris prints. Ask him if he needs any more work for his office, or if he has a friend who's been looking for art. It's a little hard at first to be forward like this. Make it friendly. Try it! They like you. They like your work. They bought from you. They're happy. Now you are connecting again emotionally so they won't forget you.

➤ After you make this call, send the client (whether she has given you a referral or not) a brief letter, 3-5 business cards, your flyer/postcard/color photocopy of your newest piece and a 10% discount coupon towards her next purchase.

➤ If the sale has been made to a business you might stop in some time to see 'How your baby's doing.' You might meet some employees and leave your business card on the front desk with the receptionist. Casually, no pressure. Send annual cards to the buyer and perhaps one to the office staff.

REFERRALS

Don't forget to ask for a referral. Many artworld professionals are glad to refer you to someone they know. Ask!

When you do receive a referral, be sure to follow up. A referral call is an easy call to make. Someone sent you and that recipient doesn't want to be impolite when an associate has recommended you. So when you introduce yourself, be sure to state who sent you. "Hi, Mr. Thomas. My name is and I was referred by Sally Parker, of Time Inc, to call you about my artwork. She thought you might be interested in reviewing my portfolio for a possible show in your corporate gallery."

Learn to chat with people. If they say something interesting on the phone, i.e., where they are calling from, what they did on the weekend, ask them something more. People love that intimacy.

Whatever the outcome, make sure you drop a thank-you note to Sally Parker for her referral. Include a couple of your business cards. Only hint for her to pass them out. If you actually make a sale to a referral, write another note of thanks and include a coupon for a discount on one of your paintings, such as "Thanks again for your

AFTER A SALE

People love to know and meet artists. Artists are special people! Be communicative!

The Mystery of Making It by Jack White will teach you how he and his wife approach galleries. This approach erned them over $3 million retail in only 11 years—$600,000 alone in 2001! Order on-line at www.senkarikstuff.com. <senkarik@senkarik.com> PO Box 2800-316, Carefree, AZ 85377 877·SENKARIK (Fax)

There is no way around investing time and energy in your prospective clients.

assistance in making my career a success. I hung a piece in Mr. Thomas' office yesterday. As a thank you for your patronage, I would like to offer you a discount of 10% on a purchase from my collection. Why don't you come by my studio sometime? I can help you decide what piece might be best in your office. Prints are now available of some of my works (flyer enclosed)." Small, personal offerings will bring successful sales.

SUCCESSFUL SELLING
BY RENÉE PHILLIPS

Stress the benefits

The selling of art begins with an awareness and expression of its benefits. Rejoice in the fact that art has communicative and healing powers; it enriches owners' lives. It has the power to educate and can alter viewers' attitudes and behaviors. When someone buys your work a permanent bond is formed. You should thoroughly savor the joyful process of sharing and exchanging it for money and recognition.

Set financial goals

Success and prosperity are subjective terms. You will attract that which you desire—however small or grand. Set a financial goal and a deadline. Commit yourself to the same high standards for your financial rewards as you do for your art. If you are frustrated with your current financial situation—good! Channel the anger into a determined effort to change. Define your sales objectives and seek professional feedback about your work and its relationship to the art market. Create a balanced, diversified plan to counterbalance your inevitably unpredictable career course. Review it regularly, be flexible, and alter it when necessary. To insure your success, include plans to share your prosperity generously with others, beginning now.

ॐ

Renée Phillips is Editor-in-Chief of Manhattan Arts International and author of New York Contemporary Art Galleries: The Complete Annual Guide and Presentation Power Tools for Fine Artists. The above excerpt is from Success Now! For Artists. She is a promotion and marketing consultant for artists, available for private consultation in person or by phone. She can be contacted at 200 E 72nd St #26L, New York, NY 10021 (212) 472 1660 www.ManhattanArts.com <ManArts@aol.com>.

RENTAL OR LEASE PROGRAMS

One of the most frequent programs I 'sold' as a rep, especially to businesses, was that of the lease. A lease is not really different from a rental, except it lasts longer than a one-month period. Suggesting a lease made it easier for me to get my foot in the door of almost any small business. It also created a flow of income, both for the artist and for myself. To my surprise, many individual company employees began to lease for their homes. I never had one piece damaged or stolen.

The consumer enjoys supporting local artists in a way he can afford but may think he can't afford an original at $3500. A quarterly fee may be within his cash flow. It's a win-win situation. Of course, you want to lease to people you feel comfortable with. Lease options work like this:

➤ The client chooses a piece he wishes to lease for a three-month period, with possible renewal of up to one year (or whatever you decide is reasonable).

➤ Delivery charge for each new piece and/or rotation of pieces is $25.

➤ The piece is leased according to its selling price, usually at 2% per month of the selling price.

Ways the lease money can go toward the purchase of a piece could be: all money paid towards the lease for the first twelve months can be applied towards the purchase price, or 60 percent of the lease fee will be deducted from the sale if artwork is purchased. In this case you might have a slightly lower lease fee per quarter and no setup charge.

Make sure you have a clear agreement signed by the owner of the company:

➤The company will be liable for damage or theft to the full price of the piece.

➤Provide a standard "Care for Artwork" sheet.

➤ Restrict where the art is displayed.

➤ Guard against risk of bankruptcy of your work by noting it is not owned by the business, only leased.

SPECIAL SALES PROGRAMS

It was a surprise for me to find that about 80% of the people I met had never before "lived with a live painting." When they spent time with their live painting, they would always rave about the beauty, many ending up buying.

PATRON PROGRAM

In the Renaissance era a patron was not an unusual possibility for an artist. In this era, artists have neglected to promote this idea.

Find a person who likes your artwork (i.e., former purchasers). Ask if he would like to participate in your career by making a $100 per-month commitment towards a new piece of artwork. He continues to pay $100 per month until he can afford a piece of your work. During that period of time he can come visit your studio, and if he sees any work-in-progress he would like to purchase (other than a commission), he can claim it as his future piece. When his monthly payments equal the piece's price, he can take it home. He also has the option of speeding up payments to pay for the piece at any time in full. Draw up a user-friendly contract to clarify all the details of your patronage program.

COUPONS

Look for preformatted coupons, three-up, at your local office supply store.

Produce a coupon to send former clients to entice them back. Do they get a 10% discount when they buy two paintings at once? Well, why not give them a 10% discount on their second painting to lure them back, or a free print with next purchase?

10% DISCOUNT VALID THROUGH 12/31/99

THIS COUPON ENTITLES _____

TO A 10% DISCOUNT ON PURCHASE OF

ORIGINAL ARTWORK

FROM THE STUDIO OF VINCENT ARGYLE

8732 MANCHESTER RD, CARLISLE, NJ (412) 697 3321

GIFT CERTIFICATES

Promote this idea around the holidays. Don't have a cutoff date. Make sure your name and address and telephone number are on the certificate so it's easy to contact you. Use preformatted note cards from the stationery store.

RENTAL AGREEMENT

Renter's Name _____

Address _____

City/State/Zip _____

Telephone _____

Start Date of Rental _____ Date Due _____ Rental Fee _____

Title _____

Medium _____ Sale Price _____

Artist/Agent Name _____

Address _____

City/State/Zip _____

Telephone _____

This agreement is subject to the terms and conditions below.

Renter Signature

Artist Signature

TERMS AND CONDITIONS OF LEASE

1. Rental period is 3 months. Paintings may be re-rented successively for one year at which time they must be purchased or returned. Rental fees can be applied to purchase price. Renter agrees to handle carefully and return on due date or pay overdue charge of $4 per day. Rental and renewal fees are payable in advance.

2. Renter shall be responsible during rental term for loss of or damage to said property from whatever cause, including fire and theft. Frame may not be painted or altered. Painting may not be painted or altered. Painting may not be transferred to another person's care.

3. At the expiration, termination or default of this Rental Agreement, Renter agrees to return said property to artist in original condition.

ACTION PLAN

❏ Attend an outdoor show to study sales techniques.

❏ Go to a gallery to study sales techniques.

❏ Study the art of getting referrals.

❏ Draw up a lease program and agreement.

❏ Draw up a patron program and agreement.

❏ Make coupons and certificates for future clients.

RECOMMENDED READING

Guerrilla Selling *by Jay Conrad Levinson*

Think and Grow Rich *by Napoleon Hill*

Ziglar on Selling *by Zig Ziglar*

Chapter 16
Advertising

Advertisement placement

National directories

Internet advertising

A master-passion is the love of news.
George Crabbe

ADVERTISEMENT PLACEMENT

The golden rule of advertising is repetition.

It's said that it takes the average consumer nine exposures to an ad before the ad is remembered. Whenever you plan to advertise you must follow the golden rule and do it a minimum of three times in the same magazine or newspaper, i.e., budget for the three-time rate.

Another rule to remember is the 25-25-50 rule. In a group of 100 people, 25 will like you, 25 will dislike you and 50 won't care. Don't waste your time on the 25 who don't like you or the 50 who don't care. Concentrate all your promotional activities on the 25 who already like you.

The approach to advertising for an individual artist is different than that for many other types of businesses. Selling original artwork through an ad does not generally work. Galleries that advertise in magazines such as *ArtNews* and *Art in America* need megabucks in their budget. These galleries are thinking of long-term promotion and the gallery's general reputation, not just of the individual show they are promoting or the sale they can make. Galleries which don't represent big-time artists can't afford to advertise in these expensive venues.

Advertising in your local newspaper or magazine does not generally bring a lot of sales. People do not buy art through an advertisement unless the artist is already known to them. If your aim is not sales but notoriety, which will lead to sales later, then advertising could be a way to go.

One big-name artist analyzed the effectiveness of his advertising in magazines in this manner: if he generates enough income just to pay for the ads themselves, the ad is worthwhile. He gains exposure and, soon, word-of-mouth will reap profits. People have seen his ad so many times it's finally sinking in. At that point he looks well established; people gain respect. That's when his ad really begins to work. If you start to advertise, you must be willing to make a long-term investment. Otherwise your money is essentially lost.

• One artist rented a billboard for two months in his small town. He painted on it for four hours daily. By the time he was done, everyone in town knew his name and his style. Not only had they seen it on the billboard, but he had major write-ups in the local press as well as national papers. Galleries called him. He took a risk and it worked!

• Another innovative artist put her art images on a software program that plays them as a screen saver. Though she is selling this, giving it away to customers and potential customers would be a good promo idea.

TV

You might check into the possibility of local cable TV. You can get a lot of notoriety from a 30-second local TV commercial. One artist advertises on local prime-time CNN. She says when she goes to the store wearing the same jacket as in the commercial, people recognize her and say, "That's the artist." That's exactly what you're aiming to do. No direct sales, simply notoriety. You carry your business card with you and invite them to your next studio show.

CROSS-MERCHANDISING

You can get your name out in many formats these days. Make a calendar for as little as $5 each, print t-shirts, mugs, almost anything. This type of image placement is a form of advertising. I wear t-shirts with my book covers inscripted on them when I do a trade show.

NATIONAL DIRECTORIES

Showcase directories for graphic designers and illustrators have been around for many years. In 1986, showcase directories of fine artists came into being. These advertising venues display a typical piece of an artist's work, along with bio and contact address, giving artists a wide exposure to fine art professionals they otherwise could never reach.

DIRECTORIES

Living Artists
ArtNetwork, PO Box 1360, Nevada City, CA 95959 (800) 383 0677
www.artmarketing.com/Ency <info@artmarketing.com>
A high-gloss bi-annual publication advertising artist's work. Eight thousand are sent complimentary to artworld professionals (in odd-numbered years) such as reps, consultants, dealers, galleries, museum curators and private collectors. Sold in Barnes & Noble. Contest is conducted for cover showcase.

ArtFolio
ArtNetwork, PO Box 1360, Nevada City, CA 95959 (800) 383 0677
www.artmarketing.com/artfolio <info@artmarketing.com>
This bi-annual booklet, spiral-bound and 6x6" in format, is sent out every other year (in even-numbered years) to 4000 art publishers, book publishers, greeting card publishers and licensors.

New American Paintings
Open Studio Press, Steven Zevitas, 450 Harrison Ave #304, Boston, MA 02118
(617) 778 5265 www.newamericanpaintings.com
A series of six regional books showcasing fine artists.

Guide to Artists
Decor, 330 N Fourth St, St Louis, MO 63102 (800) 867 9285 (314) 421 5445
<decor@cpcmags.com> www.decormagazine.com

Guidebook of Western Artists
Art of the West, 15612 Highway 7 #235, Minnetonka, MN 55345
(612) 935 5850

Art Collectors Edition
Wildlife Art News, PO Box 22439, Egan, MN 55122-0439 (800) 221 6547

Artist Showcase
Equine Images, PO Box 916, Fort Dodge, IA 50501 (515) 955 1600
www.equineimages.com
Comes out in the February-March issue. Deadline for placement is December 2 of the previous year.

REPRINTS

If you place an ad in one of these directories (or a magazine), check into buying reprints of your page. A reprint is an exact duplicate of your piece in the book/magazine, sometimes blank on the second side. Usually the cost is small relative to the normal cost of a full-color flyer.

INTERNET ADVERTISING

You do not have to own a computer to advertise on the Net!

If you already have clients throughout the country, and some are connected to the Internet, it might be worth getting a home-page. Then you could keep them updated on your new works by putting up new pieces on your home-page. You can have a company (such as ArtNetwork) upload your artwork, or with a lot of training and time, you can learn how to do this yourself.

ADVERTISING VENUES

Following are only some of the possible art sites to be listed with. Be sure to view them before you make a final decision. They vary quite a bit, not only in features but in prices.

- artmarketing.com/gallery
- art.com
- art-connection.com
- artinsider.com
- artistsregister.com
- artmall.com
- artnet.com
- barewalls.com
- b17.com
- cdiart.com
- digitalartmuseum.com
- ExperienceArt.com
- findmeanartist.com
- fineartoutlet.com
- fine-art.com
- guild.com
- iTheo.com
- justoriginals.com
- NextMonet.com
- onlineart.com
- paintings.com
- paintingsdirect.com
- scultura.com

If you're considering putting up your own site—learning how to create your own home page—think twice. It is a big task and could take vauable time away from your other marketing and creating. If you hire someone to do it (other than a friend or for a trade) it can cost big bucks.

If you do create a site keep it simple so it's fast to download.

Advanced internet marketing will be discussed in a forthcoming book from ArtNetwork, out in 2001. You can also acquire a copy of *ArtSource Quarterly*, Summer 2000 ($6/$19 per year.... 800 383 0677) which covers pertinent Internet issues for fine artists.

ACTION PLAN

❑ Check out some national fine art directories of artists.

❑ Investigate the experiences of other artists who have advertised on the Internet.

❑ Brainstorm some effective advertising possibilities.

RECOMMENDED READING

Body Language _by Roberta Smith_

Customers for Life _by Carl Sewell & Paul B Brown_

The Seven Habits of Highly Effective People _by Stephen R Covey_

Teaching the Elephant to Dance _by James A Belasco_

Chapter 17
Pitching the Press

Press releases

Formatting a press release

Meeting the press

National publicity

Everyone gets 15 minutes of fame.

Andy Warhol

PRESS RELEASES

To be known as an artist, you have to put yourself in a position to become known! You want the public to hear your name over and over again. The aim of the press release is not necessarily to make sales, but to conjure up interest, memory and acceptance of your work, and possible attendance at an exhibit.

Andy Warhol clearly understood the power of publicity. Carmen Miranda made great use of it's power. This power, however, is often overlooked by artists. Artists must learn to understand the importance of 'courting the press.' To be the feature attraction in a positive article in your local newspaper will say to the public that you are accepted. It imbeds confidence in potential buyers.

A press release is the most common source of communication with a magazine or newspaper editor. Publicity you receive from a press release is free. It will get your name out to the public, where eventually your reputation will broaden and you will become known.

Whenever there is a special event in your artistic career, notify the local art critics and newspapers about it. What is a special event? An in-person signing, an exhibition, winning a prize, the receipt of a public or private commission, a tie-in with a local charity, a donation of artwork to a nonprofit organization, teaching a course at a college, giving a class/workshop/seminar, a new method of painting you've discovered, a book you've written, a sale to a famous person, a grant award.

This type of press release might lead to a review of your work by a critic, an article about the topic, or a brief blurb excerpted directly from your wordage. If you do receive a review from an editor or critic, more likely than not it will be a favorable one, one which you can add to your portfolio, one that a gallery owner will notice.

The 'pitch' to the press (i.e., the press release) needs to be innovative and imaginative. Editors are bombarded by hundreds of press releases every week. Most editors complain about how incredibly b-o-r-i-n-g press releases are. You want to make your press release stand out in someone's memory.

It's okay to use gimmicks, but don't be too original. You might defeat your purpose. Instead of putting a dab of glitter on a letter, one artist filled her folded sheet of paper with glitter. Editors did not appreciate glitter falling in their laps when they opened the envelope.

FORMATTING A PRESS RELEASE

You want to look professional when you send a press release to an editor, so you're going to imitate the big pros. Follow the outline below.

For Immediate Release - These words are placed in the upper left or right corner of a press release. Do you want this piece to run March 29? Then note FOR RELEASE ON MARCH 29 at the top. Don't pick a very popular date, however, as there might be too much competition. Most releases say "FOR IMMEDIATE RELEASE" without a specific date.

Contact Person - Underneath "FOR IMMEDIATE RELEASE," put your name (or your publicity agent's name), phone number (even though it's on your letterhead), and if necessary the time of day to call. Make it as easy for the editor as you can.

Headline - You must think of a good, catchy title for your release. Make it clear and enticing. All caps and centered.

Body Copy - The 5 W's:

Who - State your business name and/or personal name.

What - Is it an opening, an exhibition, an open studio, etc.? Can you quote someone here, or give a testimonial with a celebrity? People love to read testimonials.

Where - State the exact address, city, state, zip code, telephone number and directions to an event, if necessary.

When - State the exact hours, day of week, month, year.

Why - The main topic of your press release.

Place the symbol "# # #" at the end of your release to indicate that there is no more copy. If there is a second page, type "MORE" and continue on second page. If you do use a second page, type "22222" (five repetitions of the number 2) at the top (just another idiosyncrasy of a news release!). You may add a note to the editor after # # # such as "Free photo upon request."

FORMATTING TIPS

➤ Double-space with wide margins so the editors can make notes easily.

➤ Make it concise—no more than one page. You are more likely to get coverage with a one-page press release than a two-page release. A small amount of information will more likely be easier to fit somewhere.

Often an editor will use your press release verbatim to fill a blank spot on his pages. If he does any editing, it's generally from the bottom of the page up.

➤ Send B&W photos. Newspapers know their readership love to see pictures. Including a B&W photo will up your chances of getting printed about 50%. Making it an intriguing photo will get you publicity for sure!

➤ Have color photos available for magazine publicity.

➤ Start with local media. Cultivate the same media contacts consistently by sending updates on your career.

➤ Read what your target media reads. Study the publications to see what is publicized. Then write your own story.

➤ Try to get publicity if you get involved with or make a donation to a charity or professional organization.

➤ Get on the publicity committee of an art organization. This will help you meet the press.

➤ Follow up with phone calls, persistently but not harassingly.

➤ Know the names of art editors and reporters.

➤ Know the requirements of any given publication.

➤ Include correct telephone number and address in the body of the press release copy. Proofread all!

MISTAKES OFTEN MADE

➤ Using graphics in your press release.

➤ Expecting immediate results.

➤ Being a pest.

➤ Sending out poorly-edited materials.

➤ Exaggerating and using superlatives or too many fancy words.

➤ Being intimidated. The editors need your help!

RESOURCES

Midwest Photo
4900 G St, Omaha, NE 69117 (800) 228 7208
Quantity B&W photo reproductions.

SAMPLE FORMAT FOR PRESS RELEASE

Contact: Name
Telephone number

FOR IMMEDIATE RELEASE

HEADLINE TO HOOK EDITOR AND PUBLIC

Paragraph 1 The 5 W'S

Paragraph 2 More details of importance to the public

Paragraph 3 Background info

Paragraph 4 Address info

#

Keep copies of publicity photos on hand. Remember that story-line you sent your local editor? Well, it resurfaced and they want to do a short story. No time for a photographer to come out and photograph you. He needs the 5x7" sent today!

STORY-LINE

A more advanced form of a press release is called a story-line or feature story. This type of story needs a hook, or a unique angle of human interest. You need a story that is new, different, and that the general public will be interested in. Is there anything happening in the current news that is a hook to what you do? A holiday or anniversary to use as a connection? Write down ideas. Brainstorm for more ideas. Don't stop at just one! Write each idea on a separate piece of paper, adding both conservative and wild ideas until you come up with the hook. These kinds of stories are often carried by large local newspapers in the Sunday edition, so go for it!

• One artist created her paintings in her barn, wearing gloves during the long winter months. This somewhat simple, but unusual, story got her front page coverage in the Arts Section of her local newspaper.

• One artist sent a small bottle of 'golden wine' to his local press of seven people. His exhibit was entitled "The Gold Country." Needless to say, he got a good response! It was also easy to follow up with calls to the editor because everyone remembered his gift and welcomed his calls.

CLIPPINGS

When you get press coverage, be sure to save the clippings from the newspaper for your files. Don't, however, include the original newspaper clippings with your portable portfolio. Instead, cut your article out, along with the name of the publication (masthead) and the date. Arrange these clippings on an 8½x11" sheet in a nice layout. You might need to reduce or eliminate part of the newspaper copy. Make the piece look tidy. No one ever reads the entire copy.

Make photocopies for your portfolio. These photocopies are to show those you are trying to impress—a consultant, gallery, collector—that you are well-received by the public, and indeed that you have a public! "I've gotten press! The public accepts me. I am recognized as an artist. My art is good."

The best place to start meeting the press is right in your home town. As your career proceeds, you must become familiar with the editors of your local publications, eventually meeting these editors in person through events that you attend.

LIST OF EDITORS

Your list of editors should be compiled in a methodical manner. Make a file card for each publication and each editor, with information on the closing dates for receiving press releases. Knowing the editorial deadlines could be the most important point involved. Monthly and weekly magazines have longer lead times than dailies, so you will need to send them earlier than to local newspapers.

Don't forget to include in your list the specialty publications in your area such as: gallery guides, shopper guides, entertainment guides, neighborhood weeklies, alternative publications, religious newsletters, sports club publications or civic publications. Because their budget and staff are limited, these smaller publications use lots of press releases.

THREE MAILINGS

It is often necessary to send editors and important reviewers three mailings.

1. **A press release.** Two months before the event. If you haven't previously sent them a portable portfolio, do so at this time.

2. **A personal invitation.** One month before the event.

3. **A postcard reminder.** Two weeks before the event.

If you are sending a press release for an upcoming exhibit, a reviewer might not want to come to the actual opening. He might want to view your work in a quieter setting—before or after the opening. Some artists suggest that the reviewer contact them for a personal tour of the exhibit. You could note this on your second postcard.

A phone call one week before an event can be an added incentive for an editor to respond. Even a message on an answering machine might do the trick. Taking the time to personally invite the editor or critic to your opening or event can better the chances they review your work by 75%.

MEETING THE PRESS

Establish a calendar for various press deadlines.

You might want to frame some of your press coverage. Blow them up and mount them on your studio wall. It is impressive when you have an open studio. People like to see that the press has accepted you!

It is infinitely better to send out publicity and not have it used than to not send it out and miss an opportunity for it to be used.

PERSISTENCE

Publicity must be constant. As one editor put it, "Think of yourself as the publicity director for a movie star." Persist, persist and then persist some more. When you continually send out new and exciting releases, it tells editors that this person means business! They take you more seriously.

FOLLOW-UP

➤ Try to speak to an editor personally.

➤ Try to catch an editor when he is not rushing to meet a deadline. Morning papers should be called mid-morning, afternoon papers mid-afternoon, TV after a broadcast.

➤ If they give you coverage, be sure to call and thank them or drop them a thank you note, or both.

I tried to get one of the artists I represented on a special news sequence once. The producer was interested, but he constantly needed to be reminded. TV is a hectic environment. Finally, after 10 phone calls, without our being forewarned a camera crew showed up for six hours one day to film the artist at work in the restaurant where he was restoring the cherub murals on the ceiling. A one-minute spot was on the news that night. Later we used the tape, along with another one he had from years before, on a VCR at an exhibit. People were quite impressed to see him on the news. It really meant something to them!

PHOTOS

Providing an outstanding or unusual visual will almost always get you PR. You know the old adage, 'a picture is worth a thousand words.' How many of us go through the newspaper "reading" the pictures?

Send a newspaper 5x7s". Before sending you will need to label the back of the photo. Do not write directly on the back as it might leave marks on the front. Write on a label, then adhere it to the back. Place the title of the photo, your name, medium, date taken, © and name of photographer who shot the photo.

Too many artists jump to regional or national promotional projects without having 'paid their dues' with local promotion. By establishing oneself locally, confidence, clientele and experience are built. When you finally expand regionally or nationally, you will be ready to hurdle the blockades that everyone experiences. National promotion is much more complicated, has more intricate politics and needs a great deal more money up-front than local promotion. Every aspect takes a lot longer.

Research is a must. Doing your homework saves time and money and lowers the risk level of the endeavor. For national sources of publicity, look in your library at the most current issues of: *Artist's Market, Gale Directory of Publications, International Yearbook, Media Guide, Bacon's Publicity Checker, Standard Periodical Directory, Editor and Publisher International Yearbook, Working Press of the Nation, Newsletters in Print, Oxbridge Directory of Newsletters, American Art Directory.*

Even very famous artists go after publicity whenever they can. Rauschenberg hired a PR firm when he had a retrospective at a museum. The museum had attempted to get him some local PR, but he wanted national PR. He knew that if he spent money on some PR his name would receive more world-wide recognition.

Keep in mind your particular style, medium and subject matter when looking for a source of national publicity. Are you a connoisseur of tulips? There are tulip societies, and thus magazines, that might be just the right place to start rounding up clientele.

When you learn about appropriate national magazines for your genre of artwork, send the editor a story-line-type press release. The key factor, remember, is the relationship between your subject matter and the needs of these editors.

Editors need news to produce their daily/weekly papers. Lots of pressure is put on editors to find new and exciting material. If you help an editor by providing him with a story-line, you'll be 100% ahead of the game. You will have a pal for life. Follow up. Remind him. Get to know him. You will get coverage.

NATIONAL PUBLICITY

Almost all artists who are selling nationally began and are still selling locally.

ACTION PLAN

❑ Think of some story-lines for press releases.

❑ Write a press release based on one of these story-lines.

❑ Write a press release based on a future exhibition.

❑ Compile a list of local press, noting deadlines for sending releases.

❑ Send a press release to the local press.

❑ Follow up with phone calls.

RECOMMENDED READING

Bullet-Proof News Releases *by Kay Borden*

Fine Art Publicity *by Susan Abbott*

The Fine Artist's Guide to Marketing and Self-Promotion *by Julius Vitali*

Getting Publicity *by Tana Fletcher and Julia Rockler*

Guerrilla PR *by Michael Levine*

How to Get Results with Publicity *by Communication Briefing*

Marketing Made Easier: Guide to Free Product Publicity *by Barry T Klein*

Marketing without Money *by Nicholas E Bade*

The Publicity Manual *by Kate Kelly*

Writing Effective News Releases *by Catherine V McIntyre*

The Zen of Hype *by Raleigh Pinsky*

Reps and Galleries

Reps

> *Locating reps*

> *Approaching reps*

The gallery scene

> *The gallery search*

> *Approaching a gallery*

Showtime

Alternative galleries

All children are artists. The trick is to remain an artist and grow up. Pablo Picasso

REPS

Those who learn to take care of their own interests usually surpass the achievements of those who turn their affairs over to others.

"Where can I find a rep?" is one of the most common questions I get from artists. Finding an active art rep can be a dream-come-true for a fine artist. Having a rep ideally means the artist can concentrate on the creation of art instead of dividing time between creation and marketing.

Locating a good rep takes time. Often a rep doesn't want to take on an artist who has no experience working with people, no sales record or a previously acquired reputation.

There are several types of artworld professionals who are often overlooked by artists. We will define some of the people in this arena who can help further your career.

ART REP

A person who usually takes on no more than 5-10 fine artists and represents their work to specific companies, galleries, publishers, etc. Sometimes a gallery acts in this capacity, sometimes the wife, relative or friend of an artist. Most artists fantasize about having a rep, yet most do not have one. In the last several years, however, it has become a more recognized profession. It appears that in the near future the fine art representative will be a better-known figure. For the right person, it is a lucrative and satisfying career. They often get 33-50% commission. The rep might also assist with other business aspects, such as bookkeeping and legal matters.

ART CONSULTANT

Art consultants are usually hired or contracted by businesses or private individuals to help locate and evaluate works of art. They are in touch with a variety of people and need a variety of works. They deal actively in art—it's their livelihood. In today's market they are the most common go-between to the corporate art collection. They could be involved with new buildings, remodelling, dealings with large corporations, book publishers, art publishers, museums, private collectors, galleries, developers and planners. They often work with state and federal agencies in the Percentage for the Arts programs. Generally each consultant has a specialty market with which he deals. Many deal internationally. A fine art consultant takes a less active role in the life of a fine artist. The business relationship can develop into a great working partnership for an artist, however.

Art consultants often are art history majors in college. They are experienced in the ability to interface client and artist, and know how

to orchestrate a project from conception to installation. They also may be responsible for cataloging, management and maintenance of such projects. Often they are the instigator of books of art for corporations.

They often take 33-50% commission on projects. Sometimes the corporation they are working for pays them a commission, thus buying from an artist/gallery at full retail. They make studio visits and monitor payment schedules. If there is a commissioned project, the consultant will see the project through to the end.

ART BROKER

A person who connects a buyer and seller, perhaps at a trade show, through former connections, etc. This person does a lot of networking, could even be an auction house. Commission varies from 15-50%.

ART DEALER

Sometimes a gallery owner, but may be a person who has many connections in the artworld and buys and sells works privately. Commission is usually in the 40-50% range.

ART MANAGER

Managers are often paid by the hour. They might do a specific type of job for the artist: bookkeeping, managing contracts, writing contracts, grant proposals, or a variety of these, including public relations.

PUBLICIST

Usually hired by the hour or project for promotion of a specific exhibition or museum opening. Often well-known artists will hire such an agency.

INTERIOR DESIGNERS

Many artists don't consider interior designers to be buyers of art or reps of artwork. Many love art, have an eye for art, and if they like and appreciate your art, could be just the right person to get your career going. I know several artists who work almost exclusively with interior designers. You might think it's always a case of matching a painting to someone's furniture—but this is just another myth. Check out interior design shows or home shows in your area. Many artists exhibit at these and make connections with designers as well as individuals interested in art.

An artist consultant is a person who works with individual artists to guide them in their careers. They will critique artwork as well as help with marketing plans and suggestions. They generally give private consultations to artists as well as conduct seminars and workshops.

Some artists have given talks at ASID luncheons to introduce the local chapter to their artwork.

Connecting with an active interior designer could bring you many sales. Interior designers must meet an increasing demand for original art in commercial and residential buildings.

LOCATING REPS

Ask for references from other artists. Talk to several reps to get a feel for who they are and what they do. Find out their philosophy. Did they write a book or magazine articles? If they have, read them. Make sure agreements are finalized in writing. If they promise you too much, don't believe it.

RESOURCES

ArtNetwork
(800) 383 0677 (530) 470 0862
Mailing lists of reps, consultants, dealers, brokers and corporate art consultants.

Art in America
(800) 925 8059
They have an annual directory, coming out during the summer months, which lists reps as well as galleries by geographic location. You can also get these names in a mailing list or diskette format.

Chicago Artists' Coalition/CAC
11 E Hubbard St 7Fl, Chicago, IL 60611 (312) 670 2060 (312) 670 2521 Fax
www.caconline.org
Has a list of Chicago-area reps and consultants for $3.50, as well as other publications and a monthly newsletter for members.

American Society of Interior Designers/ASID
(202) 546 3480
May have a current list of projects and firms specializing in commercial buildings. Call Washington, DC to ask for the number of your regional office of ASID.

APPROACHING REPS

When professionals like those mentioned above work with you, they expect you to be professional, too. They want artwork finished on time, and in accordance with any agreement. Of course the more you are asking for your work, the more tolerant they seem to be toward your idiosyncrasies. Once you show you mean business by performing well and on time, they are more likely to call upon you again.

When and if you do find a good rep, you will deal with her via legal agreements. Don't think it's going to be a breeze. Pressures inevitably come when you are working in a new situation.

There is a lot of competition to win over reps and consultants. You must outshine other artists, not only in your artwork but in your professionalism:

➤ Begin with a telephone call to introduce yourself.

➤ Ask if you can send some samples of your work. Be sure to send something they will remember—something outstanding.

➤ Follow up with a friendly call to find out their response to your work. You must create rapport with each consultant.

➤ Be sure to add their name to your mailing list so that you can send them notices of your future exhibitions. They want to see that you are active.

"Should I go with this publisher, rep or gallery?" Trust your heart and do your research. If you don't trust you dealer or gallery, you should never start working with them. Go with your gut feeling. You might be wrong, but it's all you really have to go on. If you have any odd feelings about developing a new relationship with anyone in the artworld, don't do it!

Even if a rep is handling your art deals, you will want to keep tabs on what is going on in the artworld. So study, research and help your rep! Work as a team.

One artist I know sells his pieces for up to $25,000. He does have a gallery affiliation—a very well-known gallery in New York City. I asked him why he stays with a gallery that neither sells his work nor gives him a show. He stated, "It sounds good to be listed with a gallery which has prestige, but I'd rather sell my own work because I make more money. I want them around, though, for when I become famous and too busy to sell my own work. Then they will want to give me a show."

You might not realize how few people walk through any given gallery in one year. Not many! Do you know how many average people who like art have never been in a gallery? Start asking and you'll be surprised. Most people find galleries overbearing, stiff and snobby and don't feel comfortable being in one, let alone looking at the art and considering buying it. So you're missing a huge hunk of the market if you think galleries are the only way to go.

Artists often approach galleries 'before their time.' Most art dealers want to represent artists who have already achieved critical recognition and have a substantial number of clients.

I advise artists to search for possible galleries in a reserved manner. They are generally listed last on any of my recommendations for possible venues to show work. Unless you are the number one person represented by the gallery, there are many drawbacks.

Galleries often don't seem to respect artists. They pay them late, do not repair damaged artwork before returning it, sometimes do not even return work to the artist. I cannot tell you the number of stories like this I have heard about galleries. Of course, there are some great gallery owners out there, too, but I've only heard a few stories about them. Do you know any stories about responsible gallery owners? I'd love to hear more.

A gallery can only promote a small number of artists at any given time. They want to promote artists who are easiest to sell. If you don't fall into that category, they might just be storing your work rather than attempting to sell it.

There are also many myths held by artists about galleries:

➤ Galleries make or break an artist.

➤ You must be represented by a gallery to be a real artist.

➤ Galleries pay artists on time.

➤ Gallery owners are good business people.

➤ Gallery owners are organized.

So you've found the right gallery, but they want 50% of the cost of sales? Wow! You didn't know they took that much? Remember that open studio exhibition you put on? Or that group show you held?

THE GALLERY SCENE

If you're an artist looking for a gallery to carry your work, you need to think creatively and professionally. What is it that will set your work apart from all the other artists searching for a gallery?

The cost? Generally the gallery owner has even more costs due to higher rent, more upscale clientele, etc. So if you cringe at 50%, don't even approach a gallery, or for that matter a rep. Just do it all yourself!

THE GALLERY SEARCH

Make a list of 20 local galleries to review. When you visit the galleries, jot down all the information you can about each one. From your research, decide what gallery *you* want to be in.

Focus on galleries that have proven track records and carry work compatible with your own. When it comes down to the final choice, you want to know that the gallery is going to invest in your career. They should be the first to buy a piece from a show. If you get the gallery to commit financially—buying work, framing, spending time with an exhibit, press releases, etc.—you know you have a good gallery.

FACTORS TO INVESTIGATE

➤ Styles they carry

➤ The price range and the career status of the artists they represent. You don't want it to be too far out of the range you are presently selling in. If they have very established artists selling for $15,000 and you are just beginning to approach galleries, is this going to work? Probably not. Generally you have to have similar price ranges.

➤ Customer service you receive as a visitor to the gallery

➤ Mood, atmosphere, lighting

➤ Location, foot traffic

➤ Verify the reliability of a gallery through the Better Business Bureau, Chamber of Commerce or Artists Equity Association in your area.

➤ Get references from artists whose work the gallery is currently showing. When you give a gallery your artwork, you either want to receive the work back or the money for it! Check the Better Business Bureau to see if any complaints have been filed against the gallery, and see whether they belong to the Chamber of Commerce.

The most common way an artist gets known by a gallery is through the recommendation of a friend.

➤ When a gallery takes you on, they should give you a solo show within a year and buy at least one of your artworks. What are you there for otherwise? They are investing in you!

➤ Try to make connections with the gallery by getting on their mailing list and attending openings. You're going to choose the gallery and sell yourself, your work and your story to them. When you know you've found the right gallery for your work, 'court' them. Send them cards, attend openings, etc. It will take persistence—but we've already verified that persistence pays off. Ideally, a gallery owner will have seen your work in local exhibits over the past years and will know about you.

A good way to meet gallery owners is through charity balls or fundraising events. Gallery owners are bombarded by artists introducing themselves over the phone or in person. Show that you are involved in your community. Introducing yourself via a roundabout way like this can be the best path to becoming acquainted with a gallery owner, museum curator, etc.

REFERENCE SOURCES

Art in America Annual Guide
575 Broadway, New York, NY 10012 (212) 941 2870
This directory lists by state (then city): galleries, consultants, museum curators and other art world professionals. It can be found on most magazine stands in the summer months. As a subscriber you receive it free.

New York Contemporary Art Galleries: Annual Guide
(800) 383 0677 www.artmarketing.com/nygalleries
Great guide to the NY gallery scene, updated annually. $23.95 ppd.

Artists Gallery Guide
(800) 383 0677 www.artmarketing.com/chicagogalleries
Guide to Chicago galleries. $23.95 ppd.

Collectors Guide
Wingspread Inc, PO Box 13566, Albuquerque, NM 87192
(800) 873 4278 (505) 292 7537 www.collectorsguide.com
A beautiful publication listing galleries in New Mexico.

Art Now Gallery Guides
PO Box 5541, Clinton, NJ 08809-5541 (908) 638 5255
www.gallery-guide.com
Consolidated international version as well as regional versions.

If you haven't noticed by now, it's a long road to winning over a gallery owner. Be patient. Many artists finally get in a well-known gallery after 20 years of emerging!

Your aim in sending a portable portfolio to a gallery is simply to get the director to your studio to view your work.

APPROACHING A GALLERY

One of the most common complaints we hear from gallery owners is that artists come to them seeking representation before they are sufficiently prepared.

➤ Too little experience—they want maturity in the work.

➤ Not high-quality work.

➤ No body of work to show—they want to see direction and consistency.

➤ Showing work to the wrong genre of gallery, a very common error and waste of time.

➤ Artist has not found his or her voice yet.

After researching diligently, consider in-depth the approach you will take to each gallery. Offer the owner something unique—in quality, style of work and presentation.

➤ You've done your homework and should know what to show a particular owner.

➤ You know what you want and do not want in a contract.

➤ You're confident, but not overly. You come from a professional basis of wanting to work in partnership with the gallery owner. It's a win-win situation. No whining to gallery owners allowed!

After your initial telephone call, you send a snazzy portfolio, not costly—but different than anything they've ever seen. Show how your work is set apart from others. Adjust your basic portfolio for each gallery you contact. Be sophisticated in your presentation as this may be the only introduction you have to the gallery. It must be coherent and consistent. If they cannot perceive quickly and easily what type of work you do, they will return the slides in your SASE without even looking at them.

TIPS

➤ State briefly in your cover letter why you think the gallery is the right place for your work. Did you see an exhibit? Did someone recommend you? Follow up with a call to see what the gallery owner thought, and, hopefully, to arrange for a studio visit.

➤ Don't ask for a show or suggest the gallery represent you. Suggest they come to your studio to view your work, even if you're out of town.

➤ If you are out of town, let them know when you will be in their area.

➤ Never send an unlabeled slide or breakable glass slide.

➤ Don't wrap slides in cardboard and then tape them shut with Scotch tape. Simply put them in a slide sleeve. Better yet, start by sending photos.

➤ Enclose a SASE for convenient return of your portfolio. Gallery owners *don't* like to pay for return of your slides and portfolio unless they've requested it to begin with. It is implied that there will be enough postage and an envelope of sufficient size to fit in all the items that the sender wants back.

➤ Give the gallery owner four weeks to review your slides and get them back to you. If, by that time, they have not called or returned them in your SASE, call them, but don't be pushy.

MEETING THE GALLERY OWNER

If and when you finally do get an interview, go prepared. Reconfirm your appointment the day before. Arrive ten minutes early so you can relax.

Don't show your work to a subordinate of the gallery owner or manager. This is a waste of time. Take the attitude that you are interviewing the gallery. Do you want to work with them? Don't play the part of the desperate, struggling artist.

Never go into a gallery to show your work without an appointment. Although I have heard stories where this technique has worked, don't count on it! Count, instead, on points against you.

The business relationship between a gallery and artist must be based on mutual self-interest and trust. If this is not the basis, you can count on it failing.

Dealing with a gallery is a two-sided affair. You cannot abandon them and leave them totally to their own devices. They need to receive calls and communiques, know you appreciate them.

ITEMS TO BRING

➤ Documentary portfolio and slides (with original reviews, exhibit announcements, etc.)

➤ Price list with retail prices

➤ Several original pieces of your work (if not too burdensome). You should be ready to leave these with the gallery owner on consignment. If you do leave any pieces, you must receive a signed receipt stating the retail price to the collector, the gallery's commission, and the condition in which work was received. Bring along a consignment receipt in case the gallery owner doesn't volunteer this.

Usually you will not be accepted into a gallery on the first interview; in fact, I would be suspicious if that happened. Galleries need time to share their review with other gallery owners, see what their schedule allows, and just plain think over your work.

Even if you do get accepted into a gallery, it doesn't mean you're going to have a solo show or any type of show. If it's not in your contract, don't count on it. Artists call me very excited about their acceptance into a gallery, only to find out that they won't be receiving a solo show. Some owners get greedy and don't want the gallery down the block to show your work—so they sign you up without guaranteeing you anything, just to keep you out of the marketplace. Make sure you have a contract you understand and like.

If you are rejected, ask for referrals. What do you have to lose? Gallery owners around town have lots of information on other gallery situations. They might send you to just the right spot, or tell you that you're not ready and why.

Should you be rejected, send a card of thanks. Maybe a handmade card will grab them and let them "rethink" about you. Be different from the other artists who just take a 'no' sitting down. Show them you are still interested. Get on the gallery mailing list so you can attend openings. At future openings, reintroduce yourself to the gallery owner and directors. Start networking. Never bring your artwork or portfolio to an opening; that would be too intrusive.

Make notes after your meeting with any gallery owner. Note general feeling about gallery, artwork quality in gallery, price range and subject matters, your general impression of the exterior of the gallery, foot traffic, how long the gallery has been in business, quality and type of shops nearby, etc.

THE TRUTH IS IN THE HANDSHAKE

Wondering about the truth of your meeting? What did the gallery director really think? How does he feel about you, your artwork? One way to tell—if you are a sensitive and deliberate type—is by the hand-shake and eye contact. Okay, you shook hands when you met? You didn't? Well, you should have! Offer your hand the moment you are introduced. Now it's the end of the session, and to tell the truth you don't know where the gallery director is coming from. He's nice and says he'll be back in contact, but you just don't know. When you shake his hand this time, be sensitive to what is occurring. No grip? No power? No eye contact? No sincerity. Well, there's your answer! This is an indicator that almost all people overlook.

When your art is accepted by a gallery, your job is not over. You have to keep on top of the gallery to keep them promoting you. One gallery or one show isn't going to make or break you. Your career is built upon a series of exhibitions, sales, awards, and commissions.

STUDIO VISIT

If galleries are interested in your work, they will probably want to make a studio visit. If they don't invite themselves, be sure to invite them. Having the gallery owner make a studio visit is better than visiting the gallery. They are now making the effort to come to you and see *all* your work, your history, your story—who you are and what you create—a big coup for you.

➤Give simple, clear directions to your studio. If you live in the wilderness, ask them to call you from a nearby, easy-to-find phone, meet them there, and escort them to your studio.

➤Have a tidy studio. You want them to see your work and you, not the dust and clutter you haven't cleaned for months.

➤Have some refreshments available. Alcohol is a good way to get them (and you) relaxed.

➤Hang your best works in prominent positions. If there is any-thing you *don't* want them to see, take it completely out of the studio.

➤Allow the gallery owner to conduct the interview. You are not selling at this time; you are simply showing.

➤Be prepared for questions such as: your major influences, sources of imagery, your medium.

SHOWTIME

If and when a gallery wants to give you a show, be sure to find out:

➤ How long has the gallery been in business?

➤ Does the gallery have a statement of its goals?

➤ Who has shown in the gallery in the past?

➤ Who handles PR for openings?

➤ Who pays for invitations for openings?

➤ Who pays for refreshments for openings?

➤ When will your reception be?

➤ Will your show be advertised?

➤ Deadlines for press release information?

➤ Do they have insurance for theft, fire, flood, handling damages?

➤ Who pays for framing, shipping?

➤ What is the commission on your pieces?

➤ How will they pay you?

➤ When will the work be selected for the show?

➤ When will you need to deliver your work?

➤ What date will the show be hung?

➤ How long will the show hang?

➤ When will the announcements be sent?

Even if you are having only one show at the gallery and you are not being officially represented, you need a contract. Many gallery owners don't want to sign contracts. But you do! Don't ever agree to show your work at a gallery without a contract. You are a business person who knows your rights. Have a contract ready.

Include an inventory sheet in your agreement. It's not that uncommon that a gallery should suddenly claim bankruptcy, the sheriff close the doors and seize the property. Without a consignment agreement you could have a big problem retrieving your work. Add to your original consignment as necessary when you bring in new artworks and take away or sell others. A consignment agreement should list the

title, medium, size, overall description, perhaps a picture, date left at gallery, name and signature of gallery owner, your name and signature. A consignment agreement states that art shall be held in trust for the artist's benefit and will not be subject to any claim by creditors.

One artist in Florida had his work at a gallery that closed its doors suddenly to bankruptcy, not even informing its artists of the situation. The police came in, claimed all the goods (finding no consignment agreements) and eventually auctioned the artwork off. A restaurant purchased the entire collection of one artist for quite a small sum. The artist didn't know about any of this, as he wasn't doing his part and keeping in contact with the gallery. One day he walked into the restaurant and saw all his paintings on the wall. He was quite excited. A big sale! He called his gallery only to find that they had closed due to bankruptcy. The only way he could recuperate his work was to prove that he had a consignment agreement—which he hadn't bothered to procure. He never got a cent for his pieces!

Make it clear in your gallery contract that it is legal for you to make sales from your studio. You have clients you have dealt with personally for years, and you still want to service their needs. If a gallery can't understand that, they are simply greedy. You do not undersell the gallery; you sell at the same price.

You must comply, however, with the fact that the gallery receives a commission on sales you make from your studio that were referred to you from the gallery, either indirectly or directly. This is called "working with a gallery." If a collector sees your work at a gallery and traces your name through the phone book, solely to get a reduced rate, they will be sadly disappointed. Firstly, your studio price is the same as the gallery, and secondly you know they found you via the gallery, so you will be giving the gallery their commission and must charge the full price. Can you imagine the gallery owner's surprise when this happens unbeknownst to them and you send them a $1000 check? Maybe they'll finally treat you with more respect!

CONSIGNMENT RECEIPT

RECEIVED FROM

Artist Name _____

Address _____

City/State/Zip _____

Telephone _____

Title	Description	Sale Price
1.		
2.		
3.		
4.		
5.		

Anticipated pickup date _____

CONDITIONS OF CONSIGNMENT

1. Gallery agrees to insure the above artworks against loss or damage.
2. Artist shall be notified within 10 days of the sale of any artwork and receive name and address of collector with payment.
3. Artist shall receive _____ % of the sale price, gallery _____ % of the sale price.
4. Art is being held in trust.

Dealer Name _____

Address _____

City/State/Zip _____

Telephone _____

_____ _____
Dealer Signature Date

_____ _____
Artist Signature Date

UNIVERSITY GALLERIES

Many artists overlook the local college or university gallery scene, thinking it's only for students and alumni. This is far from the truth. University galleries show all types of work—from all types of artists. I've known artists receiving five-digit figures for their pieces sold through university galleries.

For many patrons a university gallery is a much more relaxing atmosphere than the sterile, commercial gallery. University galleries are often open to avant-garde and installation work also. Explore university galleries in your community. Keep your eye on the "Call for Exhibits" posted in various art newspapers. Attend openings and see for yourself.

RENTAL GALLERIES

You will find many advertisements, especially in the major cities, for space to rent at galleries. Do not get involved in this. The cost of these exhibits, which you pay in total, is not worth it. You might get some publicity if you work really hard and show an unusual art form. The mainstay galleries in New York seem to have a monopoly on the publicity.

The only time you would rent a gallery space is if you have a large customer base in a particular area and need a place to exhibit to them. When you rent a gallery you have to do all the work: invitations, PR, refreshments, much like when you had to hunt for that exhibit space. Even if the rental gallery says they will do all the footwork, don't count on it! Their mailing list is probably not very good. If it were, they would have a real gallery.

COOPERATIVE SPACES

A co-op space or gallery is an exhibition space run by a group of artists. Artists share costs of rent, sales staff, show openings, etc. Some co-op galleries are well-respected and have been around for years. They can be the perfect exhibition venue for emerging artists. Try to locate such a gallery in your area. Look for listings in your local art newspaper. There are also nonprofit galleries run by art organizations or groups. Gallery owners will come to these exhibits (especially if they receive an invitation) and will sometimes discover new artists to add to their stable.

ALTERNATIVE GALLERIES

ArtWorld Hotline is a four-page monthly newsletter listing better-quality competitions and events for fine artists to consider entering. $30/12 issues (800) 383 0677.

ACTION PLAN

❑ Scout for a rep.

❑ Make a list of galleries to search out in the local area.

❑ Keep a notebook on the results of this search.

❑ Get on the mailing list of galleries of interest.

Chapter 19
Shows and Fairs

Outdoor shows

Applying to shows

Trade shows

Successful presentations

Selling at shows

Merchant status

Alternative shows

Ignorance is not innocence, but sin.
Robert Browning

OUTDOOR SHOWS

Outdoor shows, if chosen wisely, can be a great venue for sales for the emerging artist.

Working an art show is not necessarily easy, but then what is? Once you get the knack and find the right shows for your own work, you will see that they can be fun as well as financially rewarding. In fact, at some point you might be able to hire someone to help you. It is possible to make $1500-9000 and more per weekend. If you are a smart marketer, there are after-show sales as well. At the better shows, artworks from $1000-16,000 can sell. I know some artists who sell work priced at $9000 at outdoor shows. In order to receive these high prices, one must have a reputation in the area and have shown many years at the same show.

CHOOSING THE RIGHT SHOW

Some shows are definitely better than others. The single most important factor to having a successful show is choosing the right one to sell at. You will need to do some research. Attend a show as a consumer to see what is occurring. Study booths.

Make a calendar planning upcoming shows. Start by looking in your area first. Chat with some of the artists. See if people are carrying off packages, or if artists have red dots on their pieces. What's the general atmosphere? Are artists happy? Sales up? If you can't check it out personally, make sure it has a good review in one of the publications listed on the following page.

Calculate your costs: booth fee, table rental, motel, meals, gas, materials such as frames, shrink-wrapping, invoices, business cards. Are all the expenses going to be covered by the price you are charging for originals? Have you checked out similar fairs to see the price ranges, selling possibilities and trends? Does everyone sell prints as well as originals? Some shows don't allow prints to be sold.

➤ What are people buying? (Prints, originals, knick-knacks, photographs are almost always popular.)

➤ What attracts attention at each booth? (Mono prints priced between $50-250 sold like hot cakes at one show.)

➤ What style of art is being sold?

➤ How much does a booth cost?

➤ How many people are expected to attend?

➤ What kind of sales has this show generated for past exhibitors?

Sales tax reminder: if an out-of-state client buys something and you ship it to him, no sales tax is charged. If your client takes the piece with him, you must charge sales tax. Don't forget to charge for shipping, though!

➤ What happens in bad weather?

➤ What protection does one receive for displays left overnight?

➤ Can one demonstrate a creative technique during the show?

➤ Are your prices right for that show?

FINDING A SHOW

Local arts councils and art organizations
They often sponsor local summer shows

ArtFair SourceBook
2003 NE 11th Ave, Portland, OR 97212-4027 (800) 358 2045
(503) 331 0455 (503) 331 0876 Fax www.artfairsource.com
<greg@artfairsource.com>
Rates the top 300/600+ art shows in the U.S. @ $150/$225 subscription.

Harris List
PO Box 142, La Veta, CO 81055 (719) 742 3146
Lists and rates top 180 shows. $55 subscription. Consulting services.

Sunshine Artist
2600 Temple Dr, Winter Park, FL 32789 (800) 597 2573 (407) 539 1399
Each year this magazine lists the top 100 fine art shows across the nation (as rated by subscribers). Well-worth the $5.

APPLYING TO SHOWS

As you begin to apply to the art shows of your choice, you will find there is a lot of competition to get a booth. Shows are generally juried, although artists from previous years are often given priority. To improve your odds of being accepted, you must remember that the judges are only seeing your slides, not your original work.

➤ Many pieces can look wonderful in person, but on a slide they lose impact. Don't send slides of this type of work.

➤ Mark slides clearly and exactly how the show promoters request. Follow the prospectus instructions verbatim.

Most customers at fine art shows are people who do not like to go into galleries. They often like to have a more personal connection to the artist they are buying from.

Look for a show that is called a fine art show, not a craft show.

When you decide to apply to any particular show and are accepted, make it an aim to reapply for five consecutive years. You need to show consistency to those same customers walking around each year. Create credibility.

➤ Try to choose slides that show the individuality and originality of your work, selecting subjects that are not frequently painted.

➤ Don't vary your style, medium or color too dramatically. Technical mastery is not what you are trying to show in your slides. You are trying to emphasize overall effect to an audience.

➤ If you need a slide of your booth and have never exhibited before, you will need to take a picture, perhaps in your studio, of a potential booth.

If you are rejected, try to find out why. Was the number of applicants exceedingly high? Was it the quality of your work? The quality of your slides?

TRADE SHOWS

A trade show is where people in a particular trade (non-consumers, businesses) patronize a show. There are quite a few upscale art trade shows around the country: ArtExpo LA, ArtExpo NY, Art Chicago, Art Miami, Modernism, as well as others worldwide. Most emerging artists do not exhibit at these shows. The mainstay of the exhibitors are high-end art publishers and galleries.

Sometimes, however, you will find established regional artists who are branching out into national exhibiting. These shows are no small event and need considerable planning and bucks. Booths generally run $2000-plus. Transportation for yourself and your artwork, hotel and dining costs, setup at the show, etc. all add up to big money.

As an actively marketing artist you should attempt to attend one of these shows as a viewer. You will make observations about marketing, brochures, displays, sales techniques and trends in the marketplace. You will also be able to learn what errors the exhibitors make in their presentation.

Don't be closed to new ideas about where to market. There are shows to sell prints, flowers, garden accessories, home decorating, furniture, gifts, wildlife art, as well as many, many more. Be inventive!

Look for the following magazines and directories at your local library or ask for an inter-library loan: *Decor, Art Business News, Trade Shows Worldwide* and *Directory of Fairs, Festivals and Expositions.*

THREE INNOVATIVE SHOWS

• An artist who loved to paint orchids approached the producer of his local orchid trade show to rent a booth space. When the presenter found out he was an artist, not a grower, he refused to have him participate. The artist was determined, however, and explained to the presenter the possibilities for him. Finally he was given a 'test' booth. The test went off very well. The artist sold many 'orchid portraits' and gained many new clients. He does the show annually now, and has one of the most popular booths there. Take a risk! Go for it if you have a good idea.

• What is a fine artist doing at an office supply show? He's taking a risk, a risk that turned out to be a good one! One artist decided to reach the business world by sitting at a booth in an office supply and furniture show. He was going to sell prints as well as originals, and possible try to lease this original work to prospective clients. His main intent was to get names to follow up with after the local show was over. It worked. He became known among the business community in his area. Word gets around fast!

• One artist started her career by showing and demonstrating at her local home show. It was a lot of tough work, setting up, sitting there for the entire weekend, dealing with people's comments. She decided that painting would be a good buffer zone for her, so she did demonstrations while the public watched. She's now gone on to bigger and better things.

SUCCESSFUL PRESENTATIONS

When you decide to do a show, don't plan to party or socialize in the evening. You need to eat, rest and relax so you can center your energies for the next day. It does take a lot of energy to spend the entire day 'on the floor.' Having a winning attitude is a necessity, and it's not easy if you're tired, hung-over, or just not feeling confident.

So you've been accepted to the number-one show on your personal list. Now you actually have to face the crowds. Your presentation could be the most important part of your show. Do you need a table and chair? What kind of backdrop will you display your work on? You will need a sales receipt book, perhaps some change, a large inventory of your work, printed literature, a method to record the names and addresses of interested browsers. Will you be painting on the scene? Some artists find it easier to paint in front of people than to chat with them!

Each show presenter will inform you of what type of equipment you need for exhibiting. Many artists use canopies, not only to protect their paintings but to protect themselves from weather elements. Some bring easels and display their work on them. Generally you won't have more than a 10x10′ area to display your work.

POINTERS

➤ Be well-groomed.

➤ Arrive during the allotted time. Never break down your display until the show has ended.

➤ Make your booth welcoming for people to browse in.

➤ Design a display that is lightweight and easy to assemble and disassemble. Have a professional-looking booth.

➤ If you have assistance from a friend, relative or mate, this lends support and relief. It's important to your mental health to rejuvenate. People are hard to deal with. Some are very snooty, sassy, unintelligent, mean, nasty—all the adjectives we can think of. Remember, you are an actor and you are trying to deliver your lines the way you studied them.

➤ Take time to eat, but not in the booth. Lots of shows have volunteer relief workers to give artists a break periodically.

➤ Walk the show to check out the competition. Trend-watch.

➤ Keep an even keel.

➤ Have a price range of items from $10 up. Have lots at the $10 price, such as color photocopy prints in ready-made mats. They will sell like hot cakes.

SHOW SUPPLIES

➤ Lots of business cards

➤ Sales tax certificate

➤ Sales books/pens/client artwork care list

➤ Labels and price tags. Label your work with price, medium if necessary, and "original" or "limited edition." This clarifies to the customer what he is looking at.

➤ Display equipment/chair. Set your chair outside your booth, not inside.

➤ Red dots for sold pieces

➤ Packaging for purchases

➤ Credit card imprint machine, money for change, calculator

➤ Signs such as 'Personal Checks Accepted,' 'VISA/MC/AmEx Accepted,' 'Free Local Delivery,' etc.

Consider having prints made for ready-made frames for the $75-100 price range.

RESOURCES

Oak & Rope Designs
PO Box 424, Monticello, FL 32345 (850) 997 4913
Tall, comfortable director's chairs used by many artists at outdoor shows. $165 + $10-15 shipping (artists receive 10% discount).

SELLING AT SHOWS

If they don't like your personality, they won't buy your artwork. It's that simple!

Any sales approach could work—but it must be yours, i.e., not phony. You don't have to change your personality. You do have to think about your approach. Watch yourself acting. Isn't all life a stage? Think of being on stage at your local outdoor fine art show. Review Chapter 15 for more sales tips.

You can gain the confidence of passersby by showing that other people and companies have purchased from you in the past. Create a portfolio you can set on a table for people to look through. Validate yourself and your career. If you have work exhibited in a magazine or book, put that out. If you've given to charity make it clear, such as "original artwork donated to Wildlife Foundation." People like that. It's also an ice-breaker.

You are selling an overall appearance and 'story.' These locals want to know you will be back next year. Even though these are not the 'super big-time' buyers, this will still help gain their confidence. They want to know they are not being ripped off. They want to have their friends over to their home to show them the wonderful artwork they purchased.

DEALING WITH PEOPLE

All people walking by are potential customers. Treat them equally! Use no excuses: she's wearing clothes from K-Mart; she bites her fingernails; she can't have enough money for my artwork; it looks like he's tagging along with his girlfriend. When you start hearing yourself saying these things, it's time to take a break.

Many people who are buying at these shows might be first-time art buyers and thus insecure. Outdoor shows have an easygoing, relaxed atmosphere. Saying "Hi" can often be sufficient. Let the viewer be the initiator. Viewers don't want a sales pitch.

People don't know that they need or want something. It's your job to tell them why they want your art. Unless you know the benefits and believe in them, you won't be able to convince anyone else.

Make a list of lines you can use and just try them out. If they're never successful, then delete them from your repertoire! When someone is glancing for a while at your pieces, walk up casually and say jokingly, "Which one did you say you wanted shipped to your office?" Look at their reaction. Perhaps you want to add, "Or would you prefer the artist to bring it and help hang it for you? I offer a variety of options— just let me know!" or maybe you need to add "I'm going to be in the area for a couple days between shows because XYZ company is having me help hang a couple pieces and I have one more resident I have to go to." You're telling him you offer service. He will like that. He will also like that other customers say you're "okay."

• One of the best lines I ever heard while perusing an outdoor fine art show came from the wife of the artist, an artist who did rather large pieces. "How much space do you have on your walls?" I was so shocked by the unusual question that I didn't have an immediate response. I just sort of giggled. She went on to show me some of the smaller pieces she had 'in the back.' This was a good tactic, even though she didn't know what my objections were (in my case they were not size or price—I just didn't like the work that much).

• I went to the Sausalito Fine Art Show about three hours after it started on the first day of a three-day event. One of the first booths I came to was a corner booth, set up very nicely, showing pleasantly framed watercolor florals. The most prominent art piece had a red dot on it, indicating it had sold. I thought, "Gee, already sold! Hmmm." I looked further in the booth and yet another and still a third had red dots. I was really impressed for only three hours of sales time. These pieces were in the $900-1200 range. I thought that she just placed these red dots on her paintings to make her look popular. But as I was exploring her booth further, a man dragged his wife up to look at a $900 painting. They chatted a bit and decided within 45 seconds that they would buy the piece. Well, I realized then this lady was for real. Her pieces had sold.

TIPS

➤ Be aggressively friendly. If you appear to have shocked someone unpleasantly, back off.

➤ A strong aspect can be humor. Humor will break any deadpan buyer into a more relaxed prospect.

➤ Give attention to all, but focus on the most active 20%.

➤ Do something different: demonstrate your work, run a contest, have a story!

➤ Some prospective clients are knowledgeable, some know nothing about art. Be sensitive to the different levels of development.

➤ Be yourself. Be prepared to give of yourself.

➤ Brace yourself for negative feedback. There's always a percentage of people who will criticize.

➤ Stories are fun—and your clients do want to be entertained! Stories should be short and to the point.

Once the customer has decided to buy, tempt him to go on a buying binge by offering the companion piece at a 10% discount.

➤ Information is good: tell them how a 'serigraph' is made.

➤ Watch body language. You want your potential client to open up to you, i.e., unfold those arms.

➤ Make eye contact with your customers. They'll trust you more.

➤ Pay attention to constructive comments made by potential customers. Don't heed the person who is expressing his vanity.

➤ Talk to people on their terms—no buzz words or art slang. Just normal talk. If you use slang they don't understand, their ego will deflate.

GUARANTEE

Let your potential customers know that your work is guaranteed. If the client is not happy with his piece when he arrives home with it, he can return it. Give a time limit for this. If it should happen that someone is disappointed, have him ship the artwork back to you (be sure to instruct him well). Better yet, make an appointment to pick it up. Tell him you will bring some different paintings. Most likely they don't have quite enough confidence yet about buying a piece, but you will be able to help instill confidence in their decision. Perhaps there is an outside objection: his wife was surprised he spent $300 on a painting when she would rather have purchased a dress.

PRE-EXHIBITION OFFER

One artist uses a pre-exhibition sale offer. When she sends out her first invitation for her show, she entices collectors to come to her studio for a private showing before the actual show date. She offers them a 10% discount. She also lets buyers know that she will be exhibiting the work they purchased throughout the entirety of the show. Thus, when her opening occurs, she will already have sold some pieces. You know how impressive it is to see red 'sold' dots on pieces on the opening night of a show!

MERCHANT STATUS

If you are doing business at outdoor shows, it is imperative for you to get merchant status from your local bank. Merchant status means you will be able to accept credit cards. If you have a long-standing relationship with your bank it shouldn't be too hard. If you do apply:

➤ List your studio address (hopefully it's other than at home) as your place of business.

➤ Tell them you want it for outdoor art shows.

➤ Be aware that between 3-5% of the charge will be taken out as a service fee. You will need to charge your customers for this in some manner, most likely upping your sale price 5%.

RESOURCES

American Express Merchant Establishment Services
(800) 528 5200

The Arts Group
Cyndy McDonald (800) 873 1192

Electronic Transfer Inc
Corrie North (509) 924 6730 ext 213

MPC
Margo Hendricks (800) 928 2273 ext 2305

Precision Business Systems/PBS
Steve Holman, PO Box 1262, Galt, CA 95632 (800) 434 5443

Retriever Payment Systems
Tom Nielsen (888) 549 6424

World Wide Credit Services
(904) 471 8840

York Financial Services
Lawrence York (925) 820 3139

ALTERNATIVE SHOWS

CITY-WIDE OPEN STUDIOS

One of the two types of Open Studios occurring for artists these days—the type sponsored by a high-profile local art organization—shows excellent sales reports.

Find out when Open Studios are happening in your community and attempt to be part of them. If you don't feel you have an appropriate studio, business patrons often let artists set up a temporary studio in their facilities.

Even though the group sponsoring the city-wide Open Studio might be planning the publicity, you will also need to do a lot of planning to make it a success. Let the press know how your studio will be special during this event. Entice the public to your studio. Send out postcards. Often the arts organization provides you with some extra postcards they've printed—or vice versa, you provide them with names to mail to.

PERSONAL OPEN STUDIO

The second type of open studio is when an artist holds one on his own. That means he does the publicity and invites present and potential clients at a particular time on a particular day. One artist I know holds an open studio the first Sunday of each month. Review Chapter 7 for assistance in your planning.

ON TOUR

In some communities you can be listed as part of a cultural attraction. Consider forming a group with other artists and non-arts people who want to advertise specifically to tourists. Perhaps together you can produce a brochure to leave at all the tourist attractions in town. Contact your local tour bus guides and introduce them to your studio.

STUDIO SHOW TIPS

➤ Have excellent road signs if you invite potential clients to your studio/home.

➤ If you have children or pets, find a baby-sitter (out of your studio) for them.

➤ Encourage people who seem genuinely interested to sign your guest book so you can continue mailing to them. Be sure to

have printed material for guests to take with them: a color postcard, business card with image of your work, a bio or statement and your price list, all with your name, address and telephone on them.

➤ Hire a salesperson; ask your local arts council for a reference; go to a local tourist gallery to find a part-time salesperson who wants to make some extra money; find a friend who's a good salesperson. Hire them for the opening. Make sure you are comfortable with the salesperson's selling style—everyone is different. Educate the salesperson in detail before the event as to options for taking a piece on approval, lease programs, patron programs, and discounts for purchasing two pieces at the same time.

➤ Emphasize tax deductions for business buyers. Artworks can often be deducted as office decor if the price is under $5,000.

➤ Have a special desk set up for sales purposes. Have sales invoices out on the desk, flowers, and a chair on each side to complete the transaction.

➤ Present various sizes and prices of pieces—prints if you have them, both unframed and framed. You want to hit all price ranges. Have one original piece priced high above the others.

➤ Put the price on your work or on the tag that accompanies your work.

➤ When a purchase is made and the buyer wants to pick up the purchase another day, put a red-dot sticker on the painting tag to indicate 'sold.'

➤ Have packaging materials ready in one corner of the room for carry-out purchases (bubble bags, tape, stapler). Perhaps you can get a friend to do this packaging for you.

➤ Don't say anything negative about anything!

➤ Be strong in all your statements. Create no doubts.

➤ Know when to stop talking. When someone is reaching for her checkbook, do not say another word. Let her say the next thing. Silence is golden at this moment. This is extremely hard for even good salespeople to remember!

Check local magazines to see if there is someone who gives organized tours of artists' studios. Sometimes museums do this.

ACTION PLAN

- ❑ Make a schedule of fine art outdoor shows to visit this summer.

- ❑ Decide on two shows to do for the next five years.

- ❑ Apply to five shows, so if not accepted at the first choice there are some alternative choices.

- ❑ When accepted, start preparing sketches of the booth and gathering materials necessary to the show.

- ❑ Plan to visit some upscale art trade shows.

- ❑ Check out the marketplace for other types of trade shows.

RECOMMENDED READING

Exhibit Marketing *by Edward A Chapman Jr*

Trade Show Exhibiting *by Diane Weintraub*

Chapter 20

Locating New Markets

Competitions

Publicly funded programs

Community involvement

Museums

Religious markets

Businesses

Architects

Private collectors

> *Commissions*

The superior man is modest in his speech but exceeds in his actions.

Confucius

COMPETITIONS

Prospectus, sometimes written pros, is a brochure that lists the details about a competition, event or show. SASE, sometimes called 'sassy' by the uninitiated, stands for self-addressed stamped envelope.

Competitions, both for emerging and established artists, occur quite regularly. Many organizations, galleries and magazines sponsor competitions. A competition can be juried or non-juried (without any judges involved). Winning a juried competition is a prestigious occurrence. A winner of a competition could receive an exhibit, entry into a book, a monetary award, publicity, an article, sales or other awards.

Entering and winning a juried competition can be a good way—and indeed many artists do it this way—to initiate exhibiting work. It's also a good way to gain public recognition and start "coming out of the closet." Both emerging and established artists have equal chances of winning in a competition, as the juror doesn't see the resumé or name of the artist at the time of judging. Judges only see the slide.

Winning a spot in a show can lend prestige and authority to your work. It will also bring your work to the attention of curators, critics, dealers and collectors who visit juried exhibitions.

The sponsoring organization, university, museum or civic group generally charges an entry fee for a competition. Fees that you are paying could go to the production of the show, towards the awards being offered or to pay for the jurors. Jurors sometimes volunteer their time but most commonly are paid a fee, generally around $1500.

"Arts for the Parks" is one of the top juried shows in the nation, with awards totalling $62,000 and a grand prize of $50,000. One hundred pieces are chosen to travel across the country each year. Various museums showcase the exhibit with openings and promotional talks. Most of the 100 pieces are sold—if not previous to the tour, during the tour. The goal of this competition is to enhance public awareness and support of national parks while showcasing the creative efforts of artists. Call (800) 553 2787 for more information.

Being juried into a show can start building your resumé. It shows gallery owners, consultants and collectors that you are active, that people are reacting to your work, and that you are going somewhere with your career. If you win an award you can list it under "Awards

and Honors" on your resumé. Gallery owners will be more impressed by the entries on your resumé that were judged by established members of the art profession, so list the juror if you do win a competition.

The classified sections of local and national art publications list many competitions, both regional and national. If there are any local competitions are of particular interest to you, mark them on your calendar so you can visit them to see the results of the jurying—styles and subjects accepted by the juror or judging committee—the year prior to applying. A preview like this will help you prepare for the next year's show. Apply to local shows first. If there is a competition for a specific subject matter or style that you do, then you can extend your geographic limit. Go national only after you have explored many shows, know a little about the history of any given show, and have won some local competitions.

TIPS

➤ Prepare good-quality duplicate slides for sending to competitions.

➤ Don't enter every competition. Study them. Be selective.

➤ Museum competitions, or competitions with museum curators acting as jurors, can be a good introduction to the museum world for your work.

➤ Set a monthly limit on how much you are willing to spend to enter shows. Keep in mind the costs for entry fees, as well as slides, shipping, packing.

➤ Read the prospectus carefully. They might not return slides, they might return them only if you send a SASE, they might only accept works completed in the last two years, etc.

➤ Shows that take a commission on sales are good. That way they have initiative to sell!

ASK BEFORE APPLYING

➤ The number of entries the previous year vs. the number of works selected.

➤ What percentage of last year's works sold?

Competition deadlines are often extended. Call to verify.

A jury's decision is based solely on the 35mm representation of your work. It is imperative that your slides project well on a screen. Check them out on a slide projector before sending.

➤ Is there a sales force on-site at the opening and throughout the exhibition?

➤ How is the show advertised to the buying public?

➤ Who pays for shipping if artwork is accepted?

➤ Who is the juror? Look in *Art in America Annual Guide* if you are not familiar with the juror's name. Perhaps you can find her listed there.

➤ Will printed price lists and information on artists be available to the public?

It is shows like "Arts for the Parks"—ones with notoriety and high monetary awards and sales—that you are ultimately looking for. Not all of them will be this grand (be wary if they sound too good), but you want a show that sells, has awards and gives you plenty of exposure.

Whether you win a competition or not, try to attend the exhibit. Why was your work not selected? Sometimes there is absolutely no way for you to know. Other times you can see that the jurors had a specific idea of what they were looking for, very different from your style of work.

I attended an exhibit at Portland Museum in Oregon. The winners' works were hanging in the gallery. In a small room off to the side, slides were being shown of all the entrants' works. This was very educational. Too bad not all competitions don't have this type of display.

INSIDE THE JURY PROCESS

A jury seeks a consistent vision or aesthetic in the visual work from an artist. Jurors judge on the basis of originality, craftsmanship, style, composition, inspiration. Samples of your work that are synergistic are the best choice for sending to a competition. They will have a stronger impact.

Generally jurors sit in a darkened room with a note pad. The person working the slide projector has prearranged five projectors with each of the entrant's works to project at the same time. The jury generally doesn't know the title of a piece shown, nor the artist's name. The juror only sees the artwork. All five pieces from the same artist are

projected at the same time. What effect do they have together? Try it with your own slides and see!

Keep an inventory of where and what you send. Use a notebook for organizing. File upcoming applications by the due date. This way you won't be sending payments in advance or late.

If you lose every competition you enter, it doesn't necessarily mean you aren't ready for the marketplace. I would suggest a consultation with an artist consultant; tell her the problem and see if she can find the flaw. Perhaps it is your presentation. Perhaps it is your style or subject matter, not your ability. She can give you more guidance and, hopefully, direct you to better results.

RESOURCES

Juried Art Exhibitions: Ethical Guidelines and Practical Applications
Chicago Artists' Coalition, 11 E Hubbard 7th Fl, Chicago, IL 60611
(312) 670 2060 (312) 670 2521 Fax www.caconline.org
A booklet that will help you plan a competition. $13ppd. Send for their free publications flyer.

ArtWorld Hotline
(800) 383 0677 (530) 470 0862
A four-page monthly newsletter listing the better-quality competitions as well as a variety of other possibilities to assist artists in their careers and sales. $30/12 issues.

Guide to Entering Juried Shows
The Pastel Journal, PO Box 2791, Corrales, NM 87048
(888) 711-5544 ext 2 (505) 294 1042 ext. 2
www.pasteljournal.com <sales@pasteljournal.com>
This 32-page booklet ($9.95ppd), compiled by the editors of the Pastel Journal *magazine, has several articles from various artists and professionals.*

PUBLICLY FUNDED PROGRAMS

ARTS COUNCILS

Arts councils are funded by federal, state, county or city government, as well as by private donation. Arts councils were created to bring more art into the general public's view: performing art, visual art, music, etc. It's important to get to know your local arts council's visual art director. Community-wise they can be helpful to your career, leading to local collectors, possible exhibition venues, recommendations of all sorts, etc. They, of course, want to know that you are a serious artist and have quality work. Arts councils often sponsor seminars, have gallery space available to artists, keep slide registries, as well as other activities for an artist's benefit.

PERCENTAGE FOR THE ARTS PROGRAM

Most states have now initiated a "Percentage for the Arts" program, often managed by the local or state arts council. This is a program that requires a percentage of the construction budget of any new public building to be applied toward art. Sometimes called an "Art in Public Places Program," it is meant to enhance the environment through works of art while creating a relationship between artist and community. Keep current on "Percentage for the Arts Programs" by reading listings in weekly art publications or by calling arts councils directly and asking to be put on their mailing list for such notification.

Selection procedures for "Percentage for the Arts" programs vary. They may include:

1. Direct purchase by jury or panel

2. Invitational projects. By using a slide registry, the panel selects only one artist to draw up a proposal, and if it is accepted, the artist receives the commission.

3. Limited competition. Several artists are invited to compete by drawing up a proposal.

4. Open competition

GOVERNMENT BUILDINGS

The Russell Senate Building in Washington, DC sponsors shows. You must get a US Senator to sponsor your work. Call your local US Senator.

SLIDE REGISTRIES

A slide registry is a place where artists' slides are kept on file. Reps, consultants, architects, and designers visit community slide registries to locate artists who do particular types of work for projects they are working on. You can be listed in slide registries outside your local area also. Many consultants find artists from different regions in this manner. Some slide registries are juried, some are not. Some slide registries charge a fee to be listed, some do not. For invitational projects at arts councils, you will want to submit slides of your recent work to selected slide registries.

RESOURCES

Art publications
The classified sections of art publications often have announcements of slide registries.

ArtNetwork
(800) 383 0677 (530) 470 0862
A mailing list of both arts council and art organizations slide registries is available for rent.

ART IN EMBASSIES PROGRAM/AIEP

Though many citizens have never heard of it, this program is over 30 years old! Placements are made in U.S. Embassy offices and homes around the world, providing excellent exposure for artwork to various dignitaries, political, government and state officials. Work must be available for travel for three years, but has often been purchased at the end of the loan period.

US Dept of State
Roselyne Swig, 2201 C St NW #B258 , Washington, DC 20520-0258
(202) 647 5723

ART-IN-ARCHITECTURE PROGRAMS

The General Services Administration and the Department of Veterans Affairs, both federal agencies, have art-in-architecture programs for their buildings nationwide and maintain their own slide registries. Write AIA, PNH, GSA, Susan Harrison, 1800 "F" St NW, Washington, DC 20405.

The President was presented with a silk screen of Roy Lichtenstein's "Composition III" by Friends of Art and Preservation in Embassies/FAPE. The signed and numbered edition of 175 was donated to FAPE and the "Art in the Embassies Program." Prints will be placed in each of the U.S. Embassies worldwide. Can you imagine what publicity over the years this will bring Lichtenstein? Some of these people have never seen or heard of him!

U S POSTAGE STAMP DESIGN

Most states have annual fish, duck, wildlife, conservation, etc stamp competitions. Contact the Game, Fish and Wildlife Department in any state.

The Federal Duck Stamp Competition is held annual. Applicants must be a US citizen or resident alien 18+ years old. For detailed information contact 877·887·5508 or send a 6x9" envelope with 55¢ postage to Federal Duck Stamp Program, 1849 C St NW #2058, Washington, DC 20240.

A Conservation Stamp Competition, Sale and Show. Contact the Wyoming Game and Fish Dept, 5400 Bishop Blvd, Cheyenne, WY 82006 800·LIV·WILD www.gf.state.wy.us/html/stmpctst.htm

Each year the US Postal Service receives over 40,000 requests for new subjects to appear on postage stamps. From those requested, approximately 30 subjects are chosen, utilizing an average of 100 designs. The final selection of subjects is made by the Citizens' Stamp Advisory Committee/CSAC. Subjects are selected three years in advance of issuance.

The total commission for a completed stamp design or illustration is $3000. The artist is given $1000 upon signing an agreement for concepts. If the work is approved, the artist receives an additional $2000 for the final art. The original artwork becomes the possession of the Postal Museum.

When approved, the subjects are assigned to the Postal Service Stamp Design staff. The design staff works with five highly qualified, professional art directors in developing the designs.

The US Postal Service continually searches for new and creative talent to utilize in its design program. New artists are commissioned each year. Creating stamp designs is not an easy task. It requires unique talent, style and discipline to work within the parameters required to create art to be reproduced on such a small scale.

If you think you meet the requirements as a professional designer, illustrator or photographer and wish to be considered for a stamp design assignment, the guidelines are as follows: all works must be submitted in print form (tear sheets, color copies, etc) that will be retained by the US Postal Service. They will be made available to art directors in the event a work is approved. Original art or slides will not be accepted. All work not considered acceptable by the staff will be returned.

The US Postal Service will contact you if they are interested in commissioning your service. The US Postal Service will not:

• Acknowledge receipt of samples by letter or phone

• Offer reason for rejection of submission

To receive a guideline (one of the 500 requested annually), send to Stamp Design, Stamp Development, Room 4474E, US Postal Service, 475 L'Enfant Plaza SW, Washington, DC 20260-2437

COMMUNITY INVOLVEMENT

Under present federal tax law, no tax benefit is available for deduction; you can only deduct the cost of the materials. If a collector purchases your work, then donates it to a charitable cause, he can deduct the full market value. Not equitable for artists, but this is the law!

These days many nonprofit organizations and artists work together in their promotion efforts—Sierra Club, Harlem Theatre, KQED TV, local Little League, Brooklyn Art Museum, and many thousands more across the nation. For both parties involved this becomes a win-win situation. The key is to find the right organization for your style of work. You can receive lots of publicity, some of which you will need to initiate, some which the organization initiates. Generally a print will be made and the artist will receive royalties. Many other arrangements can also be worked out. People like to buy from their favorite charities. The artist who hits it off with an organization could create a customer base for life!

• An artist called one day to ask for a short consultation. He wanted to know what I thought of an idea he had. His idea was to take a painting he had created (which I had never seen) to a meeting of the Brothers of the Temple, an organization similar to the Elks Club. He wanted to raise funds for prints of this piece by having members of the organization buy prints at a special pre-publication price. He thought the members would like his painting enough to participate in this venture. I thought it was an innovative approach. Two weeks later he called back to report the news. He had arranged to do a sales pitch at their meeting, bringing the original artwork. Not only did the members buy enough pre-publication prints to support his printing, leaving him with several hundred copies more to sell, but they bought the original painting as well. What a coup! I told him to keep up the good work and find another, similar organization, perhaps a few townships away, create another painting, and do the same sales pitch. Take the ball and run with it!

• Another artist liked to do historical paintings. She took it upon herself to do a large mural-type painting of her town's history, which she had studied thoroughly. After completing the piece, she decided to try to sell it to her City Council. After much red tape, prints were made by the City Council and sold as a fundraiser (of which she received a nice royalty), and they eventually bought her piece (due to her lack of experience, without signed agreement) for a price less than what she had thought they originally agreed upon. All in all, though, this venture was a great success. She made a royalty on the prints, got great publicity in the town, sold her original work and had extra prints to sell on her own. Her job then was to go to the next township and propose a similar fund raising event to them, promoting the success of her first fund-raiser. This time she would make sure she had a signed contract from the start.

CHARITY DONATIONS

At some point in your career, you will probably be asked to donate a piece of artwork to a particular charity for an auction fund-raising. Auctions have been occurring for decades—a great fund-raiser for an organization, but what about the artist who is donating?

The first few inquiries you receive for a donation will pump up your ego. When you become known for giving in your community, you might receive as many as five calls a month for donations. At some point you will have to set limits.

Most artists continue to donate, but require part of the proceeds. Some artists have begun to ask for half of the auction profit from their piece. Why shouldn't you get 50%? Be aware that you may feel resentment when you find your work was sold for quite little at an auction.

Require the organization to:

➤ Set a bottom limit on your auction price. If it doesn't sell for that minimum, you receive it back.

➤ Inform you of the price it sold for as well as the buyer's name and address.

➤ Pay for framing and transportation.

➤ Give you 50% commission on the auction sale price.

Sculptor Richard MacDonald donated a 22-foot monument portraying an Olympic gymnast to the state of Georgia for the 1996 games. He took full advantage of this opportunity and received a lot of free publicity. I'm certain he also got many sales. He is now a much more common name, not only to the American public but to the world. A great investment for the long-term goals of his career!

MUSEUMS

Museums are looking for innovative exhibits. They 'rent' travelling exhibits.

Museums are looking for quality work. In the last years their budgets have shrunk. They can no longer afford to buy consistently the number-one, superstar artists. They are looking for emerging artists they can afford, whose worth will grow with age.

You could approach a museum to sell a piece, donate a piece or have an exhibit. To approach a museum, write a brief letter of introduction to the appropriate curator. Include with your letter your resumé, as well as promotional materials, announcements from solo shows, and 6-10 photoprints or slides of your work.

If you are thinking of approaching a museum for an exhibit, remember that they are not places that sell; they just exhibit artwork. Exhibiting work in a museum, however, can be a great boost to your career. Your credibility will increase tenfold. Receptions are usually held there for patrons of the museum. You, of course, will attend and introduce yourself to these patrons. You will meet curators and other museum staff as well.

Many museums have annual competitions for emerging artists. These could be your best bet for introduction. Some museums have rental galleries. This is an excellent way to find clients also.

To locate museums out of your area, ask your librarian for a museum directory. If you have a specialty market, i.e., wildlife, horses, florals, historical, look for this type of museum. Contact the curator by phone with your idea for an exhibit. He will most likely ask you to follow up by sending your portfolio.

DONATIONS TO MUSEUMS

Storing artwork has become a costly venture for most museums. Many do not want an unknown artist to approach them about possible donations of his/her work. If you are becoming well-known in a particular area of the country, however, you might try to donate a work to museums there.

If and when you do donate a piece, make the most of it. Ask the curator if you can have a formal 'unveiling.' Invite the press to the event. Be sure to list that you are in the museum collection on your resumé.

You'll need to draw up a donation contract if you give a piece to a museum. Make it clear that you still own the reproduction rights.

You can also try to persuade one of your collectors to buy a work and donate it. He can then deduct the full market value from his income tax.

Some resources to look through at your local library might be *Official Museum Directory*, *Museum Store Association*, *Museums of the World* and *International Directory of the Arts*.

• One artist donated a piece to a large museum in the south. They gave her artwork a special unveiling. The museum got the press to come, and they did several grand stories on her work. Her piece has since been rotated to different spots but for some time was at the central entrance to the museum. Her next step was to make prints and sell them to the gift shop, as well as around town. Her originals became much easier to get into galleries at that point. She had become known locally.

• One artist I know has his photographs traveling to many museums all over the country. He solicits museums with a well-prepared press kit. He is paid to exhibit and the museum packages and ships his work to the next museum on the list. He also sells cards and posters of his work. The museum gets a cut of these products. It's a win-win situation.

• One artist wanted to have a traveling exhibit of her work, which she volunteered free to any museum that would accept it. She only asked that they pay for transportation and her personal expenses for attending the opening. She would also give demonstrations of her work for several days during the exhibition. Her mailing was so successful that she actually had to refuse some museums which wanted to be on her tour!

Churches have traditionally been patrons to the arts. Today they are promoters of art more than commissioners of art, sponsoring exhibitions and performances that are not necessarily of a religious nature.

Churches and synagogues utilize and display many works of art: murals, mosaics, stained-glass windows, sculptures, tapestries, paintings, etc. The most active churches have separate foundations through which they can attract grants for arts programming.

You do not need to be a member of a church or faith to create a work of art that is appropriate for them. You do, however, need to know that particular denomination's use of signs and symbols. Various colors also symbolize particular festivals and other celebration periods for individual denominations. The architectural style of the church/synagogue, the space, and the preference of the people involved will determine the size, colors, and media of artworks—the same as if you were selling to any other art market.

Contact your local churches by mail, sending them a portable portfolio describing how you may be of service. Follow with a phone call requesting an appointment. If you can show examples of previous liturgical commissions, it would be quite helpful. If not, make some preliminary sketches of possibilities.

Memorials are often purchased by churches, so it is useful if the minister has your information on file. You can also: contact architects who are building or restoring churches; contact new churches going up in the area; contact the regional headquarters of various denominations to find out about new churches being built that might need artwork.

PUBLISHER

Barton and Cotton

Carol White, 10099 SE White Pelican Wy, Jupiter, FL 33469 (561) 743 4700
An art publisher of religious cards. They are always looking for artists who create religious works. They commission or license artwork and are interested in realistic styles. They also work with national nonprofit organizations.

RELIGIOUS MARKETS

Try renting a studio space in a church. This is a great connection as well as a practical idea, as many churches have lots of extra space, need the money, and want to assist artists. Perhaps you can even trade a piece of artwork for the rent.

BUSINESSES

Many corporations consider their support of the arts to be part of their public relations. They are not necessarily measuring their return on the dollar.

Most companies need artwork for their walls. Advertising agencies and upscale office complexes are good places to scout around. Find out who the contact people are in the given business and call them to make an appointment. Suggest to them the possibility of renting or leasing. For many small business owners, paying $100 per month for several nice paintings, i.e., leasing, is much more feasible than purchasing for $10,000. The executives are often overworked and busy, so be patient if they put you off. Some businesses to try are accountants, chiropractors, dentists, doctors, engineers, hotels, insurance companies, lawyers, stock brokers, therapists, veterinarians. Banks and institutions sometimes have unused wall space. Approach the banks with the idea of selling them a series of local scenes, originals or prints. Be sure to offer their employees some kind of deal as well. If buying is not on their agenda, try to procure an exhibit and get some publicity and new buyers.

Corporations may aid the artist in several ways:

1. By selling works in a corporate gallery

2. By donating or loaning supplies and equipment

3. By purchasing works directly from the artist

4. By establishing a foundation that follows the federal rules for grants and awards to individuals

5. By leasing artwork

To receive a commission from a corporation, you don't necessarily have to be well-known. Art consultants work with many emerging artists to acquire artworks for corporations—for decorative purposes in their meeting rooms, foyers, etc. Working with an art consultant is one of the best ways to connect to the larger corporations.

RESTAURANTS AND CAFES

Eating establishments have decorative needs. Watch for new ownerships and keep your eyes open for buildings under construction. Contact the architect or contractor for the name of the person in charge of the art budget.

If and when you do get a show at a good-quality restaurant, have a brief meeting (with the owner's permission) with the waiters and waitresses to inform and inspire them about your work. Offer them a 10% commission when they sell a piece for you.

Try to get the restaurant owners to note your exhibit within their newspaper ads. Make sure that it's okay to label your pieces with the price and that you can leave business cards and price sheets/brochures on the front counter.

MEDICAL FACILITIES

Finally in the new millennium, there is a trend to humanize hospitals. Prints are often the format desired, as they are less expensive and, if damaged, won't be such a loss. Approach the right person and be patient for the right time.

HOTELS

Go to exclusive hotels to see if they need artwork. You might find a gallery there, too, that you didn't even know existed! One good magazine to reference is *Prestige, The Magazine of Small Luxury Hotels*. Look for other reference magazines with the help of your librarian.

COUNTRY CLUBS

Country clubs need art for their club rooms, ballrooms, gift shops and dining facilities. If you do golf art, they are the perfect place for you to exhibit. Country clubs can attract a good clientele even if golf art isn't your genre. They will sometimes rent out facilities for a show and let you use their mailing list of members. One artist in Florida has a show each year at his local country club. Each year he sells out. Can't beat that—and he's not a golf artist!

STORES

Consider selling to frame stores, art shops, print shops, department stores (gift departments), gift stores, etc. Maybe a very fine boutique would be a good place to display and sell your work. Find out if your work is appropriate and call the prospect to set an appointment.

Bring order blanks, brochures, and samples of work. Many stores will want artwork on consignment. Be sure to have a signed consignment agreement if you do leave artwork.

What about florist shops, fine jewelry shops? Start brainstorming. The key is to locate a business that specializes in the same genre as your artwork. If you paint animals, for instance, contact local vets, animal hospitals, groomers, pet supply stores, etc.

Volunteer to bring art into the lives of patients by having an exhibit, perhaps in a special department. You can locate medical facilities nationwide in reference directories at libraries.

• One artist made a great deal with his prints of a local basketball coach when he connected with a car dealership. The company bought all the prints and used them as a sale giveaway to the buyer of each used car.

• One artist did a series of greeting cards and got her images on the front cover of a national azalea publication. She sold out the entire printing.

• One artist connected with the local correctional system in his town and is doing a series of murals on the jail walls.

SPECIALTY MARKETS

Do you do western-style art? Look for rodeos, western shows, western shops, etc. in your area. Specialize in horses? Locate your local horse association and find out when they have gatherings. Do they have a newsletter you can advertise in? How about florals? Lovers of specific varieties of flowers have their own associations, i.e., iris, rose, etc. Do you paint dancers, singers?

ARCHITECTS

Some art sales to corporations can be commissioned through architects. To find architectural firms that are involved in current building and renovating projects, ask your public librarian for local publications that list new construction in your section of the city or county.

➤ *Dodge Reports* is a publication of McGraw-Hill. These reports list new construction plans, describe their scale, and note the architect in charge. A subscription is very expensive ($2000-plus.) For this reason, not many libraries subscribe. Find someone in an architectural firm or construction company who subscribes, and arrange to read them at his/her office.

➤ Call the regional branch of the American Institute of Architects or your local Chamber of Commerce and ask them for a list of architects in your area who specialize in commercial buildings.

➤ Make your own list of architects by looking for building sites. They generally display signs naming the architects.

➤ Speak or display at an architects' gathering.

➤ Be listed in your local arts council's slide registry, where architects often go to locate artists for their projects.

BUILDING MANAGEMENT COMPANIES

These large businesses construct and manage buildings and often decorate their lobbies with paintings and sculpture. They frequently know which of their tenants are interested in buying artwork for their offices. They might need to furnish a model home or apartment, so introduce them to your rental/lease program.

REAL ESTATE BROKERS

Businesses tend to buy art when they relocate. Real estate agents can tell you who is moving where and whether their clients may be prospective buyers.

• One enterprising artist put together a package deal for her local real estate company that they couldn't resist. She discovered that as a promotional tool, when a salesperson closed a sale, he usually gave the buyer an inexpensive print to hang in the new house or office. She put together several medium-and small-sized framed prints and sold them for under $50 each to the real estate company. It worked so well that the artist and her husband took a booth at the state real estate convention and are now selling to real estate companies regionally.
• Another artist teamed up with a sculptor and showed work in several new homes during a builder's opening.

PRIVATE COLLECTORS

You will compile your own list of collectors over the years. It will include all the people who have shown a serious interest in your art, and all the people who have purchased from you. Real collectors are amazing. They can spend thousands of dollars within minutes.

Don't ever give the names of your private collectors to anyone—and don't expect that anyone will ever give you their names either. You will find that these private collectors are usually your best patrons. They love your work and thus sell it to their friends for you—especially if you show you are trying to make it in the artworld. It makes them feel good to patronize an artist. Someday they might give you an opening in their home or business. Court these private collectors. Never take them off your list. Mail to them at least twice a year—better yet, each quarter. Don't lose contact with them, and of course, your artwork that they own.

One artist living in Florida showcased her work in the Encyclopedia of Living Artists. She was surprised to receive a call one day from a collector in Texas. He had fallen in love with her piece in the ninth edition. Within two weeks he flew into Miami just to view the painting and to verify it looked like the picture in the book. He left Miami the next morning, having paid the artist for the piece as well as for shipping to Texas. There was no indecision on the collector's part—just pure and simple love. When someone falls in love with your painting, it is truly the biggest compliment in the world—the highest form of communication. "It all happened so quickly. It was such an exciting event," says the artist. The artist went on to say that this was the most unusual, dreamlike occurrence that she has ever encountered in all her years of marketing her art.

COMMISSIONS

Commissions are works of art produced specifically for a given individual, corporation, interior designer, art council or business. Interior designers, consultants, and architects often require commissioned work— a specific order for a specific product. Decide whether you can and want to do this type of work. Some artists don't like to do commissions. For others, commissions create the right challenge and offer a new direction for their work.

➤ Sign a written agreement for any commission you schedule.

➤ Make sure the contract includes an advance on funds for the cost of materials and part of your time.

If these people don't know you're a fine artist, they cannot be potential clients. You must inform them. Add them to your mailing list. Send them a postcard. Invite them to your studio. They'll be honored!

PORTRAIT COMMISSIONS

Artists who do portrait commissions often have a word-of-mouth clientele close to their home. They often have become known in the area.

There are also portrait dealers throughout the country. Whether you work through a portrait broker or as your own agent, be sure to have your contract in writing. The features of a portrait commission are similar to other types of commissions. You will note what medium you will be using, the size, propose the scale of the figure (full or head), specify if it will have an abstract or detailed background, completion schedule, etc. Don't neglect to include charges for a preparatory study based on a preliminary sitting or photo session. Before you start this preliminary sitting, be sure to collect the first one-third of your commission.

PORTRAIT ORGANIZATIONS

American Society of Portrait Artists
2781 Zelda Rd, Montgomery, AL 36106 (800) 622 7672 (334) 270 9020
www.asopa.com/foundation

Canadian Institute of Portrait Artists
2010 Russet Wy, West Vancouver, BC Canada V7V 3B4

Portrait Society of America
PO Box 11272, Tallahassee, FL 32302 (877) 772 4321 www.portraitsociety.org

ACTION PLAN

❑ List at least 10 potential venues to follow up.

❑ Brainstorm for some creative ways to approach new markets.

RECOMMENDED READING

Artist's Market _edited by Northlight Books_

ARTNews International Directory of Corporate Art Collections _edited by Shirley Reiff Howarth_

The Business of Art _by Lee Evan Caplin_

Chapter 21
Alternatives to Sales

Grants

Grant writing

National Endowment for the Arts

Residencies

Sources of income

"Where shall I begin, your Majesty?" he asked. "Begin at the beginning,"
the King said, gravely, "and go on till you come to the end: then stop."
Alice's Adventures in Wonderland, *Lewis Carroll*

GRANTS

Grants should not be thought of as a primary source of income. In most cases, they are intended to assist an artist while he or she is becoming known.

In this chapter we will cover opportunities—other than direct sale of artwork—for supporting yourself. Not all these ideas work for all artists. Many artists skip over these possibilities entirely in their hurry to get into the New York gallery scene. Explore this chapter and see what might work best for you.

A grant is a gift of money, sometimes called a scholarship or fellowship. A grant does not require repayment. An individual, company or foundation sponsors a grant for a specific purpose or reason. Except for the research and writing time you need to spend, you have nothing to lose by applying. Most grants don't even require a final product.

RESEARCHING GRANTS

You'll need to have persistence, stamina, resourcefulness and luck in your search. If you don't research a grant thoroughly before you apply, you're wasting your time and energy. Find a grant that specifically fits your needs and your artwork.

Foundation libraries carry books specifically on grants. They are the best place to search for grant possibilities. Your local library might also be able to help you find publications that list grants available to artists. Books on grants will give you details on eligibility, deadlines, requirements, etc. Many grants are restricted to a certain ethnic background, geographic location, or religion; some are for study, some for travel, etc. Your local art paper and most national art magazines carry listings of available grants also.

FOUNDATION CENTER LIBRARIES

Plan at least four hours at this library to do your research.
www.fdncenter.org

1001 Connecticut Ave NW #938, Washington DC 20036 (202) 331 1400
50 Hurt Plz #150, Atlanta, GA 30303-2914 (404) 880 0094
1422 Euclid Ave #1356, Cleveland, OH 44115 (216) 861 1933
312 Sutter St #606, San Francisco, CA 94108 (415) 397 0902
79 5th Ave, New York, NY 10003-3076 (800) 424 9836 (212) 620 4230
70 Audubon St #1Fl, New Haven, CT 06516 (203) 777-2386

RESEARCH POINTERS

➤ Keep your eye on the grants for *individual* (i.e., not corporations). *The Foundation Center's Guide to Funding for Individuals* is a good place to start.

➤ If the fund's name and the last name of the principal officer are the same, chances are it's a family foundation. They generally are smaller and more difficult to contact.

➤ The foundation library will have tax reports from each foundation. Check the IRS '990 Form' of the awarded grant giver you're interested in to see whom they gave grants to last year. Maybe their friends or family? Are they all from one geographic area, a certain age group, male/female?

➤ Each funding organization will have different deadlines. Note these on your business calendar to follow up.

Call the funder and ask for an application. If you have any questions that arose during your research, ask them. You are trying to eliminate grantors—yes, *eliminate*. That way your final list of three to five will be very specific and your chances will be much greater of receiving an award. Put these funders on your mailing list. Send them cards of your openings and exhibitions and press releases. You will be cultivating future possibilities.

Once you've gotten down to a list of three to five appropriate grants for which to apply, you will need to fill out forms and paperwork. Applying for a grant does not have to be torture! Following a few guidelines will help you along your way. Read the application packet carefully. Re-decide if you think this is the grant for you. When you have decided it is, your proposal writing starts.

GRANT WRITING

A grant proposal generally contains these parts:

Project Summary - One to two sentences which include the monetary amount of your request. Be specific about time frame and amounts of money. Establish credibility, believability and qualifications. For example, the allotment of $5,000 will be used in 1999 to print a catalog to be used for the Hoyt Museum exhibit.

The Problem or Need - The problem that receiving funds will resolve, as in "I wish to make the most of having received a solo-exhibition at the Hoyt Museum in 1999. A catalog is the best possible manner. By receiving the grant for $5000, I will be able to print a quality catalog of my works, which will be sent to museum patrons, present customers and local art collectors."

The Objectives - The nature of the project, i.e., the project is to include compilation and printing of a catalog of current works for my Hoyt Museum solo exhibit in June 1999.

The Method - How and by whom it will be done, as in "Projected quote from designer through printer for 10,000 catalogs is $5000."

All aspects must be covered in detail and with certainty. Every word counts. You must write concisely and clearly. No rambling. Be direct. No lies. Write and rewrite this proposal, leaving a lapse of time to weed out unnecessary words. You want to make sure you have communicated why your idea is especially worthy of funding.

GRANT WRITING TIPS

➤ Reach the hand of the appropriate funding source. Do your research.

➤ Know whom you are writing this for. Who are the people on the committee?

➤ Find out if the grantor's mandates match your qualifications. You don't want to apply to a grantor who wants to support minorities if you don't qualify!

➤ Usually a grant application will require you to limit your request to a defined space. Therefore you need to make it as concise as possible. It should answer the who, what, when, where, why, and how of the funding request. If a question does not apply to you, write "N/A" or "Not Applicable." They will know then that you haven't overlooked a question.

➤ Don't philosophize. Be specific and clear in your request. If the panel can't decipher your concept, you'll be dismissed.

➤ Phrase your request so that they don't have to read and reread to achieve clarity.

➤ Don't use jargon.

➤ Follow directions precisely; keep your application neat, clean, and easy to read. Most grant guidelines request specific information in a specific format. Comply with all requests in the order requested. If a request is made for three letters of support, don't send five. If an applicant is not willing to follow directions in submitting an application, the grantor may question the applicant's ability to account for grant monies.

➤ Your application should be typewritten or computer-generated, i.e., legible. No typos. Use bold, italic and indentations to emphasize certain ideas. Be sure to have someone proofread the manuscript for typos.

➤ Don't include promises that you can't keep.

➤ Make your numerical calculations clear, correct and easy-to-follow.

➤ Indicate what you hope to do and where the money is going.

➤ When itemizing your expenses, don't forget an artist's fee. You should be compensated for your time, not just the material cost of the project.

➤ Send no extraneous material. Make it as easy as possible for the reviewer to "like" your request.

➤ Be positive. A chip on your shoulder will not get you any grant.

➤ If asked for work samples, send your best.

➤ If you are making a proposal to open a creative arts center, you must demonstrate that you have thoroughly investigated location, cost, time, who it will benefit, etc.

GRANT WRITERS

It is possible to hire a grant writer if you don't want to write the application yourself. Some also are capable of doing preliminary research for your particular needs. They can save you hours of research time.

You are not only writing this grant for the funding foundation, but you are writing it for yourself. You will come to understand your artwork and aims much more clearly once you have gone through this process. It often inspires new ideas and brings into your consciousness latent thoughts.

LOCATING GRANT WRITERS

➤ Call one of the foundation libraries.

➤ Look in your local art paper in the classified section.

➤ Ask your local arts council.

➤ Contact a local Lawyers for the Arts organization. They often hold seminars on grant writing.

MEETING WITH JURORS

If you've passed the written proposal, the next step is meeting with the jury panel in person.

➤ Arrive early. Relax. Breathe deeply.

➤ Before your meeting, learn their names. Research their vocations and interests. Determine the key person(s).

➤ Plan your agenda to include three to five goals and key points, as well as an opening and summary. Thank them for the opportunity.

➤ State your objective and purpose, considering what they want to know.

➤ Conduct an interactive dialogue—no monologues. Establish eye contact. Their questions and your answers should comprise at least one-third of the presentation.

➤ Don't become defensive over objections that might be raised. If need be, ask for clarifications of their question or concern.

➤ Remember, you are not selling anything; you are explaining a project you would love to be able to accomplish.

REPORTING GRANTS TO THE IRS

Most grants must be included in your annual income tax return. Only grants that meet one of the following criteria *may* be tax free:

➤ Recipient is selected without any action on his part.

➤ Recipient is not required to render services as a condition to receive money.

➤ Amount of the award is transferred to a tax-exempt government organization.

Send a thank-you note if you are awarded a grant, to all levels of the foundation; the president, the secretary whom you spoke to many times on the phone, etc. You will continue to send them cards and press releases—they are one of your best clients. If someone you've come to know goes to another agency, be sure to send them postcards and press releases at their new address.

Try to find out before you apply if the grant is taxable. If it is taxable, see if you can split the monies received—50% in one year and 50% in the next. Additionally, for your own personal accounting it might be best to have monthly payments transferred to your checking account so you don't spend it all at once.

RESOURCES

Americans for the Arts

1 E 53rd St, New York, NY 10022-4201
(800) 321 4510 ext 225 (212) 223 2787
Opportunity Factsheets

Associated Grantmakers of MA

55 Court St, Boston, MA 02108 (617) 426 2606

Going for Grants

NYFA, 155 Ave of the Americas 14th Fl, New York, NY 10013-1507
(212) 366 6900
A 20-minute video focusing on the most productive ways individual artists can approach foundations. $13.50ppd.

Grant Searching Simplified

(800) 383-0677 (530) 470 0862 www.artmarketing.com/grants
Workbook on how to apply and research grants: $29.95. Comes via e-mail in PDF format.

GRANT WRITERS

Nancy E Quinn Associates

50 Oak St #304, San Francisco, CA 94102 (415) 621 3186 (415) 621 3110 Fax
<quinnassociates@aol.com> www.nequinnassociates.com
A group of grant writers providing arts management and fundraising assistance.

Hannah Ullman

(800) 442 0788 (510) 898 6322 www.moneyforart.com
Extensive help for artists wanting to procure grants.

Grants and awards are not generally subject to the self-employment tax (Schedule SE). Call (800) 829 1040 for IRS Publication 520 which details reporting requirements for grants.

REGIONAL ARTS ORGANIZATIONS

Arts Midwest
528 Hennepin Ave #310, Minneapolis, MN 55403 (612) 341 0755
Illinois, Indiana, Iowa, Michigan, Minnesota, North Dakota, South Dakota, Ohio, Wisconsin

Mid-America Arts Alliance
912 Baltimore Ave #700, Kansas City, MO 64105 (816) 421 1388
Arkansas, Kansas, Missouri, Nebraska, Oklahoma, Texas

Mid-Atlantic Arts Foundation
22 Light St #300, Baltimore, MD 21202 (410) 539 6656

New England Foundation for the Arts
330 Congress St #6Fl, Boston, MA 02210 (617) 951 0010
Connecticut, Maine, Massachusetts, New Hampshire, Rhode Island, Vermont

Southern Arts Federation
1401 Peachtree St NE #460, Atlanta, GA 30309 (404) 874 7244
Alabama, Florida, Georgia, Kentucky, Louisiana, Mississippi, North Carolina, South Carolina, Tennessee

Western States Arts Federation
1543 Champa St #229, Denver, CO 80202 (303) 629 1166
Alaska, Arizona, California, Colorado, Hawaii, Idaho, Montana, Nevada, New Mexico, Oregon, Utah, Washington, Wyoming

NATIONAL ENDOWMENT FOR THE ARTS

NEA
1100 Pennsylvania Ave NW, Washington, DC 20506 (202) 682 5400

RESIDENCIES

Artists send excellent reports on the stimulating and rewarding time had when attending a retreat or residency.

Residencies, art colonies, art communities and retreats are places that provide opportunities of space, free of distractions, so an artist can focus on a specific undertaking in a serene and creatively supportive environment. They also provide a congenial atmosphere for the exchange of ideas with other artists. Many are free (a grant award). Some require a nominal fee.

TIPS

➤ Contact your local or state art council for more details about specific opportunities.

➤ ArtNetwork has a mailing list of 200 grants and residencies available on peel-and-stick labels. You could mail a postcard to each requesting information (800) 383 0677.

➤ Watch the listings in the back of your local or national art newspaper/magazine for deadlines.

TRAVEL PROGRAMS

A number of opportunities exist for artists to travel and study abroad, with the assistance of a fellowship or scholarship to cover full or partial expenses. Fullbright grants provide funding for a year of study and training overseas.

RESOURCES

Allworth Press
10 E 23 St #210, New York, NY 10010 (800) 491 2808 (212) 777 8396
www.allworth.com
Publishes Artists Communities: A Directory of Residencies in the United States That Offer Time and Space for Creativity, *$18.95.*

Lucky Dog Multi-Media
PO Box 65552, St Paul, MN 55165-0522 (651) 771 0909
Go Wild! *is a 52-page booklet listing national park residency programs. $7.45ppd.*

SOURCES OF INCOME

Wayne Thiebaud, a world-renowned artist, was a teacher for 30 years at UC Davis in California.

Besides selling your artwork, you may need to augment your income through some art-related activity. This can lead to good connections and, eventually, clients for your artwork.

➤ Teach art at a college, through an adult education program, art organization, craft shop, art store, YWCA.

➤ Work at an art museum.

➤ Be a judge or juror for a show.

➤ Write a column for a local art paper.

➤ Organize a lecture or slide show.

➤ Start a local art newsletter.

➤ Work at a gallery or framing gallery.

INTERNSHIPS

Internships occur mostly in art organizations or museums. An intern may assist a director in a museum, an art organization or even another artist. Not only are you learning the trade, but you are meeting people, among them potential clients. Some interns actually get paid.

Volunteering your time can connect you with local arts councils, art organizations, museums, etc. These groups have access to gallery space, slide registries, job banks, studios, credit unions and technical assistance. The more people who know you are an artist, the more chances for commission referrals.

INTERNSHIP POSSIBILITIES

New Museum of Contemporary Art
583 Broadway, New York, NY 10012 (212) 219 1222
Has a multi-cultural internship program that provides training and experience in the museum field.

HOUSING/WORK SPACES

In the last several years, art housing projects have cropped up all over the country. Keep in contact with your local arts council for possibilities in your area. Sometimes these housing projects include live-in space, sometimes only studio space.

RESOURCE

Space Place
Maria Walsh Sharpe Art Foundation, 443 Granite St #7Fl, New York, NY 10013 (212) 925 3008
Subsidizes studios in New York City.

BARTERING

Bartering is an age-old concept. Today many small and large firms are successfully bartering for products they need—in fact, some of these companies have bartering departments.

We have known artists who have bartered for dentistry work, doctor visits, motorcycles, printing, logo design, photographing artwork, ad space and much more. People are generally quite willing to strike an agreement. There are more benefits than just the trade. Having a painting in your dentist's office could bring you more business.

If you do barter with someone, it's best to put in writing what you are trading, to make it clear for both parties.

Remember the IRS when you barter. Under the Tax Equity and Fiscal Responsibility Act of 1982, your exchanges are taxable on the fair market value. Too bad we can't barter with the IRS!

ACTION PLAN

❑ Decide whether or not to apply for a grant.

❑ Research an art retreat for vacation.

❑ Try bartering with your dentist for your next appointment.

RECOMMENDED READING

A Day Book, Journal of an Artist *by Anne Truitt*

Artists' and Writers' Colonies *by Gail Hellund Bower*

Career Opportunities in Art *by Susan H Habenstock and David Joselit*

Individual's Guide to Grants *by Judith Margolin*

Money for Visual Artists *by Suzanne Niemeyer*

Opportunities in Visual Arts Careers *by Mark Salmon*

Chapter 22
The Print Market

Self-publishing

Alternative printing methods

Where to market prints

Locating a publisher

 Contracts

Other publishing possibilities

 Calendars

The future belongs to those who believe in the beauty of their dreams.
 Eleanor Roosevelt

SELF-PUBLISHING

In the print world money is made by volume sales.

The publishing industry is the largest part of the art industry—a multi-billion-dollar segment to which some artists are adverse. Some believe in the myth that multiples degrade their work. You might be doing your career a disservice if you aren't considering the idea of publishing, though.

There are two basic methods of getting your work into print:

➤ Publishing it yourself; pay for printing and marketing yourself.

➤ Having an established art publisher print and market; you receive a royalty.

Many artists believe they can make lots of money by self-publishing their work. They forget, however, about the marketing aspects. At least 50% of your time, energy and money will need to be spent on marketing. With an original, you sell it once. With a print, you must sell it hundreds of times. Not only will you have to finance the printing, but you will also need to organize and participate in the marketing. Many artists are over-charging on their prints, and thus not selling. If they sold in the $10-20 range they would be selling.

For other artists, self-publishing is the right direction to go. They have lots of outlets at which to sell their prints: outdoor shows, galleries, tourist shops, etc.

Under most circumstances, it is recommended that artists seek out a publisher.

If you want to go into self-publishing, you need to have a very detailed marketing plan in position before you spend $2000-10,000 on prints. One of the most common requests I receive is, "How can I *get rid* of my 500 prints sitting under my bed?" They don't even ask how to sell them, but how to get rid of them! Don't let this happen to you! Plan ahead.

ADVANTAGES OF SELF-PUBLISHING

➤ You make 100% profit less the marketing costs, of course, which can be enormous.

➤ You have total control of the production of your image.

➤ If you sell at outdoor shows, self-publishing can be a boost to your sales.

➤ You increase exposure to all economic levels that can't be reached with originals.

➤ If your prints begin selling, your originals become even more valuable.

➤ People who like your work and originally buy a $100 print will often return as collectors and buy another print (or, if their income has increased, an original).

DISADVANTAGES OF SELF-PUBLISHING

➤ Output of money

➤ Output of time; you must do all the research, marketing, etc., unless you have funds to hire someone. You might be able to locate a distributor, but this also takes time and searching.

➤ You personally have to sell 250 times the quantity of an original. How many have you sold before?

You'll need to study the print market, go to print galleries, ask them what sells. Get brochures from big print houses; look at magazines to see what is advertised and what is selling.

BOOKLETS AND MAGAZINES

Producing and Marketing Prints
Sue Viders, 9739 Tall Grass Cir, Littleton, CO 80124 (800) 999 7013
<viders@worldnet.att.net>
A great book by Sue Viders that takes you through all the steps of self-publishing. $14.95 plus shipping. Also available is an audio tape covering color theory and pricing by Sue Viders called Hints on Prints. *The $19.95 price includes a resource booklet. Also* Marketing Plans for Print Artists *is $9.94 + shipping.*

Art Business News
(888) 527 7008
Subscribe to this magazine to study what other companies are publishing.

Decor
(314) 421 5445
Retail poster shops are the main subscribers to this publication.

Ask yourself two questions before you spend money on prints:

Will they be cost-effective?
Will they sell?

LIMITED EDITIONS VS. OPEN EDITIONS

A true limited edition is one that can have total pre-sales. For example, when Bev Doolittle prints limited editions—often in the 20,000 quantity range—she has pre-sales on all these prints!

Many artists print a limited edition before they ever print an open edition. They think they will receive a higher price for this limited edition. This is bad logic. In fact, when I see limited editions from an emerging but still unknown artist, these limited editions mean nothing to me unless they are in an edition of 50 or less. The way I measure whether an artist has the clients to print a limited edition is: can he/she sell the entire print-run within one or two years? Many times, when I see limited editions being sold by an artist who is new to the marketplace, I think she is charging far too much: $150-250. This price range is for the more established artist's prints.

If you do have a limited edition, you need to personalize it: sign it, repaint on it, frame it uniquely. Having a certificate of authenticity can, in the same manner, add value to an open edition. If you sign an open edition, you can charge $5 extra. Why not use gold ink or something special?

Current economic trends show that items priced over $20 may undermine typical impulse buying. Take this advice and start out by selling open edition prints in the $10-20 range. If sales become brisk, raise your price.

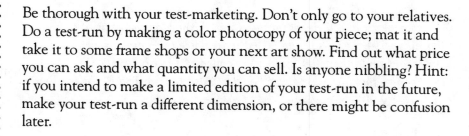

Be thorough with your test-marketing. Don't only go to your relatives. Do a test-run by making a color photocopy of your piece; mat it and take it to some frame shops or your next art show. Find out what price you can ask and what quantity you can sell. Is anyone nibbling? Hint: if you intend to make a limited edition of your test-run in the future, make your test-run a different dimension, or there might be confusion later.

You need to know your printing costs (get quotes from several printers), who your target market is, the number of prints you must sell to break even.

Then you need to make contacts with distributors, approach possible free promotional sources and design your marketing materials.

Today there is a wide variety of choices regarding reproductions. Depending on your purpose and intent, you will want to investigate some of the varieties mentioned on the next pages.

IRIS/GICLEE PRINTS

Iris prints seem to be the most talked-about type of printing these days. The Iris Graphics Printer was first presented at a trade show in 1987. Designed for color accuracy, it did not, at that time, find its way into the fine art market, mostly due to the lack of archival longevity that it provided. Through the years the archival quality has been improved, and since 1994 Iris printers have been hot on the market for fine art reproductions. The Iris printer is a four-color, continuous-tone printer that can accurately reproduce multiple color transitions and intricate detail. Print quality is as good as, and some say better than, screen printing or traditional lithography. Iris printers create images by spraying microscopic droplets from a nozzle onto a substrate that is attached to a drum rotating at 100-200 inches per minute. These droplets, indistinguishable to the naked eye, build a lush and vivid surface at 1200-1800 dpi (dots per inch), making this method of reproduction quite good for hard-edged painting or fine-grained photographs.

The process starts with a digital image stored on a floppy disk, tape or cartridge. Resolution and files vary depending on the nature of the image and the size for output. Each service bureau prices and works differently with its artists.

Consider the following carefully:

Paper. Choices are varied. Be sure to inquire about this.

Pricing. You will need to inform the service bureau about file formats and sizes, output size, type of paper. A typical price ranges from $170-350 for the first 20x40″ image on watercolor paper with UV coating. Subsequent reorders will cost less. You need to remember that, although you have proofed it, different batches of inks create slightly different tones. Ten prints will cost an average of $60 each.

Color. If you plan to do Iris prints and are working from a computer, work with a color palette that has been calibrated to your future Iris printer.

Coating. Some printers use coatings to protect the finished work.

Sizes: Size capacities vary slightly. 34x46″ is standard.

Be sure to place orders in writing and keep a copy of your order—then there is no confusion on either party's side. You might want to have the printer sign a notice of a policy regarding prints: "No additional images are printed for any reason whatsoever without the explicit written permission of the artist."

Documenting these prints is important. Note artist, title of work, medium, image size, paper size, paper print number, edition size, number of proofs and pertinent dates.

It is good to have a "Note of Verification" which states, "I guarantee that the above information is correct and that no other proofs or impressions exist that are not part of this documentation sheet." This should be signed by both printer and artist.

Your image doesn't have to start on the computer. Your two-dimensional piece is scanned onto a computer disk.

GICLEE SERVICE BUREAUS

Bishop Street Press
300 Ohukai Rd #C2-203, Kihei, HI 96753 (800) 818 6189 (808) 874 8808 <iame@maui.net>

Classic Editions
3185-G Airway Ave, Costa Mesa, CA 92626 (714) 432 7212 www.ClassicEditions.com

Cook Editions
1740 DeFoor Pl, Atlanta, GA 30318 (404) 351 6776

Coupralux
1616 C Hi Line Dr, Dallas, TX 75207 (214) 760 0080

Finer Image Editions
5901 Noble Ave, Van Nuys, CA 91411 (800) 464 2864 (818) 373 1100 www.finerimage.com

Fine Print
1306 Blue Spruce Dr, Fort Collins, CO 80524-2067 (800) 777 1141 (970) 484 9650 (970) 416 6352 Fax www.fineprintimaging.com <mlukes@fineprintimaging.com>

Harvest Productions
8050 E Crystal Dr, Anaheim, CA 92807-2524 (714) 279 2300

Hunter Editions
PO Box 1130, Kennebunkport, ME 04046 (888) 278 4747 www.huntereditions.com

Winthrop Editions
49 Central St, West Boylston, MA (508) 835 4880 www.naturegallery.com

ALTERNATIVE PRINTING METHODS

COLOR PHOTOCOPY/COLOR LASER COPY

Check your local printer for prices. They print from photographs, originals, or in some cases, from slides. Check out a few machines before you decide which is the best.

I purchased a color photocopy print for $20 from an artist at an outdoor show. He had the original at the booth. It was striking to see how closely the colors matched. The color photocopy was just as good as a lithograph could ever be. At $20 it is not intended to last a lifetime!

PHOTOGRAPHIC PRINTS

You can sell these at local outdoor shows. Try your local color lab.

MICROPIX

These prints are individually hand-pulled. You can create 4-10 prints at a time. Printed with environmentally-friendly water-base inks on 100% rag paper, Essex, 270 gram (110 lb), acid-free, buffered with calcium carbonate to prevent environmental contamination. Artworks with strong, sharp colors or soft, delicate shades are captured equally well. Maximum size is 24x24" (paper 24.5x24.5"). Prices are calculated by combined inches (length plus width); 18x24" or 42 combined inches would cost $109 for four prints, plus $19 for the initial proof. Certificates of Authenticity are $2.00 for four. Contact Dennis at Micropix, 900 Walt Whitman Rd, Melville, NY 11747 (516) 271 2808 8490 Fax.

ROSCO

The world's first product for digital art murals offers a unique process to reproduce your art as seamless works in color up to 16x62' from photographic transparencies and digital image files. Final piece is suitable to indoors or outdoors. Contact 5945 Pacific Center Blvd #510, San Diego, CA 92121 (619) 597 1177.

THERMASTROKE

A versatile process (patented) for recreating textured art, from canvas/linen weaves to exact duplicates of originals including heavy impastoed works. Several levels of texture are available. Considerable research and testing has been done to guarantee the best permanent inks, UV absorbing barriers and non-yellowing surfaces.

CanvasMarque images can be replicated on surfaces such as fine linen, rough linen and a variety of canvas weaves. Unlike canvas transfers, the imagery is on the surface just like an original painting, thus the brilliance and resolution of the image is retained, and glare is virtually eliminated. Artist-enhanced brushwork in pigmented mediums or clear gels is available as an option. Contact St Croix Technologies Inc, 527 205th Ave, Somerset, WI 54025 (715) 247 4174.

PRINT ON CANVAS

This process takes a print or photograph and, through heat, pressure and adhesives applies it to the canvas. It is then stretch-mounted on wood bars and finished with a raised, brush-stroke or pallet knife texture. 24x30" is $72 plus $10 shipping. Contact Fine Art Prints on Canvas, 6206 Mission Gorge Rd, San Diego, CA 92120 (619) 582 6858. Color Q has also introduced prints on canvas. Contact them at (800) 999 9818 for full details and pricing.

ACCUBALANCE DIGITAL CAMERA

Printing with no film intermediary. Carter-Rhoads Editions, Bob Hall, 318 S Dixie Hwy, West Palm Beach, FL 33401 (561) 659 5242 <bob@carter-rhoads.com> www.carter-rhoads.com

TIPS

➤ Perhaps you can get financing from former buyers or collectors by offering them the first print in the series. You'll be gathering the necessary money and selling prints at the same time.

➤ When you produce a limited edition print, you must keep track of *each* print that is taken out of the studio, whether on consignment, to be framed, sold (note the collector's name, who sold it, and how much you received), or for an exhibit. Use 3x5" index cards.

➤ You should also keep an historical record (some states require this) of your methods and procedures—where you made the print, who assisted you, type of paper, size of paper, size of image, whether or not the screen or block was destroyed, number of prints, number of artist's proofs, numbered impressions, etc.

➤ It's helpful to keep notes on color formulas and other details for future reproductions.

Register your limited edition or poster in the same manner you register your slide copyright, but this time you send an actual print for the Copyright Department's archives.

FOUR-COLOR POSTER PRINTERS

Colson Printing

711 N Oak St, Valdosta, GA 31601-4599 (800) 323 7280 (912) 242 7015
www.colsonprint.com <art@colsonprint.com>
Has an excellent art information kit, free.

Color Q

2710 Dryden Rd, Dayton, OH 45439 (800) 999 1007 (513) 294 0406

IMAGE EVALUATION

Sue Viders

I9739 Tall Grass Circle, Littleton, CO 80124 (800) 999 7013
<viders@worldnet.att.net>
Author of Producing and Marketing Prints *and an international art marketing consultant, Sue Viders is offering a practical evaluation of the marketability of your artwork chosen for prints. Send her a picture (no slides), a short note with specific questions and SASE. This is a free evaluation sponsored by Color Q Printers.*

WHERE TO MARKET PRINTS

Spend some focused time thinking about the marketing of your prints before you actually commit to printing. This is the main step artists neglect. Think about people in your own locale who might be willing to support your artistic talents: bank, library, corporate office, doctor office, dentist office, business, etc.

If you want to expand your market from outdoor shows or gallery exhibits, try local museum gift shops, retail gift shops, frame shops, interior decorators and specific retail stores in your area. These people will be useful in selling your prints but also might be interested in your originals. Realtors, who often give a print as a housewarming present to new home buyers, are another good possibility. Scan the local ads for building permits. New offices often need decor for their walls and would be glad to see a local artist's work.

An artist from Northern California stated that the most important aspect of selling prints or going into the publishing business is getting your name out there. Create a distinctive advertising campaign and logo design so people will remember you. Plan a good publicity schedule. If you advertise, be sure to do repeat advertising. Your image and logo must get out there. The same artist said that the worst thing about getting published is that you get categorized, i.e., a landscape artist, a marine artist. It's hard to break away from a particular category once you're published. People expect you to create the same images. She also suggested letting someone else choose the pieces you are going to print, such as a gallery owner or art professional. Professionals pick the pieces that sell better and choose what the audience will appreciate.

DISTRIBUTORS

These sales reps sell prints wholesale to poster and frame galleries and specialty shops such as zoos, florists, etc. Finding the distributor is not easy. After you find one, you must continue to find more! What if he goes out of business? Distributors want to see quantity. They don't want to represent one print; it's not time-efficient. ArtNetwork has a list of print distributors available (800) 383 0677 .

ADVERTISING VENUES

Art Business News Annual Guide

(800) 598 6008

Comes with annual subscription

Decor's Annual Sources

1801 Park 270 Dr, Maryland Heights, MO 63146

(800) 867 9285 (314) 824 5500 www.decormagazine.com

FREE PUBLICITY VENUE

Showcase

1801 Park 270 Dr, Maryland Heights, MO 63146

(800) 867 9285 (314) 824 5500 www.decormagazine.com

Each month Decor *magazine presents new limited editions and posters. Send a press release and photo/slide of new poster two months prior to desired publication date (they don't guarantee free publicity!). Be sure to include the title, original medium, edition size or open edition, quantity of signed and numbered copies, contact phone number and address information.*

PRINT TRADE SHOW

Many publishers attend the up-scale trade shows for artworld professionals: ArtExpo, Art Chicago, Art Miami, etc. There are also some trade shows for the middle -and lower-end print market.

Art Buyers Caravan

1801 Park 270 Dr, Maryland Heights, MO 63146

(800) 867 9285 (314) 824 5500 www.decormagazine.com

Shows throughout the country sponsored by Decor *magazine.*

My personal recommendation to most artists is to search for an established publisher.

➤ You'll have no financial output.

➤ A minimum of your time will be spent on promotion.

➤ At minimum, you are getting some exposure—perhaps even advertising that you couldn't afford (i.e., your name is getting out).

➤ You have printed work that you can buy back at wholesale (make sure it's in your contract) from the publisher and resell at your shows.

Of course there are disadvantages: your publisher might not be that good a promoter; therefore your artwork doesn't sell; a particular publisher might not be honest; therefore you don't get paid for all prints that sell. This makes many artists uncomfortable. Ways to avoid this:

➤ Know this aspect of the print world from the start. If you do not feel confident that your publisher is honest, don't work with him.

➤ Make sure your contract states that you can audit the company every 12-18 months. Read more about this in Chapter 23.

After you find one publisher, don't give up searching for more. It's an ongoing process. Never put all your eggs in one basket. If you have a poster publisher, look for a limited edition or greeting card publisher Just as with all parts of marketing, you never stop searching.

SEARCHING FOR PUBLISHERS

The Artists Market
F&W Publishing (800) 289 0963
An annual book listing art and book publishers.

LOCATING A PUBLISHER

If you place ads in a variety of venues, be sure to code them so you can be aware of which sources are productive.

US Art Magazine
220 S 6th St #500, Minneapolis, MN 55402 (612) 339 7571

George Little Management
(800) 272 SHOW www.glm.com
Attend a trade show a publisher exhibits at: ArtExpo New York and Los Angeles, Boston Gift Show (March and September); National Stationery Show (May 1 in NY), Atlanta National Gift Show, Chicago Gift Show (January and July) at McCormick Place Expocenter; NY Gift Show (January and August) at Jacob Javitts Center.

Gift and Stationery Business
1 Penn Plaza, New York, NY 10019 (212) 714 1300
A magazine with leads.

Local card stores
Look on the backs of cards for addresses. Many of these greeting card publishers also print posters and limited editions.

FIVE STEPS TO A PUBLISHED PIECE

➤ An artist creates the image.

➤ A publisher makes arrangements for the artist to work with a certain printer.

➤ A printer prints the artist's work.

➤ A distributor markets the print to a retail dealer (sometimes publishers are also distributors).

➤ A retailer markets the print to the public.

Give publishers a great idea on how to use your work, i.e. a calendar with a particularly vogue idea behind it.

WHAT DO PUBLISHERS PAY?

The amount of royalty the artist will receive for a print contract will vary. What I have seen lately in this market is that the artist generally receives about 5-10% of the wholesale.

Instead of being paid quarterly, try to have your contract state that you will be paid a lump sum up-front. In that way you won't have to worry about whether or not the publisher is being honest in his calculations. With this kind of advance, the publisher is still limited, per the contract, to how many he can print.

HOW TO APPROACH PUBLISHERS

Publishers are approached similar to the way you would approach a gallery. Publishers are less interested, however, in your resumé. When someone buys a $2500 artwork, she wants proof it's worth that much—a history. When people buy a $20 print, they don't care about the history of an artist. A publisher is mostly interested in the impact of the image. She also wants to know that you can produce more pieces in that same style. What if they loved one of your pieces, contracted you to print it, it sold out quickly, people wanted more and you couldn't produce more of that same style? They would be losing out on a lot of sales possibilities. All the original promotion they did for your work is only feeding that one piece! That's not cost-effective.

A contract is a must.

Always copyright your work before sending it to a publisher!

CONTRACTS

Some points to remember before signing:

➤ How are you paid, royalty or flat fee? Royalties may take a long time to dribble in.

➤ If paid in royalties, do you get an advance? Try to negotiate a nonreturnable advance.

➤ Will they want to buy the original artwork? Try to keep it if possible. The value will increase as the reproductions become successful.

➤ Will they provide insurance while the artwork is in transit? Will they pay for shipping?

➤ Do they want exclusive representation?

➤ What kind of promotion do they provide? Catalogs? Mailings?

➤ How large will the edition be?

➤ Number of artist's proofs? How will they be designed and numbered? Does the publisher require any artist's proofs for sale?

➤ Number of printer's proofs for use as documentation and for promotion and exhibition purposes? Usually these are not marketed. These proofs can be stamped on the reverse side in large letters to identify them as printer's proofs. Provide for one printer's

proof to become the property of the printer pulling the edition. All plates should be preserved in their cancelled states for art historical purposes. The contract should specify whether such plates are to be the property of the artist or the publisher.

➤ All trial proofs that are not destroyed should be the property of the artist and should be delivered to the artist on or before the date of publication of the edition.

➤ Specify return of transparencies to the artist after printing.

➤ Provide for delivery to the artist of a cancellation proof showing that the plate or stone has been destroyed or otherwise rendered unusable for further printing.

OTHER PUBLISHING POSSIBILITIES

BOOK PUBLISHERS

Many artists' artwork could be used as cover designs for books. Several fine artists have taken advantage of this venue. Most publishers use the exact artwork you have created for their book cover design. If it was a success they will use another piece, perhaps even commission a piece. Usually you create the piece in whatever size you normally do, then the book publisher sends a photographer to meticulously photograph it for reproduction. The exposure your distinct style can receive on a bestselling book cover is phenomenal.

RESOURCES

International Graphics
Dennis Kirk, 11923 E Beryl Ave, Scottsdale, AZ 85259 (480) 314 9275
Expert in design, layout, marketing and promotion of self-published books for artists.

ArtNetwork
(800) 383 0677 (530) 470 0862
Has a mailing list of 330 book publishers on labels.

One artist had her first book cover on a bestseller. She quickly made postcards of her art piece (she did not relinquish total rights to the artwork!) and sent them out to publishers she had researched. Within two years she had contracts for 20 book covers, her prices escalating slightly each quarter. Her career boomed with this exposure. She had already had a print publisher and started publishing some of her own prints. She was in many galleries across the country, and because she had prints already made for them to sell, they loved her. She went to signings and really promoted herself. In other words, she took the ball and ran. She was off to the Bahamas for rest and recuperation last time I talked to her!

POINTERS FROM A REP

This artist is fortunate. She has a niche—the tourist trade in Hawaii—and a rep—her husband. He markets via retail outlets, interior designers, consultants, private sales. He started by looking in the Yellow Pages and calling interior designers. One of these designers got his wife a commission for a hotel. The hotel wanted some originals and a large quantity of prints. With the monies from the contract, they were able to print four pieces for the hotel, keeping several hundred pieces for future distribution. Over 75% of their gross income now comes from sales of reproductions like these.

He recommends getting 4x5" transparencies of all your artwork. All reproductions should be of excellent quality. If a piece is sold, you might not have another chance to get film work later. Even if you have to pay double for the transparency, it's worth it.

He suggests working closely with a printer. Work locally so you can easily be at the press run. Before the press is set up, find out what pieces of paper will be blank, and plan to use this space to print small business cards, gift enclosure cards, etc. Don't waste any white space when printing.

He makes sure that interested tourists are able to contact him easily by putting his name and address on the back of each printed card. These note cards are his best form of advertising. He also puts a small note into each box of cards, stating "send for free brochure."

A computer is a must if you are going into the publishing business, to keep your lists updated, create mailers, and do your accounting.

RECORD COMPANIES

The record industry also uses fine artists for their CD and cassette covers. You could propose a particular idea for a CD cover of your favorite entertainer, or show them your style in general. Send for guidelines on how to approach each company.

CALENDARS

Planning a calendar is a long project. If you are already selling other products wholesale, you will eventually want to offer your customers another affordable product. A calendar could be the answer. People who get excited about art in a calendar want to share it with friends and thus buy calendars for gifts.

TYPICAL CALENDAR PRODUCTION SCHEDULE

Mock-up occurs 14 months before the final product is put on the market. The mock-up is what will be sent to trade shows and reps.

September. Mock-up starts.

December. Mock-up is finalized.

Spring. Mock-ups are shown at shows/orders are taken.

Summer. Printing is finished/orders are sent.

Fall. Calendars are in stores for the following year.

ORGANIZATION

Calendar Marketing Association
Dick Mikes, 710 E Ogden Ave, Naperville, IL 60563 (630) 579 3264
(630) 369 2488 Fax www.calendarmarketplace.com <cma@b-online.com>
Call or write for information on what this association offers.

Everyone buys calendars, maybe even two or three a year.

ACTION PLAN

❑ Calculate the costs of making a print.

❑ Consider printing small quantities by alternative methods.

❑ Start searching for a publisher.

❑ Consider the idea of finding a book publisher for commissioned covers.

❑ Contact calendar publishers.

RECOMMENDED READING

Artists of the Page: Interviews with Children's Book Illustrators *by Sylvia & Kenneth Marantz*

Handbook of Pricing & Ethical Guidelines *by Graphic Artist's Guild*

How To Be a Successful Illustrator: A Practical Guide *by Ray Evans*

Publishing Your Art as Cards, Posters & Calendars *by Harold Davis*

Song Writer's Market *edited by Cindy Laufenberg*

Chapter 23
Greeting Cards

Self-publishing

Handmade cards

The printing process

Locating a greeting card publisher

They gave it to me for an un-birthday present.

Through the Looking Glass, *Lewis Carroll*

SELF-PUBLISHING

Cards canserve to introduce your artwork to a wide spectrum of people.

Whether you decide to find a greeting card publisher, publish your own greeting cards, or make handmade cards, you will need to know the ins and outs of the greeting card industry. If you don't do your homework and study the greeting card marketplace, you will get lost and find failure quickly.

The greeting card business is a huge part of the publishing world. Seven to eight billion cards are sold annually. Billions of dollars ($6 billion in 1996) pass through greeting card industry accounts each year.

Think of a *new idea* to bring to the greeting card industry. One lady makes cards with buttons attached. Another artist makes fragrant cards, another Braille cards. What is your niche?

Each line, however popular it may be, will need to continue to add new designs and concepts. Once you start a line, you want to expand it by creating cards for a variety of occasions and seasons so both your rep and store remain happy. No one-year plans here. You will need a well-created, five-year business plan to succeed in this business.

Many artists are starting their own greeting card business these days; however, 80% of the cards sold are from full-service companies such as Hallmark (40%), American Greetings, Gibson, etc. Only 20% of the market is alternative or niche marketers. As a solo creator and publisher of your cards, this last market is the one you'll be in.

CYCLE/TIME-LINE

Often a card has only an eight-month life-span, a life-span similar to products in the fashion industry. Of course, there are exceptions. Some cards and designs, especially those with well-known characters, will be seen year after year.

The greeting card industry has a high and low season. The quieter seasons are November-February when all the Christmas orders have been taken, and indeed the Valentine orders, too. New lines are being prepared for the Spring Stationery Show in New York in mid-May.

TIPS

➤ Cards are put on shelves with the top one-third showing. Create your design and wordage with this in mind.

➤ Cards on uncoated stock are often avoided by store buyers

because they quickly become dirty and crumpled from handling.

➤ Most buyers want cards to state the occasion on them, so make your cards specific. Probably 50% of the market is birthday cards, the next largest market being Christmas cards (partly because they're purchased by the box); then Valentine's Day, Easter, Mother's Day, Father's Day, Graduation, Thanksgiving, Halloween. Don't leave them blank inside unless you package them for writing cards.

➤ Make your card appeal to both sexes. If you have to create for one sex, keep in mind that 85-90% of all cards are purchased by women.

➤ Front color is very important.

➤ Colored envelopes can be catchy but not too dark—the writing won't be legible.

➤ Organize your card inventory so you can easily keep track. Each style will probably have a set of 12-16 cards. For coding put the style, name, and year it was printed on the back as part of your code.

➤ The back of the card should have the name of your card line, logo, artist's name, identification number (you make this up!), price, ™ sign if you've trademarked your image, copyright year, and "Printed in (country)" if imported.

HOW REPS WORK

Most companies sell their cards through reps. These reps show several lines of cards, often going to trade shows around the country, as well as directly to clients' stores. The presentation which reps carry to show your line is very important. Many reps require as many as 48 samples to choose from. They want to see that you have a varied and unique line, that you will keep producing and that your price is right. They also want to feel they can sell your work.

➤ Reps take orders and get a commission from you on the orders they pass on to you. You fill the order, ship it and pay the rep.

➤ Reps generally receive 20% of their gross wholesale orders.

➤ Reps are paid 20 days after you ship to the customer for whom the rep took the order.

Time line of a greeting card:

February

Ship and invoice orders

March

Receive payments from stores, and pay reps

May - August

Trade shows

September

Fill orders

October

Start designs for next year

November

Select designs

December

Print new samples to take to trade shows next year

➤ Reps generally have exclusive sales territories. They also may have a specific industry (i.e., florist industry, children's accessory stores, etc.). A greeting card company often has two to eight reps in one area covering all the various markets.

Interview greeting card reps and check their references, just as you would a potential employee. Verify the territory they cover, length of time in business, retail accounts they call on (i.e., how many?). Is their mailing list available for you to do a promo? Do they sell other products? How many? What trade shows do they participate in?

FINDING A GREETING CARD REP

Stationery and gift shows where reps set up booths are a good place to talk to reps. You could also ask your local stationery store who their reps are. Try your local design center and see if any reps have set up shop there. The LA Gift Mart, for example, is a great place to check out. Some manufacturer's reps have showrooms there. You can study what they sell and see if your work is appropriate. Call (213) 749 7911 for the LA Gift Mart, and they will tell you their hours and what you will need to present to them to gain entry (usually a resale number, business card, etc.).

Your small company will need 1-2,000 accounts. Marcell Schurman has 15,000 accounts which are handled by their own in-house reps. An example of your income would then be: 1000 accounts x $100 sales (the minimum) = $100,000 in wholesale sales for the year. When you work on your five-year plan, you will try to anticipate future income and expenses by taking into account the number of reps you anticipate having.

Once you have a rep, keep in contact. It will mean more sales. If you have a rep who exhibits at stationery and gift shows, see if you can assist at the exhibit in some manner.

RESOURCES

Directory of Greeting Card Sales Representatives
GCA, 1200 G St NW #760, Washington, DC 20005 (202) 393 1778
Contains over 160 companies and individual sales reps in the U.S.
$100ppd for non-nmembers.

National Rep Group Directory
Spoor & Associates, 5246 Mill Creek Ln, San Jose, CA 92649
(800) 770 7470 (408) 226 9853
Lists over 2000 reps in all the major markets and has a calendar of major
U.S. gift shows and much more. $98.50ppd for the 2000 edition. The
Directory is in its 10th year.

The Rep Registry
Box 2306, Capistrano Beach, CA 92624 (949) 240 3333
www.giftbusiness.com <repregistry@thegrid.net>
The Original Gift Industry Web Yellow Pages, *lists e-mail and web site*
addresses in addition to phone and fax numbers for trade associations,
trade publications, show promoters, 1000+ venders, manufacturers, reps
and more. $32.50.

DISTRIBUTORS

As your become grows, you might consider a distributor. A distributor
is slightly different from a rep:

➤ He purchases and inventories a product and usually has exclu-
 sive rights to be your sales agent in a particular geographic area.

➤ He sells your product and pays the rep his percentage.

➤ He charges you 50%-plus of the wholesale cost.

Having someone take care of these miscellaneous business aspects will
leave you free to develop new ideas and to continue producing cards
as well as original work.

PRICING

Greeting cards are sold wholesale by the dozen. For instance, a card
that you want to retail at $2.50 will sell wholesale for $15 per dozen
(12 x $1.25). Your rep would get 20% or $3 per dozen. (Handmade
cards, which can run from $3-10 retail, are sometimes sold individu-
ally rather than by the dozen.) $100 is generally the minimum order
(i.e., 7 designs x $15 per dozen = $105). Stores don't want to order
less than $100 as it's too much trouble. Stores pay the shipping costs.

"Guaranteed Sales" is a term, if in your contract, which will enable a retailer to return goods unsold after a pre-specified time. You don't want this! Soil, tears and marks will make your cards unusable after they are returned. Only large companies can deal with the cost of returns, so don't agree to guaranteed sales under any circumstances. Guaranteed sales is similar to consignment, and you don't want that, either. Consignment is unheard of in the greeting card industry, so don't even offer it to local stores if you are doing the selling yourself.

TRADE SHOWS

You will not need stock for shows. You will only show samples of the different lines for which you will be taking orders. It's best to have 24-48 designs for customers to choose from. Representing yourself at shows is a costly venture that has paid off for many artists. You could also rent a space cooperatively with a group of artists.

Try to find some niche market shows to attend, such as florist shows, dog shows, etc. One lady had an entire booth of cards at an outdoor art show. She was doing a whopping business selling her cards from $3 up. People are almost always ready to buy a card.

Research will be a factor in your distribution success.

NATIONAL TRADE SHOWS

The National Stationery Show
George Little Management (800) 272 SHOW
The main show for the U.S. market, held in New York each year the first week of May

Atlanta Gift & Stationery Show
(404) 220 3000
There are many small shows around the country taking place in major cities. This is the second largest.

ORGANIZATIONS

Greeting Card Creative Network/GCCN
1200 G St NW #760, Washington DC 20005 (202) 393 1778
Provide an information network for the greeting card industry.

Gift Association of America
PO Box 26696, Collegeville, PA 19426 (610) 831 1841
Members are generally retail store owners, wholesalers and affiliates. If you're in the greeting card industry, this is a subdivision that you should eventually investigate for connections. This is the area where cross-merchandising of products often occurs.

MAGAZINES

Giftware News
20 N Wacker Dr #1865, Chicago, IL 60600 (800) 229 1967 ext 50
(312) 849 2220
$5 for sample issue

Gift & Stationery Business
1 Penn Plaza, New York, NY 10019-0004 (212) 714 1300

Party & Paper Retailer
107 Mill Plain Rd #204, Danbury, CT 06811-6100 (203) 730 4090
$5 for sample issue

CARD SUPPLIES

Clear Solutions
PO Box 2460, W Brattleboro, VT 05303 (603) 256 6644 (603) 256 8057 Fax
www.cleardisplays.com
Manufacturer of racks for cards. Custom and regular designs.

Impact Images
4919 Windplay Dr, El Dorado Hills, CA 95702 (800) 233 2630
(916) 933 4700 www.clearbags.com
Plastic sleeves for greeting cards and original artwork

Rice Paper Box Co
530 Acoma St, Denver, CO 80204 (877) 825 8287 (303) 825 8287
www.ricepaperbox.com
Card boxes in a variety of styles and colors: stock and custom order.

CARD PRINTERS

Color Q
2710 Dryden Rd, Dayton, OH 45439 (800) 999 1007

Wittech Foto Graphics
112 SW 3rd St, Lee's Summit, MO 64063 (800) 996 4464
www.artimages.com
Packages start at $39.95

Many artists are starting their own greeting card businesses by making beautiful handmade greeting cards—indeed, beautiful enough to frame. Bookstores, paper stores, gift shops, museum stores, children's stores and private individuals are just the tip of the iceberg for possible markets for handmade creeting cards.

Unlike printing cards by the thousands, the low financial risk of handmade cards offers more flexibility. You will need to do lots of research before you actually hit the marketplace with your creations.

➤ You can make and sell cards from your home.

➤ Low investment. Eventually you might see that you want to go into printing cards because yours are so popular.

➤ Because of their unusualness, they can be easy to sell to stores. In some cases you'll see a pin on a card as part of the design—an easily-purchased and not too expensive gift or thank-you.

ASK YOURSELF

➤ Are there cards similar to your design on the market?

➤ How do they sell?

➤ How are yours different enough for a store to want to carry them?

➤ Can you come in at a competitive price?

➤ What paper seems to be used most?

➤ What price ranges do you find?

➤ What sizes are the cards?

➤ What's 'hot' on the market?

TIPS

➤ Verify that your card is mailable; if it has something attached like a button or pin, will it break in the mail? Your envelope may need to say in large letters, "Hand Stamp." This could be an added expense.

➤ Package fewer cards in each box to make your overall price lower, i.e., eight cards instead of 12 or 10.

HANDMADE CARDS

One artist sent a handmade card to the president of a telephone company, and his wife ordered 500 to send out as corporate Christmas cards.

➤ On the back of the card put a blurb about how it was made, tell a story, make it more interesting. Customers love reading about artists and how they create.

PRICING

Calculate the labor costs from a test run of 20 pieces. An hour is based on a 50-minute time-frame. Retail needs to be 6-10 times the actual cost.

Sample budget for 1,200 greeting cards (100 dozen)

Envelopes @ .05	$ 60
Bags @ .05	$ 60
Photocopy/paper	$ 40
Cutting	$ 10
Hand-coloring	$144
Total	$314

Let's take the example above. Outside costs are at $314 or $3.14 per dozen. Multiply this $3.14 x 10 to get retail price of $31.40 per dozen or $2.61 per-card retail. Not a bad price at all for a handmade card!

THE MAKE-UP OF A $2.50 CARD

Use these quantities when compiling a budget for your prospective company.

50%	Store markup	$1.25
10%	Rep commission	.25
10%	Production	.25
10%	Overhead	.25
7.5%	Promotion	.19
7.5%	Profit	.19
5%	Artwork	.12

COST TO START A BUSINESS

You will need to consider: paper, supplies such as glue and paint, envelopes, packaging (bags or boxes), inserts, labeling, printing, assembling, labor, company business cards, catalog sheets for advertising, trade journal ads, travel to trade shows. When you make your five-year business plan, be sure to include all these factors.

If you are going to print cards in four-color in small quantities, the costs will skyrocket. 1000 cards would be around 38¢ each ($375). Photocopy and then hand-paint them. You can then call them handmade cards. One artist I know hires disabled workers to help her assemble pieces that have to be repetitively created. Call your local Salvation Army for referrals.

MARKETING

Some reps sell handmade cards, but not many. You will have to do most of your marketing. Try to find unusual outlets for your unusual cards: hospital gift shops, restaurants, garden shops, record stores, florist shops, beauty salons, frame shops, children's stores, quick-stop stores, zoos, museums, hotel shops, bookstores, new age shops, tourist shops, etc. Find your niche market and go for it!

THE PRINTING PROCESS

Dealing with a printer can be time-consuming and nerve-racking. The selection of a printer is an important one.

Purchase the book "Pocket Pal" at your local art store. It will help you learn the lingo and techniques of the printing process.

A large part of the cost, as well as an important step in the process of printing, is pre-press—typesetting and platemaking. If you have a computer, your typesetting costs can go down because you do them yourself.

Have your work photographed by a professional photographer. It's a real shame to spend money on reproductions that don't come out top-notch—besides, who will buy the cards then? A 4x5" or 8x10" transparency will reproduce slightly better than will a 35mm. Unless you begin with an excellent-quality positive, your piece will not look good. Many color separators can make the separation directly from your original, provided it can be mounted on a curved drum.

Always get quotes from several different printers. I've been amazed at the variations in prices among printers. Different presses have different limitations, so the quotes you receive can vary as much as 100%.

Get to know the printer. Get samples of his previous work. Ask for and call to verify referrals. Have questions ready when you call the referrals: Did the printer meet your deadline? Did he let you bring the original to the printing to compare colors? Did he have any hidden costs? Did he answer questions promptly during the printing process?

ASK

➤ Make sure the printer of your choice is familiar with 'fine art' printing. Printing fine art has specific requirements other types of printing doesn't have.

➤ If I make the size of my piece one inch smaller, will I be able to four-up instead of three-up?

➤ Can I be put on a four-color run with someone else's job and save money? Will the color come out as good?

➤ Get a press proof, even if you have to pay more for it. Make sure your colors are as vivid as they are supposed to be.

➤ Standard size paper is generally 25x35" or 25x38" for text weight and 26x40" for heavier cover stock. This will generally be made into the standard size card of 5x7". Check with your printer about using any extra space on the paper. Use it for package inserts, business cards, labels, whatever you can create.

Many artists start out in the greeting card industry being published by an established publisher. This publisher's job is to finance the printing, market, publicize, and handle all dealings related to the card business. This leaves artists free to continue producing original work, gives them another product to sell at an opening or show, and exhibits their work to a larger audience, all without much financial output.

The largest publishers don't like to pay royalties. They prefer to buy the right to a design outright. Calculated on the percentage of anticipated production and sales, they usually pay 5% of the wholesale sales income to an artist. For a novice in the business, that might mean between $250-500 per design. They will usually buy the rights to greeting cards *six designs* at a time. They need to have several choices.

Example: 5% of $5000 wholesale estimate (5000 cards sold at $1 wholesale/$2 retail) = $250 x 6 designs equals $1500 up-front payment. It's best to state in your agreement the limit of each print run. 5000 is a normal quantity for a first-time run. If the publisher wants to reprint, they should be paying you for a second run via a revised agreement.

HOW THEY WORK

Hallmark has an in-house creative and production staff. They also offer an apprentice program. American Greetings hires free-lance artists. They send you the words, and you design the illustration. Gibson does both free-lance and hiring.

Remember: if you are 'hired', and in some cases if you do 'free-lance', the design or creation *might not* remain in your possession. You will need to have a contract stating that the company hiring you is using it for a one-time use only and that you own the copyright. If you don't have an agreement in writing, you may regret it in the future. They will consider it work-for-hire (see Chapter 6). If, for instance, you develop a particular character or logo in your designs, be sure that *you* trademark these designs. It could mean your future in the business. The company might want to claim trademark rights. Don't let them!

LOCATING A GREETING CARD PUBLISHER

Look on the back of greeting cards to find the name and address of a publisher, then contact appropriate ones for your type of work.

ACTION PLAN

❑ Investigate greeting cards at several local stores.

❑ Attend a show to study the market.

❑ Locate a publisher.

RECOMMENDED READING

Complete Guide to Greeting Card Design and Illustration _by Eva Szela_

How to Write and Sell Greeting Cards, Bumper Stickers, T-Shirts and Other Fun Stuff _by Molly Wigand_

Which Paper? _by Silvie Turner_

Chapter 24
The Licensing Industry

What is licensing?

Now you see. It takes all the running you can do to keep in the same place. If you want to get somewhere else, you must run at least twice as fast as that! Through the Looking Glass, *Lewis Carroll*

WHAT IS LICENSING?

Many more people appreciate fine art than can afford it. There will always be room for licensed products.

Licensing is the business of leasing the right to use a legally protected graphic, artwork, name or logo. Licensing includes publishing, i.e., printing of posters, greeting cards, etc. It also includes 'cross-merchandising' items—t-shirts, coasters, carryall bags, book marks, mouse pads, aprons, pillows—literally hundreds of items.

The licensing industry has boomed over the last several years and most likely will continue to grow. Sports licensing has become a multi-billion dollar industry. Logo licensing has also become popular. Yes! Companies actually 'rent' logos.

Making money in the publishing or licensing industry comes when you sell large quantities. To create this large quantity, you often need a variety of items—sometimes called cross-merchandising. Cross-merchandising is done through licensing agents. Similar to publishers, they buy rights and give the artist royalties to have their artwork printed onto different objects.

As an individual artist competing with huge companies for a piece of the cake, you might ask, "How can I introduce my work to the licensing marketplace?"

For the emerging artist, it can be tough to get a break until your reputation has been established. Studying the marketplace and doing your homework, of course, always helps. Many artists have been quite successful. One artist who received her start in the card industry some 14 years ago has 50 licensees now and is heading for more.

RECRUITING AN AGENT

A licensing agent, the ideal way to enter the licensing industry, is always looking for the perfect 'marriage' in the marketplace for her artist and product. Publishers often act as agents for their artists, showcasing their work at licensing shows.

Getting an agent takes time, effort (attending a licensing show, calling agents), money (buying a directory) and also the appropriate art for a particular niche market.

An agent's commission is generally 35-50%. Having an agent is well-worth the fee. Agents are more aware of the marketplace, thus able to get more licenses. Being your own agent in this field is a full-time job that you don't want. Stick to art!

ROYALTY RATES

Our survey concludes that royalty rates vary! Every artist we asked had a different rate. Some rates were higher because the artist was more established. Others seemed to vary simply from licensee to licensee.

In 1994 the royalty rate on artwork generally ran between 6 and 9%, the average being 6.9%. In 1995 this average rose to 7.8%. This percentage is on *wholesale* sales.

Breakdown: prints and posters 10-15%; calendars 5-10%; greeting cards 2-5%; t-shirts 5-10%; various household items 4-8%; and textiles 5-10%.

For example, a cup retails for $10, wholesaling for $5. If you were to get 9% (the higher end of the range), you would receive 45¢ (9% of $5 wholesale price) on each cup *sold*. If an agent got you the contract, your agent would get 15¢ and you would get 30¢. Remember, you might get nothing if you don't have an agent!

PROTECTING YOUR WORK FROM PLAGIARISM

Many consumers, as well as fine artists, don't understand the copyright law and why it is important to protect your rights. Even museums have been known to infringe on artists' work—they own a piece and think they have the right of reproduction. This is a false assumption.

As the creator of an artwork, you are the legal copyright owner, even after you sell the original work. The only way you can give this right away is by signing an agreement that gives the right to another party, usually for a limited period of time and for an amount of money—to a licensor, publisher, perhaps to a nonprofit organization you are working with.

If you think your creative material has been plagiarized:

1. Discuss the matter with the company or person you think is plagiarizing. Except in the rare case where a misunderstanding has occurred, they will either deny their plagiarism or ignore your accusation totally.

2. You must then file a lawsuit within the statute of limitations or your claim will be denied due to the passage of time. You will need an experienced "intellectual property attorney" for litigation.

LICENSING GLOSSARY

Advance

Part of the payment required for a license, usually paid upon signing an agreement

Cross-licensing

The combination of two or more properties on one licensed product

Cross-merchandising

The joint retail display of two or more licensed products based on the same property. Cross-merchandising tends to increase sales and is a growing phenomenon for properties.

Grant of rights

A major provision of a licensing contract, outlining what properties, products, territories and distribution channels are authorized under the agreement

Infringement

The unauthorized use of a trademark/artwork

Licensed promotions

Events that generate awareness for the promotional partners

Licensee

The party who acquires the rights to utilize a property

Licensor

The property owner

Property

A legally-protected entity that forms the core of a licensing agreement. The property is what is leased by the licensee from the licensor.

Copyright infringement actions can only be brought about in a federal court. A plaintiff can seek an injunction against continuing and future infringements and either compensatory damages or statutory damages.

3. Your next problem will be to pay the attorney, as most intellectual property attorneys don't work on a contingent fee basis. This could cost big bucks.

ROYALTY AUDITS

A common concern of artists is, "How do I know the companies are paying me my royalties in full, i.e., not underpaying me and playing with the books?" Many artists are so paranoid about this factor that they use it as a roadblock to pursuing any publishers or licensees for their work. Large companies have this same concern.

The only way you can truly know you are getting your due is by auditing the licensee's books. In more polite terms this audit is called a 'compliance review.' The most efficient way to do this review is to hire an accounting firm that specializes in this type of audit.

Even reputable companies can make honest mistakes. When a company is handling many items from a lot of artists, one incorrectly-coded digit input into a computer can make a large difference in the amount of royalty paid.

In the licensing industry there has rarely been reported a company that does not comply honestly with paying rightful royalties. They want to keep a clean record amongst industry patrons. As in any business, however, there are unscrupulous people you have to watch out for.

Auditing arrangements should be stated within your initial written contract with the publisher, licensor or organization. Generally an audit is allowed every 12-18 months.

If the audit proves there has been an underpayment, the licensee should be liable for the amount underpaid plus interest. Often a contract will note that if there is an underpayment over a particular amount, commonly $1000 or perhaps 5% of royalties actually paid, the licensee will then be liable for paying for the audit. (This must be stated in your written agreement.)

Because these audits can be expensive, a group of artists being licensed by the same company can get together and have a group audit, splitting the accounting firm's cost.

CONTRACT GUIDELINES

Each agreement should require that the licensee place the licensor's statutory copyright on the licensed products and on all packaging, advertising and promotional materials. The licensee should submit samples of materials prior to distribution to insure that the notice requirements have been complied with.

Until you have been paid for the use of your artwork (i.e., received your royalty check in hand) per your licensing contract, the piece is not technically licensed. So be sure you're paid before anything is marketed!

- **Minimum guarantee.** This is the amount that your contract will guarantee you receive, usually half of what is estimated you'll eventually be paid.

- **Advance.** Usually one-third to one-half of estimated income

- **Term.** Two to three years is usual to begin, then both sides determine how well the product has done.

- **Exclusivity.** Rare

- **Geographical territory.** i.e., USA or International

- **Audits.** See the above information

LICENSING REVIEW

COP Corp
Robert Postal, 1365 York Ave #38K, New York, NY 10021
(212) 249 1484
This licensing agent is seeking artists to represent in the licensing industry, and will review artists work for free. If your work is not suitable for his licensing connections, he will tell you why, and perhaps where it would be more suitable. Send 20 photo prints or slides.

INTERVIEW WITH A LICENSING AGENT

The Lockhart Licensing Group specializes in the design management and licensing of today's most unique and talented illustrators, product designers and craft persons. The Lockhart Licensing Group made its debut at the Surtex Design Exhibition in New York City.

Licensing by Design is the company motto. "We create an unconventional approach to licensing successful products for the future. There is no longer a formula or boiler plate for the licensing of product. One must follow the consumer and identify the retail channels of distribution and be the 'matchmaker' in the creation of each licensed venture," states President Johanna Lockhart.

What exactly do you do as an agent?

An agent acts as a business manager to her artists. She handles all aspects of selling and marketing works targeted to specific products in her respective wholesale and retail channels of distribution.

An agent is a 'matchmaker' seeking out business contacts with potential to commercially reproduce an artist's designs onto product(s). She attends trade shows, tracks trends in various industries and monitors the business climate on many levels.

An agent can also act as a 'design manager' in partnership with the artist, concepting new products and assisting the artist in all aspects of preparing the design presentation for marketing to targeted customers.

When I exhibited at Surtex, I had 28 artists stop by and want me to look at their portfolios. My policy is that I don't review work at these shows—it kills me not to take a peek. However, in deference to the artists whose work I am trying to sell at the exhibit, I ask the artists to contact me later at my office. Of the 28 who were so eager for my time and comments, only three responded after the show. The artist must be persistent and follow through!

Do you deal much with print publishers?

Print and poster publishing is one of the first good potential contacts an artist should seek out in licensing his work; however his work must meet the specific requirements for that industry. I currently deal with many print publishers and represent several artists who have work published on posters or prints.

Who are your clients?

Clients who have used my product development services over the past nine years include: Treasure Craft, The San Francisco Music Box Co, Markings, Royal Doulton, The Toy Works, Calliope Designs, Lynn Chase Designs, Amcal, Pictura Graphica, Carlton Cards, The Progama Corp, Courtney Davis Inc, Goebel, Dragon Heart Co. The clients are a select group of specialty retailers, wholesalers, designers, both domestically and on an international level.

How does an artist locate an agent? Are there lots of agents around?

An artist can seek out appropriate representation in a number of ways: attending shows where agents are exhibiting the work of artists they represent, i.e., Surtex, The Licensing Expo; by contacting LIMA; asking for recommendations at local artist groups; or by word-of-mouth.

There are lots of licensing agents and agencies out there. The key is to select the one that will best suit your needs, as well as one who has experience with and understands the type of work an artist wants to market.

What do you look for in an artist's work?

Over the years my artists and/or client contacts have come to me through recommendations. I have also sought them out on my own, acting as a 'talent scout' for new talent and potential licensees for my artists.

I never turn down an opportunity to review an artist's work. I look at EVERYTHING! I focus on the level of the 'commercial potential' in the design and how it can be developed into product for a specific industry, whether it be published work, gifts, stationery, home textiles, housewares, etc.

I work with each artist in assembling materials, preparing a portfolio and specific design presentations.

What is the average royalty artists receive?

Royalty rates vary depending on the product, industry and retail channels of distribution. The average that I see is in the 5% range.

Percentage agent receives?

An agent's fee is usually 50% of any monies/royalties negotiated. Some agents (I for one) believe that the artist should get a larger percentage, and in some cases the artist gets 60%.

Licensing agreements?

A licensing agreement should be between the artist and the licensee, with the agent acting as 'the duly authorized agent' to collect royalties and manage the project.

An agent also has a contract with the artist. Agent agreements should specifically state terms of future agent compensation after the termination of the agency agreement.

The importance of copyrighting work?

Copyrighting of an artist's work is always recommended, but it doesn't always protect the work. It is good to have if there is a litigation. Many artists have been known to lose infringement cases even with documented copyright registration. Regrettably, the law has several loopholes and interpretations, etc. Each case seems to be unique.

Your review policy?

I am always looking for new talent and am happy to review portfolios. One major requirement is that the artist include a SASE.

BOOK

Licensing Art 101 by Michael Woodward

Published by ArtNetwork, PO Box 1360, Nevada City, CA 95959
800·383·0677 530·470·0862 530·470·0256 Fax
www.artmarketing.com/Lic101 <info@artmarketing.com>
Published in May 2002, this book gives you all the detailed information you need to make it in the publishing and licensing world. It even has over 200 contacts that have answered a questionnaire regarding the type and style of art work they are looking for. $23.95

ORGANIZATION

Licensing Industry Merchandising Association/LIMA

350 Fifth Ave #2309, New York, NY 10118-0110 (212) 244 1944
The organization for the licensing trade. Has a Licensing Resource Directory, Licensing Trends Newsletter *and an educational program.*

LICENSING TRADE SHOWS

US Licensing Show

Advanstar (800) 331 5706 (218) 723 9130 www.licensingshow.com
The leading trade show for the licensing industry, held annually in mid-June in New York. Many large companies display there: Disney, Simpsons, etc. This show has made efforts recently to provide spaces for individual artists to exhibit their work.

❑ Have a consultation to see if artwork is appropriate for the licensing world.

❑ Attend a licensing show.

❑ Search for an agent.

ACTION PLAN

RECOMMENDED READING

A Primer on Licensing *by Jack Revoyr*

Licensing Art and Design *by Caryn Leland*

Licensing Survival Guide *by Jack Revoyr*

Wallpaper and the Artist *by Marilyn Oliver Hapgood*

INDEX

1-800-POSTCARD 171
20-second glance 118
20th Century Plastics 133

A

A Manual for Art Sales 188
A Practical Guide for Temporary Exhibitions 89
A Primer on Licensing 319
Accounting 44
Accubalance Digital Camera 284
Ace Paper Tube 84
Acid materials 96
Activities schedule 32
Administrative Arts 45
Agent, licensing 312, 316-317
Air freight 87
Airfloat Systems 82
Allworth Press 71, 273
Allyson's Title Plates 91
Americans for the Arts 28, 271
American Express 241
American Color Printing 180
American Society of Portrait Artists 263
American Sound & Video 142
American Way 62
Answering machines 36
Approaching a gallery 222
Architects 258
Art & Fear 20
Art Business News 216, 279, 287
Art Business News Annual Guide 287
Art Buyers Caravan 288
Art Charts 146
Art dealer 215
Art in Embassies Program 251
Art in America 216
Art-in-Architecture Programs 251
Art in Public Places Programs 250
Art Law in a Nutshell 72
Art Now Gallery Guide 221
Art Office 30
Art representative 214

Art Without Rejection 20
ArtExpo 235
ArtFair SourceBook 233
ArtFolio 198
Artistic Checks 27
Artists' Communities: A Directory of Residencies 273
Artist's Guide to Having a Successful Exhibition 106
Artists' Labels *132*
Artist's Market 211, 264, 289
Artists of the Page: Interview with Children's Book Illustrators 296
ARTNews 198
ARTNews International Directory of Corporate Art Collectors 264
Arts for the Parks 246, 248
Arts Midwest 272
artsumbrella.com 40
artsusa.org 40
artswire.org 40
ArtWorld Hotline 229, 249
ArtWorld Mailing Lists 180, 293
ASID 217
Associated Grantmakers of MA 271
Atlanta Gift and Stationery Show 302
Audits 53, 314
Automobile deductions 49
Awards & Presentations 91

B

B&W Photos 130
Bacon's Publicity Checker 211
Balance sheet 51-52
Bank account 26
Bartering 275
Bingham, Todd 188
Bishop Street Press 282
Body Language 202
Body of work 155
Book publishers 293
Brassco Engraving 91
Brochures 174-177
Bryant Productions 141

Bold type = Companies, shows and organizations

Italic type = Publications and videos

INDEX

Budget 102, 306
 Personal 57
Bus lines 87
Business and Legal Forms for Fine Artists 72
Business Book 114
Business Card Graphics 116
Business cards 115
 Printers 115
Business checking account 26
Business Letters for Artists 144
Business license 26
Business name 26, 109

C

Calendar Creator 31
Calendar Marketing Association 295
Calendars 294-295
California Overnight 88
Call forwarding 36
Call hold 36
Call waiting 35
Calling tips 162
Canadian Institute of Portrait Artists 263
Cardcrafts 91
Care of artwork 96
*Caring For Your Art: A Guide for Artists
 and Collectors* 97
Carter-Rhoads Editions 284
Catalogs 174
Change Your Mind, Change Your Life 24
Check companies 27
Check Gallery 27
Checking account balancing 45
Checks in the Mail 27
Chicago Artist's Coalition 217, 249
Citizens Photo 131
City-wide open studios 242
Clark Cards 115, 171
Classic Editions 282
Clear Solutions 304
Client status sheet 160
Closing a sale 188

Collectors Guide 221
Color photographs 130
Color Q 169, 180, 286, 304
Colson Printing 286
Commissions 263
 Portrait 263
Competitions 198, 246, 252
Complete Guide to Greeting Card Design 310
Computers 38
Conquering the Paper Pile-Up 42
Conservation Stamp Competition 252
Consignment receipt 228
Consultants 214, 251, 303
Contests 198, 246, 252
Contracts 67-68, 193, 228, 291, 315
Cook Editions 282
Cooperative spaces 229
COP Corp 315
Copiers 38
Copyright 60-62
 Hotline 61
Copyright Handbook 72
County clerks office 26
Coupons 192
Coupralux 282
Cover letter 140
Crating 84
Crating, Packing and Shipping Art 89
Craven Home Videos 141
Creative visualization 24
Cross-merchandising 197
Customers for Life 202

D

Daily planner 32
Decor Magazine 216, 279, 288
Decor's Annual Sources 288
Deduction categories 48
 Automobile 49
 Home-office 49
Defining success 21
Deluxe Business Forms 31

Bold type = Companies, shows and organizations

Italic type = Publications and videos

INDEX

Deluxe Office Products 30
Depreciation 49, 52-53
Desktop copier 38
Dexter 115, 279
DHL Worldwide Express 88
Digital Plus 282
Direct imprint slide labeling 132
Direct mail 178
Direct Promotions 115
Directory of Greeting Card Sales Representatives 301
Discounting policy 77
Distributors 301
Donations 254-256
Duplicating slides 130

E

E-mail 39
Editing Your Newsletter 182
Editor and Publisher International Yearbook 211
Editorial Free-Lancers Association 178
Editors 209
Elements of Style 126
Encyclopedia of Living Artists 79, 198
Envelopes 114
Establishing confidence 186
Estate planning 65
Exhibit Marketing 244
Exhibitions
 Brochures 102
 Budget 102
 Invitation 102-103
 Planning 100-105
Expense ledger 47
Exposures 138

F

Faben Inc 45
Fax machines 37
Fear of rejection 19-20
Federal Duck Stamp Competition 252
Federal Express 88
Federal identification number 29

File cards 157
Fine Art Publicity 212
Fine Print 282, 336
Finer Image Editions 282
Flat prints 83, 90
Flip-chart portfolio 138
Flyers 174
Form 1040 53
Form 1099 55
Form 4562 49, 52, 53
Foundation center libraries 266
Framing 90
Fresh Ideas in Letterhead and Business Card Design 116
Future Safe, The Present is the Future 66

G

Gale Directory of Publications 211
Gallery Association of New York State 89
Gallery guides 221
General Tax Guide and Recordkeeping Kit 53
George Little Management 290, 302
Get the Best from Yourself 24
Getting organized 30
Getting Publicity 212
Giclée 281-282
Gift and Stationery Business 290, 303
Gift Association of America 303
Gift certificate 192
Giftware News 303
Go Wild 273
Goal-setting 148
Going for Grants 271
Good Show! A Guide for Temporary Exhibitions 106
Gorman, Geoffrey 41
Grants
 Foundation libraries 266
 Writers 269, 271
Grant Searching Simplified 271
Grant writing 267-269
Graphic Dimensions 133
Great American Printing Co 115
Great Papers 148

Bold type = Companies, shows and organizations

Italic type = *Publications and videos*

INDEX

Greeting cards 298-310
Greeting Card Creative Network 303
Greetings 303
Guarantee of your work 240
Guerrilla Marketing in the 90s 116
Guerrilla PR 212
Guerrilla Selling 194
Guide to Estate Planning 66
guild.com 198
Guild Sourcebooks 198

H

Handling objections 187
Handshake 225
Hanging artwork 92-94
Happiness is a Choice 24
Hardware for Hanging 89
Harris List 233
Harvest Productions 282
Health Insurance: A Guide for Artists 29
Hints on Prints 279
Hold Everything 30
Holland Photo 131
Home-office deduction 49
Homemade Money 168
Hospitals 259
Hotels 259
Housing 275
Howard, David 142
How to Buy A Personal Computer 38
How to Create Your Own Catalog Economically 178
How to Design Trademarks and Logos 116
How to Get Results with Publicity 212
How to Organize and Operate a Small Business 42
How to Organize Your Home 30
How to Photograph Using Natural Light 134
How to Register Your Own Trademark 111
How to Start Your Own Business...and Succeed 42
How to Turn Your Money Life Around 58
How to Write and Sell Greeting Cards 310
HTML 40
Humidity 95

Hunter Editions 282

I

Image evaluation 286
Image Innovations 133
Imago 181
Impact Images 304
Impact presentations 282
Income ledger 46
Info USA 180
Infringement 61, 313
Insurance 28, 88
Interior designers 215-216
International Art Business Symposium 45
International Directory of the Arts 256
International Graphics 293
International Interior Design Association 215
International Yearbook 211
Internet 39-40
 Advertising 200-201
Internet for Dummies 42
Internships 274
Interstate Label Company 114
Invasion of privacy 63
Invitations 103
Iris prints 281-282
IRS 53-55, 270
IRS Publications 54

J

Jackson, Zella 45, 189
Jeffrey, Erica *178*
Julian Block's Year-Round Tax Strategies 58
Juried Art Exhibitions 249
Jury process 248-249, 270

K

K&L Custom Photographics 131
Keeping the Books: Basic Recordkeeping 58
Kodak Photo CD player 143
Kolor View Press 180

Bold type = Companies, shows and organizations *Italic type = Publications and videos*

INDEX

L

Label companies 114
Label placement 94
Lane, Wendy 173
Lang, Cay 41
Law art seminars 71
Learning to sell 184
Lease program 164, 191
Ledgers 46-47
Legal Guide for the Visual Artist 72
Legal rights 60
Legal structure 29
Letterhead 113
Letters 140
Letterhead and Logo Design 116
Letterheads: One Hundred Years of Great Design 116
Libraries, foundation centers 266
Library of Congress 61
Licenses 26
Licensing Art and Design 319
Licensing Industry Merchandising Association 318
Licensing review 315
Licensing Survival Guide 319
LicensingWorld 318
Liebowitz, Kathryn 123
Life's Little Instruction Book 24
Light Impressions 132, 138
Lighting 95
LIMA 318
Living More with Less 58
Local gallery guides 221
Logo 110
Long-term goals 151
Lucky Dog Media 273

M

Mail organization 32
Mailing lists 156
Mailing tubes 83
Make it Legal 72
Make Your Phone Work for You 163

Making a sell 189
Manhattan Arts International 190, 221
Maria Walsh Sharpe Art Foundation 66, 275
Mark Ireland Productions 141
Market value pricing 75
Marketing Made Easier: Guide to Product Publicity 212
Marketing schedule 33
Marketing with Video 142
Marketing without Money 212
Martindale-Hubbell Law Directory 71
Masterpak 83
Media Guide 211
MediaLink 141
Merchant status 241
Michael Craven Video 141
Micropix 283
Mid-America Arts Alliance 272
Mid-Atlantic Arts Foundation 272
Midwest Photo 206
Miles Kimball 148
Model release 63
Modern Postcard 171
Money: The Feisty Woman's Plan-Ahead Guide 57
Moving companies 88
Museum Store Association 256
Museums of the World 256
Myth of the struggling artist 19

N

Nameplates 91
Nancy E Quinn Associates 271
National directories 198-199
National Endowment for the Arts 272
National Rep Group Directory 301
National Stationery Show 302
NEA 272
Netlaw: Your Rights in the Online World 42
Networking 165
New American Paintings 198
New Arts Program Resource Library 89
New Media Printing 171
New Museum of Contemporary Art 274

Bold type = Companies, shows and organizations

Italic type = Publications and videos

INDEX

New York Contemporary Art Galleries 190, 221
Newsletter Resources 172
Newsletters 172-173
Niche marketing 166

O

Oak & Rope Designs 237
Objections 187
Official Museum Directory 256
On-line resources 40
One-Minute Designer 116
Open editions 280
Open Studio Press 198
Open studios 242
Outdoor shows 233-240
Overnight shipping services 88
Oxbridge Directory of Newsletters 211

P

Paper Access 113, 179
Paper Direct 113, 179
Party & Paper Retailer 303
Patents and Trademarks Office 111
Patron program 164, 192
Percentage for the Arts Program 250
Perseverance 21
Personal budget 57
Phillips, Renée 190
Phone tips 158
Photo labels 114
Photographic prints 282
Photographing Your Artwork 134
Photographing Your Paintings 134
Pictureframe Products 83
Plagiarism 313
Planning an Exhibit 100-106
Planning and Goal-Setting for Small Business 148
Pocket Pal 308
Popcorn Report 42
Portfolios 137-138
 Video 141-142
Portrait commissions 263

Portrait Society of America 263
Post Script Press 171
Positive Impressions: Effective Telephone Skills 168
Postal, Robert 315
Postal shipping 87
Postcards 170
 Printers 171
Power Calling 168
Powerful Telephone Skills 163
Pre-exhibition offer 240
Precision Business Systems 241
Press coverage 147
Pricing
 Artwork 74-79
 Greeting cards 306
 Time and overhead 74
Pricing and Ethical Guidelines 80
Pricing tips 76
Print broker 181
Private collectors 261
Pro-Pak 83
Producing and Marketing Prints 279
Profit/loss statements 50
Projections 56
Protecting Your Heirs & Creative Work 71
Publicist 215
Publishing Your Art as Cards, Posters & Calendars 296

Q

Quality House 91
Queblo Images 179
Quicken 45
Quill 132, 139, 179

R

Rank Video 141
Real Magic: Creating Miracles in Everyday Life 24
Real estate brokers 261
Record companies 294
Referrals 189-190
Reliable Home Office 114
Religious markets 257

Bold type = Companies, shows and organizations

Italic type = Publications and videos

INDEX

Rental agreement 193
Rental galleries 229
Reps 217
Reprints 199
Resale Royalties Act 64
Residencies 273
 National Parks 273
Resumé categories 119-122
Rice Paper Box Co 304
Roadblocks 18
Robinson-Patman Federal Act 77
Rolodex 115
Rosco 283
Rosencrantz & Guildenstern 27
Royalty audits 314
Royalty rates 313
RSVP 23
Running a One-Person Business 42

S

SBA 41
Sales tax permit 27
SASE 223
Schedule C 53
SCORE 41
Self-employment tax 53, 271
Self-publishing 278-280, 298-304
Selling Art on the Internet 39
Service Corps of Retired Executives 41
Sherwood 91
Shippers 88
Shipping Tubes 84
Short-term goals 150
Shows, planning 100-106
Shrink-wrap 83
Signing work 79
Signs by Gwynn 91
Signs by Paul 91
Six Steps to Free Publicity 207
Six Steps to Success 155

Slides
 Duplication 131-132
 Labeling 131-132
 Registries 251
 Storage 132
Small Business Administration 41
Small Business Development Center 41
Small Time Operator 58
Smith, Constance 41
Song Writer's Market 296
Southern Arts Federation 272
Space Organizers 31
Space Place 275
St James, Synthia 23
Standard Periodical Directory 211
Statement, artist's 123-125
Story-line 208
Stationery House 31
Straight Talk on Money 58
Studio show 242
Studio visit 225
Sunshine Artist Magazine 233
Superior Rubber Stamp 82
Surtex 318
Swim with the Sharks without Being Eaten Alive 152

T

Tagline 112
Taking the Leap 41
Tapette Corporation 142
Target market 166
Target Marketing for the Small Business 168
Taxes
 Depreciation **52**
 Quarterly estimates **55**
Teaching the Elephant to Dance 202
Telephone 35, 158-163
Testimonials 175
The 5 W's 205
The 90-Minute Hour 152
The Art Law Primer 72

Bold type = Companies, shows and organizations

Italic type = Publications and videos

INDEX

The Art of Displaying Art 97
The Art of Selling Art 194
The Art of Showing Art 97
The Artist Observed 24
The Artist's Friendly Legal Guide 72
The Artist's Guide to Exhibition at Fine Art Expos 237
The Artist's Handbook for Photographing Their Own Artwork 34
The Best of Business Card Design 116
The Budget Kit 58
The Business of Art 264
The Care and Handling of Art Objects 97
The Publicity Manual 212
The Rep Registry 301
The Right Frame 97
The Seven Habits of Highly Effective People 202
The Whole Internet User's Guide and Catalog 42
The Write Touch 113
The Zen of Hype 212
ThermaStroke 284
Think and Grow Rich 194
Three-tear calendar diary 148
Tickler postcard 103
Time and overhead pricing 74
Tips for Successfully Photographing Your Work 134
Titling work 79
Trade Show Exhibiting 244
Trade shows 234-235, 288, 302, 312, 318
Trademark 110
Transfers to canvas 284
TransFix 132
Transparencies 130
Travel programs 273
Treaty Oak Press 171

U

Ullman, Hannah 271
United Manufacturers 91
University galleries 229
UPS 87

US Art 289
US Licensing Show 318
US postage stamps 252
User-friendly agreements 69-70

V

Video duping services 142
Video portfolios 141
Viders, Sue 146, 279, 286
Visual Artists and the Law 72
Visual Artists Information Hotline 41
Visual Horizons 131, 133
Volunteer Lawyers for the Arts 71
Volunteer Urban Consulting Group 41

W

Wallpaper and the Artist 319
Web of Art Business 188
Western State Arts Federation 272
What a Way to Go 89
Which Paper? 310
Whole Internet User's Guide & Catalog 42
Wishcraft: How to Get What You Really Want 24
Wittech Foto Graphics 304
Work-for-hire 66
Working Artist 45
World in Color 131
World Market Products 171
Worldwide Express 88
Writing Effective News Releases 212

Y

Yazoo Mills 84
Your Business Plan 152
Your Income Tax 58
Your Money or Your Life 58
Your Money, Your Self 58

Z

Ziglar on Selling 194

Bold type = Companies, shows and organizations *Italic type = Publications and videos*

Art Office

80+ business forms, charts, legal documents, sample letters and business plans....

all for fine artists' business needs.

Forms include:

Twelve-month planning calendar • Sales agreement • Model release

Rental-lease agreement • Form VA • Slide reference sheet

Competition record • Target market chart • Customer-client record

Phone-zone sheet • Monthly project status • Marketing plan

Twelve-month show planner • Checklist for a juried show • Print planning calendar

Bill of Sale • Pricing worksheet • Press release

and lots more.......

all for photocopying!

$14.95

Also available on
MacIntosh diskette/$14.95
(runs on PageMaker software only)

ArtNetwork

530·470·0862 800·383·0677 Voice mail 530·470·0256 Fax

PO Box 1360, Nevada City, CA 95959-1360

www.artmarketing.com <info@artmarketing.com>

Newsletters

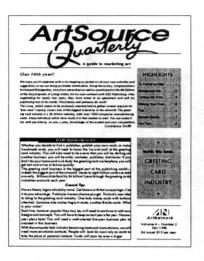

ArtSource Quarterly

Published every three months, this eight-page newsletter is packed full of new ideas that give fine artists the creative edge their art business needs, taking sales to new levels. Each issue covers a specific topic such as: publishing, pricing, the greeting card industry, publicity, sales, the licensing industry and more.

- Interviews with successful artists
- Articles by artworld professionals
- Innovative marketing ideas
- Hot tips and leads

8 issues (2 years) $36

4 issues (1 year) $19

Only $4 per issue!

ArtWorld Hotline *In its 11th year!*

This four-page monthly newsletter has listings not found in any other publication—the best opportunities to advance your career.

Listings include:

- Consultants looking for artists
- Publishing opportunities
- "Percentage for the Arts" commissions
- Gallery calls
- Residencies and grants
- and more!

2-year subscription $48

1-year subscription $26

ArtNetwork
530·470·0862 800·383·0677 530·470·0256 Fax
PO Box 1360, Nevada City, CA 95959-1360
www.artmarketing.com <info@artmarketing.com>

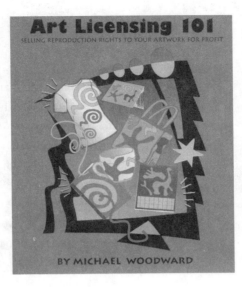

Art Licensing 101

In this book you will learn about the licensing and publishing industry—
how it really works and how to approach its participants:
Targeting your presentation • Trade shows • Licensing agents
Protecting your rights • Self-publishing • Publicity
Names and addresses of over 200 people to contact in the industry are
listed in the back of the book—calendar publishers, licensing agents,
greeting card publishers, print publishers, print distributors and more.
Michael Woodward has worked in the licensing and publishing industry
in the U.K. for over 20 years. He now lives in Florida and works as a
consultant. He also conducts seminars on licensing.

$23.95

ArtNetwork
530·470·0862 800·383·0677 530·470·0256 Fax
PO Box 1360, Nevada City, CA 95959-1360
www.artmarketing.com <info@artmarketing.com>

Directories

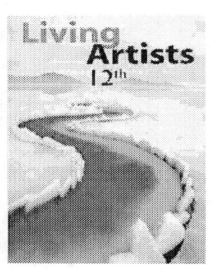

Living Artists

In this competitive and fast-paced world, an artist needs to take marketing seriously. Here's a way to do it dynamically and economically! The *Living Artists* (formerly titled the *Encyclopedia of Living Artists*) is a direct link to prime customers—including reps, consultants, gallery owners, art publishers and museum curators. These artworld professionals use this book to select artwork throughout the year for various projects. Artwork in the book is reproduced in high-quality, full-color, along with artist's name, address and telephone number. Prospective buyers have direct contact with the artist of choice. All fine artists are invited to submit their work; a maximum of 75 artists are chosen for publication. Published biannually in odd-numbered years. A contest is conducted for the cover position.

ArtFolio

Publishers are constantly seeking out new and innovative art work for posters, greeting cards, limited edition prints and licensing opportunities. This 6x6" spiral bound booklet (printed on heavy postcard stock) is the smartest way for artists to contact these publishers. *ArtFolio* exposes 98 artists to over 4000 art publishers for only $499! Published biannually in even-numbered years.

ArtNetwork
530·470·0862 800·383·0677 530·470·0256 Fax
PO Box 1360, Nevada City, CA 95959-1360
www.artmarketing.com <info@artmarketing.com>

ArtWorld Mailing Lists

130 print distributors .. $40
170 calendar publishers .. $40
160 licensing companies ... $40
110 corporate art consultants $50
280 Canadian galleries .. $50
325 book publishers .. $50
500 galleries selling photography $55
400 greeting card reps .. $60
840 interior designers ... $65
475 art organization newsletters $70
900 greeting card publishers $70
850 architects ... $70
530 museum gift store buyers $75
650 corporations collecting art $75
875 museum curators .. $75
1000 arts councils .. $75
500 foreign galleries .. $90
1900 university galleries ... $130
1950 university art departments $130
1750 art publishers ... $130
2000 art organizations ... $140
2000 frame and poster galleries $140
2000 reps, consultants, dealers $140
6500 galleries ... $75 per 1000
41,000 artists .. $95 per 1000

Mailing lists come on peel-and-stick labels and can be rented for one-time use.

E-mail lists

1350 Corpororate facility managers $75
800 U.S. art galleries ... $50
300 Foreign galleries ... $25

E-mail lists are sold for unlimited personal/business usage.
They cannot be resold. They were gatherd by a California sculptor for the promotion and sale of his work.

ArtNetwork
530·470·0862 800·383·0677 530·470·0256 **Fax**
PO Box 1360, Nevada City, CA 95959-1360
www.artmarketing.com <info@artmarketing.com>

www.artmarketing. com

Surf our 1000⁺ page site

- Browse to our book section and find articles to improve your marketing techniques.
- Go to HotArtLinks and find leads to residencies, grants, lawyers, consultants, organizations, art fairs, licensing agents, art magazines, museums, galleries, resources and art supplies of all types, info about taxes, special travel adventures for artists, and more!
- Sign up in our guest book.

Join us in the on-line revolution!

ArtNetwork
530·470·0862 800·383·0677 530·470·0256 Fax
PO Box 1360, Nevada City, CA 95959-1360
www.artmarketing.com <info@artmarketing.com>

Your Own Home Page

Send potential clients to your personal address on the web, i.e., www.artmarketing.com/gallery/yourname. Corporate art buyers, art collectors, interior designers, reps, consultants, gallery owners and the general public browse our site. ArtNetwork continually mails to art world professionals informing them of our Internet address, encouraging them to visit the gallery. The cost to have a home page is nominal. Five pieces for two years, which includes 200 words of copy—only $160.

Your full-color web page includes five photos of your artwork. The page at right is what your main page will look like. Each artwork clicks to an enlarged rendition, approximately three times

the size. Your clients can go directly to your page, skipping all intermediary pages and sites. To sign up for Internet exposure, simply follow the directions below or go on-line at www.artmarketing.com/Ads/artap.html. You can download all necessary documents.

No commissions taken!

Only $160 for two years exposure.

To apply send:

❑ Five images for ArtNetwork to scan. A combination of horizontal and vertical is fine. We prefer photo prints, but slide or computer diskettes are fine. If you send a photo/print, it can be no smaller than 2x2", no larger than 8x10". Artwork will be electronically scanned and reproduced, using a 72dpi resolution. Quality may differ from slide/photo to some extent. No color corrections are made, so send well-taken slides/photos.

❑ List of images indicating title, size, medium, retail price, and if prints are available, cost and size of prints.

❑ Check, money order or charge card number (VISA/MC/AmExpress/Discover) for $160 for two years of service.

❑ Legible copy of no more than 200 words. If you have an e-mail address, be sure to include that so we can post it directly on your home page.

❑ A #10 SASE ($1) for return of materials.

ArtNetwork
530·470·0862 800·383·0677 530·470·0256 Fax
PO Box 1360, Nevada City, CA 95959-1360
www.artmarketing.com <info@artmarketing.com>

MarketingArtist

This business management tool for fine artists functions on any computer. It
manages patron and client contracts • keeps a journal of each contact
inventories artwork • tracks consignments
records the history of each art piece created along with a jpg of the original
tracks projects • tracks show entries

Usage of this software is offered **free** to small businesses (50 contacts/artworks or 1Mb of storage).
Those businesses that need more extensive file space can subscribe—starting at $4.95 per month. A
subscription includes storage space for 1000 contacts or artworks.

On-line demo

To test out this software, go on-line to **www.marketingartist.com**. Any questions, suggestions or
problems you might find with the system, simply e-mail <help@marketingartist.com>.

ArtNetwork
530·470·0862 800·383·0677 530·470·0256 Fax
PO Box 1360, Nevada City, CA 95959-1360
www.artmarketing.com <info@artmarketing.com>